Mushroom Wanderland

Mushroom Wanderland

A Forager's Guide to Finding, Identifying, and Using More Than 25 Wild Fungi

Jess Starwood

THE COUNTRYMAN PRESS
A Division of W. W. Norton & Company
Independent Publishers Since 1923

This volume is intended as a general information resource. Neither the publisher nor the author can guarantee that every reader will be able accurately to identify every variety of fungus described in these pages. Please use common sense before gathering or coming into other contact with plants that may cause an allergic reaction and do not ingest anything that you have not definitively identified as safe and nontoxic. Use particular care when foraging or cooking with children. This book is not a substitute for medical advice; no remedy described in these pages should be used in lieu of individualized attention from a qualified professional. As of press time, the URLs displayed in this book link or refer to existing websites. The publisher is not responsible for, and should not be deemed to endorse or recommend, any website other than its own or any content available on the internet (including, without limitation, any website, blog page, or information page) that is not created by W. W. Norton. The author, similarly, is not responsible for third-party material.

Copyright © 2021 by Jess Starwood

All photography by Jess Starwood, except on the pages listed below:
Pages 130, 134, 135, 149, 158, and 208: photography by Kyle J. Lapp
Pages 174 and 178: photography by Mary E. Smiley

Illustrations © Epine_art/iStockPhoto.com

For information about permission to reproduce selections from this book, write to
Permissions, The Countryman Press, 500 Fifth Avenue, New York, NY 10110

For information about special discounts for bulk purchases, please contact
W. W. Norton Special Sales at specialsales@wwnorton.com or 800-233-4830

Manufacturing by RR Donnelley Asia Printing Solutions Limited
Book design by Allison Chi
Production manager: Devon Zahn

Library of Congress Cataloging-in-Publication Data

Names: Starwood, Jess, author.
Title: Mushroom wanderland : a forager's guide to finding, identifying, and using more
than 25 wild fungi / Jess Starwood.
Description: New York, NY : The Countryman Press, [2021] | Includes bibliographical references and index.
Identifiers: LCCN 2021006711 | ISBN 9781682686348 (hardcover) | ISBN 9781682686355 (epub)
Subjects: LCSH: Mushrooms. | Mushrooms—Identification.
Classification: LCC QK617 .S79 2021 | DDC 579.6—dc23
LC record available at https://lccn.loc.gov/2021006711

The Countryman Press
www.countrymanpress.com

A division of W. W. Norton & Company, Inc.
500 Fifth Avenue, New York, NY 10110
www.wwnorton.com

10 9 8 7 6 5 4 3 2 1

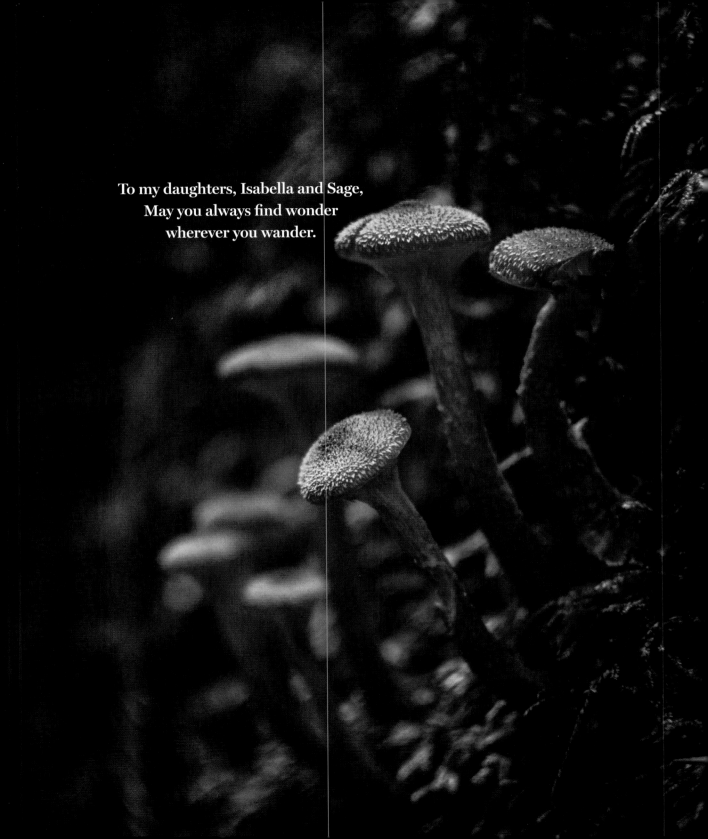

To my daughters, Isabella and Sage,
May you always find wonder
wherever you wander.

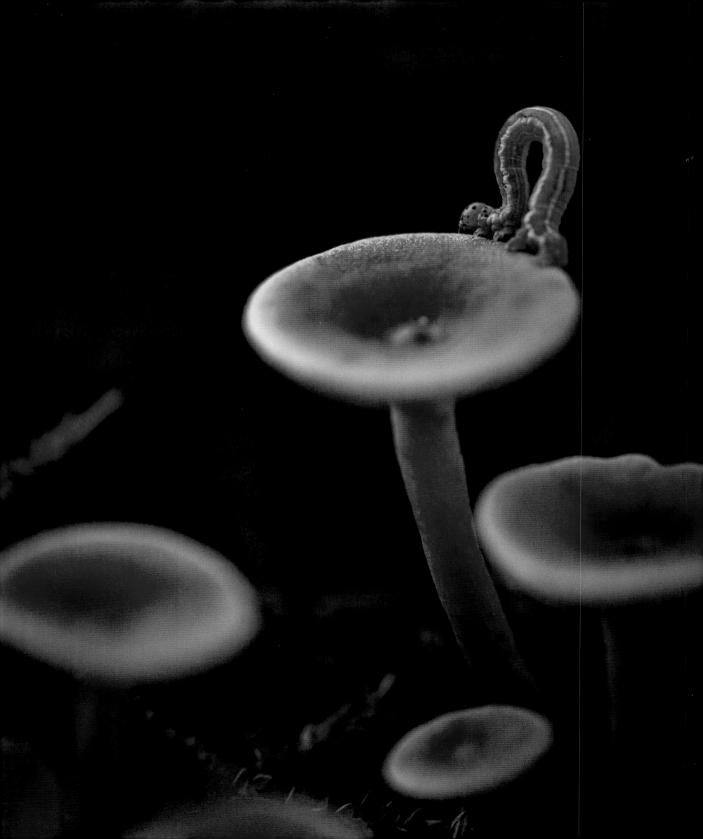

Contents

9 Introduction:
The Wanderer's Path

The Forager's Forest

19 Into the Forest and Out of
Your Mind: Finding More
Than Mushrooms

31 The Fungal Frontier:
Mushrooms as
Food, Medicine, and
Enlightenment

41 In Pursuit of Fungi: Foraging
Practices and Safety

59 The Forest on Your Plate:
Cooking and Preserving
Mushrooms

Meet the Mushrooms

87 Culinary Mushrooms
89 Meadow & Prince Mushrooms
95 Oyster
99 The Puffballs
103 Milk Caps & Candy Caps
107 Chicken of the Woods
111 Lobster
115 Chanterelle

119 Porcini
123 Black Trumpet
127 Morel
131 Hen of the Woods
135 Matsutake

139 Medicinal Mushrooms
143 Turkey Tail
147 Lion's Mane
151 Cordyceps
155 Reishi
159 Fly Agaric
163 Magic Mushrooms

167 Toxic Mushrooms
169 Jack o' Lantern
171 Webcaps
175 Destroying Angel
177 Death Cap
181 Deadly Galerina

183 Other Curiosities
184 Coral and Club Fungi
185 Russula
186 Earthstars
187 Jelly Fungi
189 Inky Caps
191 Slime Mold

193 Acknowledgments
195 Resources
197 Bibliography
201 Index

"I went to the woods because I wished to live deliberately . . ."
—Henry David Thoreau

Introduction

THE WANDERER'S PATH

Just what is it that fascinates us so deeply about mushrooms? Is it their curious shapes, mystifying colors, and alluring textures? Is it their mysterious and ephemeral nature, showing up ever so briefly, seemingly whenever they please? Or is it a primal and natural feeling of hunting for food that they evoke from us? Maybe it's their uncanny way of showing us just what it means to be human in this complex experience of life. As a parent, a teacher, and once a curious child myself, I've even noticed a feeling of childlike wonder that comes with mushroom hunting. After all, I have never known a child who was not inherently curious about the natural world around them.

I distinctly remember my first mushroom hunting adventure. It was a cool, dreary November morning in Los Angeles when I met up with a group of like-minded nature-curious folks for a class on wild edible plants and mushrooms. I already had some introductory knowledge of edible plants and medicinal herbs, as that was the focus of my master's studies at the time, but I was relatively clueless about anything related to fungi. Like a majority of people in contemporary American culture, picking a mushroom from the wild to eat seemed like a foreign and also frightening concept.

Other cultures consider mushroom hunting commonplace and a regular practice taught throughout the generations. But, growing up in the Sonoran desert of Arizona, my experience with mushrooms was next to nothing. To me, mushrooms were mystical inhabitants of lush vibrant green forests that I had only seen in animated movies and illustrated storybooks. It didn't help that most of my family members detested them—there were no foraging outings with grandparents and no treasured family recipes on how to prepare them. I was stepping into new territory.

In the foothills of the Angeles National Forest, after our group discussed the wide variety of edible plants for a few hours in the oak woodlands, we were instructed to look for mushrooms in the leaf litter under the looming oak trees. At first, I didn't see anything at all, just a carpet of brown and tan leaves covering the forest floor. I felt like I was missing something and ambled about as I strained my eyes. Suddenly, someone in the group called out excitedly, "Found one! Can we eat it?!" The instructor came over and examined it, identifying it as a type of bolete (most likely a *Xerocomellus* species) and that yes, in fact, it was edible. This concept blew my mind. It did not resemble anything I had seen at the grocery store. It was a small red and yellow stemmed mushroom with a spongey underside. I intensely looked again at the nondescript landscape before me but nothing stood out apart from leaves, sticks, and a few rocks.

Others were clamoring excitedly over their finds. I felt a bit defeated, but just as I was about to give up, I saw it. Pushing up eagerly from the earth was what looked like only a rock underneath the layer of fallen detritus. Brushing aside the leaves and dirt, I carefully extracted it from its hiding place, fully seeing its mushroom form that was previously hidden from view. I quickly collected a small handful, but had absolutely no intention of eating any.

This was the first of many experiences over the years I had in training my eyes to pick out the subtle visual cues that indicated mushrooms in the landscape. I would learn that some are incredibly easy to spot—like the enormous vibrant orange and yellow "chicken of the woods" mushrooms that grow on the sides of trees. But others are cleverly disguised, hiding among the duff on the forest floor, leaving only the most subtle clues for the seasoned hunter to notice. Once I began to learn more, mushrooms seemed to simply show up in plain sight, over and over, where

previously I would have missed them. From that day on, mushrooms seemed to make their way into my life in every way possible, even though they had been there all along.

NATURE'S GRAND WORKS of art can be found in the sweeping, awe-inspiring vistas of the mountains, the dramatic landscapes of the coasts, the intricacies of the temperate rainforests, and the arid yet vibrant deserts. Yet, hidden below the surface, between our cells and intertwined with every part of earth, is the true canvas upon which this artwork has been built. Fungi are the connecting threads in our ecosystems. The interwoven connectedness of our very existence happened over the course of millennia, crafting our environment from organic and nonorganic materials, physically integrating life into the foundation of the earth below and through us. They weave in between the cells of the living and transform the dead into the building blocks of new life.

These connecting threads are called mycelium, the true organism of what we see as the mushroom. In actuality, the mushroom only serves for spore dispersal—fungi's unique reproductive process. Mycelium, and the

intricate underground network it creates, is nearly invisible to the human eye—finding its way inside of trees, plants, and even insects and animals, until it seems to magically sprout a fruiting body. This mycelial network connects information, nutrients, and energy flow between other fungi and plants and trees—in effect, the internet of the forest.

The fungi kingdom includes not only the mushrooms we commonly think of (and that are featured in this book) but also molds, yeasts, rusts, parasitic microfungi, and lichens. As we'll discuss in coming chapters, mushrooms and mycelia were some of the first organisms on the planet, paving the way for plants to evolve in terrestrial habitats. Much of the fungi realm is still unknown and a good portion remains to be explored, where every foray into the wild presents the possibility of discovering a previously unknown species. Fungi make up an area of research that is continually changing, DNA sequencing having switched up how we have named, categorized, and understood the seemingly endless variations of species. Fungi show us how we all depend on each other, whether they play a visible and apparent role in our lives or only support us invisibly in ways we have yet to understand.

From food, beverages, and medicine to culture and religion, fungi have crafted a framework for our very way of life, creating connections on every level of our being despite our lacking awareness of them. Some have even garnered a cult following, such as the exquisite delicacy known as the morel.

Entire festivals are dedicated to this delicious mushroom, as well as to the magic mushroom, which heralded a cultural movement and captured the attention of scientists. There is even a fascination with the classic *Amanita muscaria*, claimed to be the basis of much folklore and fairytales worldwide.

Outside of what we think of as cleverly designed structures in our society and cities, we are merely attempting to recreate the networks and interconnectivity that nature has already created, the same way a child attempts to emulate a mother. But somehow humans decided that, with our self-proclaimed advanced intelligence, we can outsmart nature and control it to our level of comfort. While occasionally, we might seem to get ahead with our fancy technology, nature swiftly reminds us who always has and always will have the upper hand.

When I was growing up in the deserts and forests of Arizona, my parents instilled in me a love for nature and an invaluable connection with the land. They shared their passion for living simply and off-the-grid for long periods at a time as we camped in the most remote places we could find. For weeks, we would disappear so deeply into the forest, not encountering other humans the entire time. My most cherished childhood memories occurred during those adventures—driving the dirt roads early in the morning to spot and photograph deer and other animals on the move, building forts and tree swings with my brother and sister, fishing with my dad, finding and observing plants and flowers, and collecting little treasures that I still have to this day. These memories made a foundation that inspired a lifelong curiosity and wonder for the natural world.

However, the modern world does not easily allow for such a slow and natural way of life. It beckons us away from the forest with its flashy, seductive media. It occupies us with endless to-do lists and agendas, senseless paperwork, and nonstop messages, the next latest and greatest must-buy item to keep us satiated for just a moment. It teaches us to consume blindly with no consideration of the energy and resources lost in creation. But what if we were to stop for a breath, take a step out of the circus show, and brush away all the nonsense. What if we walked into the forest, to just slightly shift that perspective and discover that the cycle of nature is different? It uses everything it creates, and the cycle is continued without waste and without landfills that will outlast every aging tree in the forest.

Like everyone else I knew, I was swept away from the forest and into mainstream culture, like a fallen leaf into a swiftly moving river, leaving behind everything it had known before. It wasn't until my first daughter was born that I had a moment of clarity one afternoon while rocking her to sleep for her nap. The path I had been walking was not right for me. So I sought out alternatives, questioned my decisions, and reconsidered the role I played on the earth. I planted a garden

from seeds, raising vegetables for us to eat. I learned the names of the weeds—the plants that could be found on the nearby trails—and they weren't that frightening. I began to take walks by myself at a pace that was right for me, not one that was focused on a specific destination in the least amount of time and effort.

Whatever path I took, be it long and winding or direct and to the point, I didn't know where it would lead—I just knew it was mine alone and it needed to be walked. I came to know that I couldn't truly understand myself without understanding the environment I came from. I learned how I was a part of the environment and the environment was inextricably a part of me.

We all have a role to play as stewards of the land we borrow from. If we are aware and active participants in the time we have on earth, we can leave it maybe just a little better than when we arrived. This book will introduce you to wild mushrooms—ones that you can forage yourself, some that are tasty, some that are healing, and some to avoid. But there's a little more to it than that. It is an invitation to the forest, an open invitation to walk into the woods with fresh eyes to see what has been waiting for you. Each of us has roots in the land; we just have to take the time to explore and look for them.

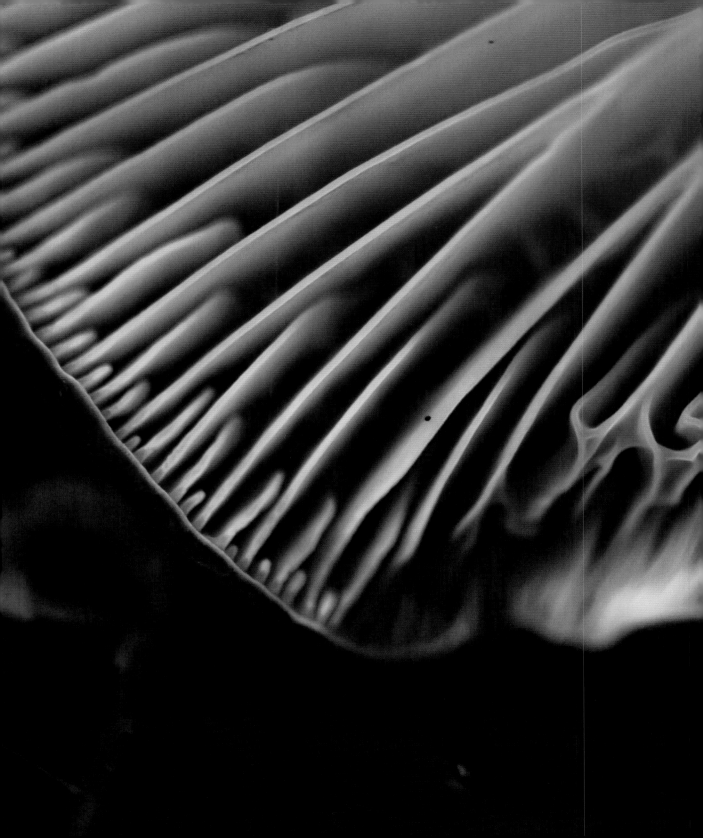

The Forager's Forest

"We are travelers on a cosmic journey,
stardust, swirling and dancing in the
eddies and whirlpools of infinity. Life is
eternal. We have stopped for a moment
to encounter each other, to meet, to love,
to share. This is a precious moment.
It is a little parenthesis in eternity."
—Paulo Coelho, *The Alchemist*

Into the Forest and Out of Your Mind

FINDING MORE THAN MUSHROOMS

Mushroom hunters always remember their biggest firsts. The first morel. The first chanterelle. The first porcini. These highly sought-after mushrooms make an unforgettable first impression. Sometimes—often—it takes years of searching, wandering hillsides, and scouring the forest floor, season after season, returning only with an empty basket. But sometimes that first discovery is the product of a lucky glance in the right direction, coming to us when we least expect it. Sometimes they never appear at all, eluding us and undermining our hunting skills. But no matter how that moment of discovery happens—whether it's the first time or the thousandth—we are reminded once again that there is still magic in the woods, in our neighborhoods, or even right at home.

I had been hunting mushrooms in the Los Angeles area for quite a few years when I became obsessed with finding morels. Los Angeles was certainly not the most ideal location to adopt mushroom hunting as a hobby. The combination of an arid landscape and a very short rainy season produces only a modest amount of any mushrooms. You are lucky to find any edible varieties there. As I was learning the identification of various species, I was an active member of a few online mushroom hunting groups and, when springtime came around, everyone was abuzz about finding morels. These drably colored cone-shaped structures, much like a pine cone with a deeply pitted surface, are elusive. I remembered seeing them on fancy dining menus back when my life was much different and I could afford such luxuries. But to find them in the wild? For free? I was determined to succeed.

So, one late spring morning I had taken a hint from a friend to head north towards Mount Shasta—a good ten-hour drive from home. I had planned to attend the McCloud Mushroom Festival that weekend, which, in general, is usually a clue that there are mushrooms to be found in the nearby forests. I brought my new dog Wiley along with me for our first big adventure together and we searched every mountainside we encountered. For hours. For days. Not a single morel to be found. There were many other mushrooms—boletes, oysters, corals, and shaggy manes—but not what I was out to find. I was at a loss. That is, until I met a local sommelier, who, upon hearing about my empty-handed

travels, gave me a veritable treasure map to find my gold.

I followed her directions carefully and distinctly remembered her saying the map would lead to an open area that was recently burned. But even with this visual guide, Wiley and I struggled to find our prize, hiking for miles until I nearly came to the conclusion that morels were in fact mythical creatures, no more likely to be found than a unicorn. Tired, I decided to sit on the forest ground for a moment before continuing, joking out loud to Wiley, "How funny would it be if they just showed up next to us here!" And sure enough, as I cast my gaze around from this new, low perspective, there they were.

I saw one. Then another. Then three, then several more dotting the path we took up the hillside. Had I been missing them all this time? Or did they finally call to me, like mischievous pixies, deciding they had tormented me long enough? Or, maybe, as one in their right mind would conclude, I only needed a literal change of perspective to spot them. Either way, I filled my basket modestly that day, which made the ten-hour drive back to Los Angeles just a little bit easier.

Since that day, I have gathered hundreds of pounds of morels and the quest and excitement for them never wanes. Each outing, each morel spotted and plucked from the earth feels just as surprising as that first time on Mount Shasta.

I've experienced similar moments of serendipitous discoveries, like when I had been hunting with a friend, looking for oyster

mushrooms for hours, in all the right places—on the old, burned willow and cottonwood trees along the creek. The day was growing long and the sun had already slipped below the horizon. We had wanted to bring some back to make dinner that night after finding them in the same area several times before.

Out of frustration, I exasperatedly said to my foraging companion, "All this searching and I bet they'd show up right here."

As I pointed blindly to a tree behind me, my friend was dumbfounded to see that in the exact location where I had pointed was the biggest oyster mushroom cluster I found in my early days of hunting.

Sometimes I feel that mushrooms have a sense of humor, or they find delight in seeing to what extent one would go to find them. It seems to happen that way, whether it is a sort of manifestation or some secret connection between the fungi and our conscious minds. Are we somehow in tune with their whereabouts? I have heard similar stories from nearly every other mushroom hunter I know—hours spent wandering the forest, only to discover that the fungi they sought was feet from where they got out of their car in the first place. But it's because of this wandering journey that many of us see and appreciate the value of mushrooms.

Now, after years of mushroom hunting, the forest is no longer a place of unknowns, but a second home to me. The act of foraging has sharpened my senses in a way that modern life, with all the noise of our fabricated world, never could. When the mushrooms are calling—on a tree along a city street on my way to a meeting or in the neighbor's lawn on the way to run daily errands—nature offers little reminders that it is continuing on with the cycles of the season. And in this way, mushrooms bring us back to life, reminding us to breathe, see, hear, feel, and connect.

With more and more people recognizing their role not in only our lives but on the earth around us, there has been a resurgence or a reawakening curiosity about the realm of fungi. As we explore, the intricacies of the fungal frontier demonstrate how every aspect of life depends on the complex and intimate connection these organisms create between the living and non-living. They usher us through all the stages of life, silently doing their work in the background. They're responsible for transforming inorganic materials into nutrients that sustain organic life, and then ultimately help disintegrate that same organic life. This is how it has always been and how nature continues to work.

Language of the Land

While mushrooms might seem to have minds of their own (and who's to say they don't have some sort of intelligence that we don't yet understand?), they can help us learn the language of the landscape. The presence, or absence, of fungi can tell us about the health of the trees, soil, and environment. They have also been used to assess the presence of radioactive activity in an area; they easily

bioaccumulate these compounds. Careful observation of patterns in plant communities and weather can help determine when and where mushrooms might appear, if they do at all, the next year.

Unsuccessful hunts can lead you to gather information about habitats and environments that will be helpful in the future. It's an opportunity to learn about the trees that grow there and what microclimates the seasons bring. Our senses can pick up data about the area at that time and give us clues into why there may not be mushrooms—which directions the hillsides are facing, the possible flow of water runoff, plant communities, sun and wind exposure, and varying temperatures. All of these variables, and more, affect mushroom growth. This information gathering helps us understand which particular relationships the fungi depend on, but also which organisms depend on the presence of fungi. With time, the experienced hunter develops an invaluable connection to the environment.

Plants, especially mushrooms, have a unique language. While fungi can interact and communicate with their surroundings and environmental cues through changes in light, direction of gravity, pressure, and nearby objects, much like we do, they do not speak in words that we understand. Only the animal kingdom has the benefit (or perhaps the disadvantage?) of eyes and ears connected to a central nervous system.

Other organisms, like mushrooms, rely on sending chemical signals to each other through their root systems. This is facilitated by the mycelial networks of fungi. Airborne volatile oils can attract and repel other organisms, even warning neighboring plants that danger is near. In this way, every organism and organic particle is part of a greater conversation. A constant flux of information is exchanged, some of which we can ever-so-slightly eavesdrop on through aromas and tastes. As our body takes in molecules from the environment, these senses help us decode that environment. And by using our sensory inputs, we can turn mushroom hunting into a literal practice, invoking the habits of our early ancestors to read the landscape and find our food.

Some mushroom hunters I know are convinced that they can smell a mushroom before they have visual confirmation of its whereabouts. This is not unusual in the case of stinkhorn mushrooms, whose foul odor of rotting meat is often noticed first, or the use of trained dogs or pigs to pick up the scent of a truffle hidden underground. But what about the other subtle sweet aromas of chanterelles, the anise scent of oysters, or the distinct earthiness of morels? The smell of the forest is a cacophony of various notes. But with awareness and a discerning nose, sniffing out mushrooms is not an impossible task.

Taste is also a unique way that humans can sense their surroundings, although I'm not suggesting that you taste everything you find in the forest before understanding its edibility. Smell and taste are intricately linked. Flavors are simply chemical compounds that enter our body and react in a physiological

way. These gustatory inputs are translated into the five tastes: bitter, sweet, salty, sour, and umami (mushrooms take the savory cake in the final category with their considerable levels of glutamate). Each of these tastes trigger specific metabolic actions in the body. For example, sweet flavors activate receptors that maintain energy balance while bitter flavors increase digestive action. For humans, our mediocre receptors of smell and taste clue us in to what we need to survive. It's the balance of flavor that creates a perfect and satisfying meal—sweet, salty, sour, bitter, and umami. And these flavors help us to meet our basic nutrient needs of carbohydrate, protein, fat, vitamins, and minerals.

What's more, mushrooms actually have an incredible range of unique flavors and aromas that don't always correlate to the tastes we recognize. Our language can't quite evoke an accurate description, much like the language of sommeliers attempting to describe the vast layers of aromas and flavors of wine. Everyone will have a different experience and relationship with a new flavor. For example, the flavor and aroma of the highly regarded and valuable matsutake mushroom can be difficult to adequately describe. Some say it smells like a combination of dirty gym socks and Red Hots candy, while others say earthy pine and spicy cinnamon. But all can agree, its aroma is simply the distinct smell of what is collectively known as matsutake.

Exploring the forest in this way gives us the opportunity to widen our depth and range of flavor experiences. Some advanced mushroom hunters sort through the edibility of the notoriously difficult-to-identify *Russula* genus by taste testing them. If they are acrid, peppery, or bitter, they are discarded. But if it is mild and palatable, it can be collected for a tolerable meal. Theoretically, even deadly mushrooms can be taste tested and spit out without consequence, but this is absolutely not recommended.

Tasting the landscape offers us a new perspective and a new way to experience the world around us. When we think of a country farm or garden, we imagine the flavors of fresh eggs and bacon, or the freshness of a garden salad. But what does the forest taste like on a chilly fall day when the chanterelles and acorns appear? Or the springtime when the morels and fiddleheads are just bursting forth? The land does not speak in a language of words and phrases we are accustomed to, but if we tune in, honing our senses of taste and smell, it reveals our world to us through a new lens.

Immersion

Watching and observing while you forage can also help you build a relationship with the land. And as we build those relationships and understand the land's complexity and what it provides for us, the more we can appreciate it.

As I write this, some of my favorite places to wander are being ravaged by wildfires. But it is fire season, an occurrence that is not entirely foreign to these forests. When I return, it will never be the same as it once was, but I will notice how nature always comes back,

adapting to the stresses that the fire brought. New life is able to spring forth again as it couldn't do before. Meanwhile, other lands, once rich with vast populations of delicious fungi, are now being leveled flat and strangled of their wildness to build shopping malls or high-rises, as the city ever-so-swiftly expands its reaches. But no matter what, nature is persistent, edging through the crevices in the concrete, grasping for some sort of community that it once knew and belonged to.

It surprises me sometimes when I am teaching a class, even to children, that there are folks who are very uncomfortable with the outdoors. That's not to say they aren't interested in learning about mushrooms or nature, but they seem conditioned to believe that the outdoors is a scary and dangerous place to be. But usually, we're frightened by the things we don't understand. Sometimes we have to start from the beginning and learn to find comfort in nature. This may simply be the practice of returning to the same forest many times throughout a season, even over many years. A special place where one can get to know the trees, how plants change from one season to the next, what mushrooms appear after the rains, and if they return the following year.

Just how much do we move unconsciously through our lives? As we go from the comfort of our home and daily routines on the same route to the same workplace day after day, we easily become complacent to changes in nature. We rarely notice the shift in the way the shadows fall across the trees in autumn, the coming and going of seasonal creeks and springs, or changing bird songs. When we become so preoccupied with life experienced only through a screen, we easily find ourselves out of touch with the natural rhythm of our environment. By reacquainting ourselves with the land and witnessing its seasons, we develop an invaluable and intimate relationship with our environment. Only then are we rewarded with a renewed sense of connectedness, curiosity, and wonder of the natural world wherever we go.

There is delight and surprise in seeing mushrooms erupt in the middle of a dry and sandy desert where we least expected them. Or there is the childlike awe in stumbling upon a moss-laden forest floor dotted with hundreds of mushrooms glimmering with dew.

It sounds fantastical, but countless studies that have been done on the physiological effects of spending time in and interacting with nature, such as lowering cortisol levels, blood pressure, and stress, which improves overall physical and emotional health. This practice has long been known in Japanese culture as *shinrin-yoku*, or "forest bathing," and is even prescribed by some doctors. Maybe that's why we can't get enough. It is not only the mushrooms, but also the forest and the mountains calling us home. And, for our health, we must go.

Setting out into the forest, basket in hand, an enthusiastic novice hunter has an idea of what they are seeking, whether they dream of filling their basket with morels and porcini or they have been lured to the forest seeking the unfamiliar.

As with many things in life, when we set out with expectations, our results are not always what we had in mind. Some days the hunting is incredible, whereas other outings are mediocre, and you have to settle for either an empty basket or an underwhelming find.

Instead of seeing this as defeat, as with my morel hunting adventure, we should recognize it as an opportunity for patience and perspective. Often times, turning around and heading back to the car is just enough to change your point of view, both literally and figuratively. Or, maybe we still just end up with an empty basket, but a clear and refreshed mind full of inspiration and clarity to return to our families, friends and workplaces. Sometimes what we set out to find isn't necessarily what we need.

The teachings of fungi do not end at the edge of the forest. As we venture home with a basket of mushrooms, we are reminded of the fleeting aspect of time and that the fungi, still, do not wait for us. Time is of the essence; we must clean and process these rewards or they may quickly be tomorrow's compost. We are reminded to take only what we need or share this gift with others. Hoarding them for ourselves will probably lead to waste and excess.

Going deeper down the rabbit hole, we can also access the peculiar entheogenic nature of some mushrooms, teaching us about the complex interconnectedness of nature, challenging our perceptions and ego, and causing us to step into a sense of what it means to be human in a greater web of reality. The realm of fungi may open the perceptual door a little wider, wipe the windows a little clearer, but they still ask us to do the work and continue on our humanly paths. But while we're here, they can also feed and heal us.

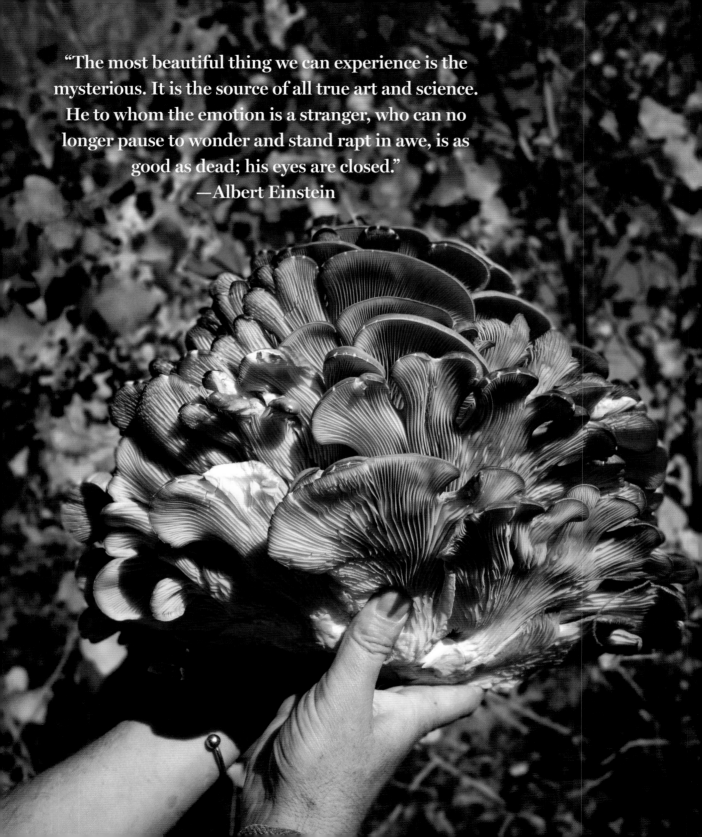

"The most beautiful thing we can experience is the mysterious. It is the source of all true art and science. He to whom the emotion is a stranger, who can no longer pause to wonder and stand rapt in awe, is as good as dead; his eyes are closed."
—Albert Einstein

The Fungal Frontier

MUSHROOMS AS FOOD, MEDICINE, AND ENLIGHTENMENT

From our humble human perspective, fungi are food, medicine, and, at times, our spiritual guides. However, their history long precedes our awareness of them. Fungi have been here longer than we originally presumed. Whether they evolved spontaneously from a primordial earth alongside bacteria and, eventually, plants, or their indestructible spores stumbled upon a planet that had just enough sunlight, water, and ideal temperatures to take up residence, fungi have helped to shape our very existence on Planet Earth.

Without more oxygen in the atmosphere and a foundation for ideal animal and human habitats, we wouldn't be here. But we really owe these developments to mushrooms and the plants they helped grow. As plants made their way onto land, they lacked root systems and relied on the hyphae of fungi's mycelial networks to grow inside them and into the soil. In this way, plants and mushrooms became symbiotic partners, exchanging resources that only one or the other could provide. As time progressed, plants became more complex and developed photosynthesis, capturing the energy of sunlight and transforming it into sugars that also benefited the fungi.

Meanwhile, the fungi evolving alongside these plants developed a defense mechanism. Antibiotic and antifungal compounds within their system essentially worked as an external immune system to protect the plants on which the fungi depended. This growing network of mycelium connected other plants and brought communities together, building a cohesive system that cycled nutrients through growth and decay. This created a mutualistic dependence whereby the fungi would transform inorganic matter into food for their plant partners to survive. And as the plants survived, the mushrooms thrived, which allowed the plants to evolve into more complex and diversified organisms.

Only recently in this epic coevolution of life on Earth have humans entered into the land that fungi built—and we needed food to eat and medicine to keep our health in check. At least twenty-two species of primates consume fungi for nutrition, as do many animals, birds, insects, amoebas, nematodes, gastropods, and bacteria—even other fungi. Very few mammals feed exclusively on mushrooms; however, they make up a small yet important part of the mammalian diet. Not long ago, mushroom hunting was as normal as it is for us to forage for our food at the supermarket. Somewhere along the way, industrialization left the art of mushroom hunting behind and replaced it with the paltry offering of canned button mushrooms.

I recall the first time I intentionally ate a mushroom. Due to my father's intense dislike for anything that grew from cow manure (a common misconception, as mushrooms grow on many substrates), my mother never prepared them for the family despite her enjoyment of them. Much like most other Americans, I thought mushrooms were meant to be avoided, if not kicked and stomped on.

It wasn't until my mom took me and my sister on a girls-only summer retreat to a cabin in the woods that I learned mushrooms' other uses. It was a time of indulging, nearly recklessly, in all the activities that weren't encouraged at home. We spent our days perusing the antique stores in the little town nearby, looking for unusual treasures, taking leisurely walks in the forest, and, as it happened, eating mushrooms. My mom had bought some white button mushrooms from the market. She took them out of their ordinary package and asked me to help slice them. I was a little nervous about how these would affect our dinner, with their spongy texture and earthy smell.

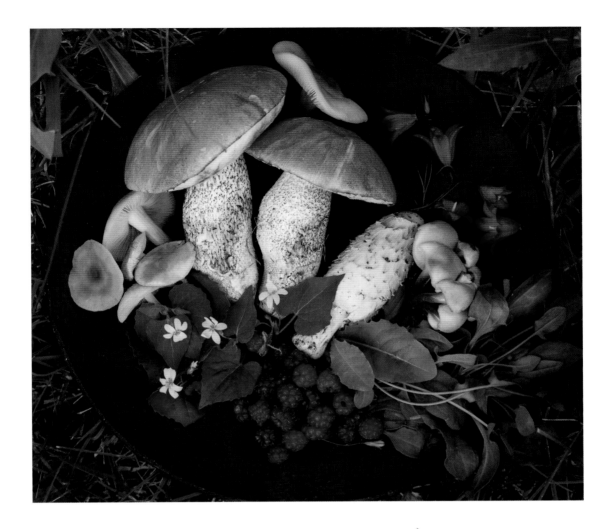

Certainly they were not like any vegetable we were accustomed to eating. We tossed them in the pan, and then the magic happened. A dollop of butter was added and I watched in fascination as the nearly overflowing mound of mushrooms shrank down to a modest handful. Then the taste was something I had never experienced before. It was complex, savory, and downright satisfying. I most definitely licked the plate.

Fungi as Food

Compared to the diversified and seasonal diets of our ancestors, human foods come from a very limited number of species, whether plant, animal, or fungus. As modern-day food production advances, we often rely on what is commercially available to us. The standard American diet today is built upon only twelve species of plants and five livestock species (and only one species of mushroom, as

mentioned above)—with a good percentage of these species being contributors to common food allergies (wheat, corn, soy, egg, dairy). To seek out those lesser-consumed species, we have to venture out of the supermarket and into local farmers' markets, specialty growers, or directly from the source—the wild itself.

One of the most important dietary benefits of diversifying the species of plants and fungi is the increased levels and greater range of micronutrients that have been lost in modern agriculture. But as our soils are farmed over and over, increasing our production for a rapidly increasing population, we are simultaneously depleting our farmed fruits and vegetables of the very same nutrients that the majority of Americans are deficient in. These include protein, calcium, phosphorus, iron, riboflavin (vitamin B2), and vitamin C, as well as magnesium, zinc, and vitamins B-6 and E, and, especially, Vitamin D. As crops grow bigger with higher yields, the nutrients are spread thin and unable to uptake these compounds from an exhausted soil. Artificial fertilizers and amendments just aren't as effective as real, living earth.

So what about those missing micronutrients, found only in wild foods and a diversity of species? Those nutrients would provide our bodies with the ability to naturally boost our immune systems, increase vitality, adaptability, health, and overall wellbeing. Interestingly, mushrooms (in general, each species will vary a bit) contain notable amounts of protein, calcium, niacin, phosphorous, magnesium, selenium, iron, copper, potassium, and vitamins C and D, plus many of the B vitamin complex—all of which are also deficient in our farmed foods.

And it just so happens, eating mushrooms will make you happy—and no, it's not just the psychedelic kind. All mushrooms have significant levels of vitamin D—the sunshine vitamin, or at least a precursor compound known as ergosterol, which is then converted by ultraviolet light to a bioavailable form of vitamin D that our bodies can absorb. Strange, coming from an organism that typically never sees the light of day until it makes a mushroom, but it is even more strange coming from a non-animal organism.

Vitamin D is naturally found in fatty fish and commercially extracted from sheep's wool for supplements—not things typically suitable for those on a plant-based diet. It is uncommon to find large quantities, if any at all, of this vitamin in plants, which makes mushrooms an important and viable addition to a well-balanced vegan or vegetarian diet. Mushrooms naturally have a modest amount of vitamin D, but when they are exposed to ultraviolet light (gills facing upwards towards the light), a single serving of mushrooms can produce at least or more than the recommended daily amount of vitamin D. Morels, maitake, and chanterelles contain the highest amounts (5.2 to 28.1 μg/100 grams) while non-ultraviolet light treated white button, cremini, and portobello mushrooms contain the least amount (0.1 to 0.3 μg/100 grams), with others falling somewhere in that spectrum.

In general, mushrooms also have significant amounts of B vitamins, which play a large role in overall health, energy levels, cell metabolism, and functions. Vitamin B12 is another vitamin that is also rarely found in non-animal sources but is present in several species of cultivated and wild mushrooms such as shiitake, black trumpets, and chanterelles. Folate, another important B vitamin that is often deficient in many diets, produces DNA and RNA, helps to form red blood cells and prevent anemia, and is important for pregnant women to prevent brain and spine defects. It is prevalent in many mushrooms, but highest in oyster and enoki.

Aside from being a missing link to many of our dietary woes, mushrooms offer new territory for chefs and home cooks alike. It is currently estimated that 2.2 and 3.8 million species of mushrooms inhabit the earth. This means they outnumber plant species six times. Of all mushroom species, approximately 350 are consumed throughout the world, yet only one species (cleverly labeled as several different types throughout its various stages of growth) is used most often in the American diet: the *Agaricus bisporus*. In the supermarket it is known as white button, portobello, cremini, and chestnut, depending on its color and size. Even though the common button

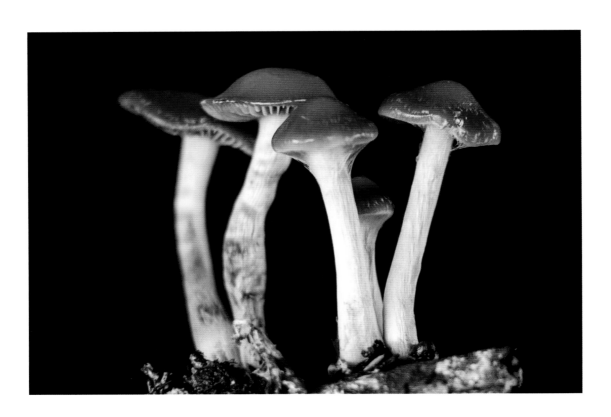

mushroom certainly has its health benefits (see page 89), there is so much more depth and subtle nuance to the world of wild culinary and medicinal fungi—a culinary frontier ready to be explored.

Fungi as Medicine

Mushrooms have garnered the attention of humans for as long as we have walked the earth. Their mysterious and transient nature has captivated various cultures into speculating if fungi possess magical powers. People have used mushrooms as talismans, or taken them as a remedy for a vast range of ailments. But are they food or are they medicine? Undoubtedly, they're both. As we've seen, adding some fabulous fungi to one's diet increases micronutrient intake and valuable levels of different vitamins. But mushrooms may also enhance our immune systems.

Medicinal mushrooms have been a controversial hot topic among scientists and alternative practitioners alike. Some say they are nothing more than a sugar pill with no side effects while others claim these mushrooms cure all that ails under the sun. Countless studies have been done on many different long-used mushrooms with enough evidence to conclude that more research is warranted.

Evidence from many studies has indicated that fungi are helpful to the immune system in a very unique way. While our body's immune system is designed to fluctuate over time and adapt to environmental stressors, it doesn't always work that way. Sometimes the body's self-defense mechanisms don't always step up to the plate like they should, or in autoimmune diseases, they work too hard and the slightest disturbance can cause a problem. But mushrooms have been shown to modulate the immune system as it is, bringing it back into balance from either extreme. This unique quality of mushrooms, with little to no side effects, shows potential in addressing issues that are not easily treated with pharmaceuticals, which come with their own list of side effects. Our bodies are designed to fight off disease, but sometimes they need a little help from our fungal friends.

While some are skeptical about the use of mushrooms as panaceas in alternative medicine, fungi play a crucial role in modern medicine, given that they are the basis of many important pharmaceuticals, from the antibiotic penicillin to cholesterol-lowering statins, such as lovastatin, and even anticancer drugs such as paclitaxel (Taxol). They even serve us in antifungals, antivirals, and immunosuppressants. Many mushrooms have been studied for their anticancer and tumor-suppressant properties and are often used in conjunction with radiation treatments to mitigate the effects of chemotherapy.

One of the most significant compounds found in mushrooms is the polysaccharide group, a type of carbohydrate made up of bioactive beta-glucans, which are responsible for most of their medicinal qualities. These compounds are also considered prebiotics, feeding the beneficial microbiota that reside in our digestive systems. These digestive bacteria are also a crucial part of fighting disease, properly digesting foods, and producing

Mushroom Extracts

There are a growing number of mushroom supplements to explore. The extracts on the market may come in powder or liquid form. However, mushroom powders should not be consumed raw. All of those good and important beta-glucans are encased in rigid cell walls made up of chitin—an indigestible compound similar to the cell walls that make up crustacean shells—that need to be broken down in order to be absorbed. Otherwise, they simply pass through the body.

It is certainly possible to make your own medicinal tea or extracts. For tea, simply chop your fresh mushrooms (such as reishi, chaga, or turkey tail) into small bits and allow them to dry completely in a dehydrator or in the sun. When you are ready to make your tea, add a small amount to a pot of hot water and simmer for 25 to 35 minutes, then strain and sweeten to your liking. The extended length of time for simmering helps break down the chitin and release all of the polysaccharides into the water, which are mostly only soluble in hot water. Other compounds, such as terpenes (specifically, triterpenoids), sterols, and flavonoids, can be drawn out with double-extraction.

Double-extraction is similar to hot water extraction, but requires an initial extraction with alcohol. To do this, combine your selected mushrooms with a high-proof alcohol (at least 80 proof or stronger, such as vodka or Everclear) in a glass jar with just enough alcohol to cover the mushrooms. Seal and allow to sit for a few weeks to a month, shaking periodically. After time has passed, strain out the mushrooms and place in a pot of water. Reserve the mushroom-infused alcohol in a separate container. Bring the water and mushrooms to a simmer and allow the water to reduce by about half. Be careful not to let it completely evaporate. Strain the mushrooms again and reserve the water and allow to cool to room temperature. Combine both the mushroom-infused alcohol and the mushroom-infused water together in a jar and shake to mix thoroughly. The alcohol content will help preserve the water infusion and make it shelf stable for long-term use.

important B vitamins, riboflavin, and vitamin K. Maintaining a healthy microbiome has also been shown to play a role in improving neuro-psychiatric disorders such as autism, anxiety, stress, and depression. In addition, many autoimmune diseases are connected to a dysfunction of the microbiome.

Given the myriad ways in which they can help improve our health and well-being, occasionally adding mushrooms to your daily diet could help create a balance in your immune system. And if it turns out mushrooms don't quite live up to the hype of being medicinal cure-alls, edible mushrooms can, at the very least, make a fabulous meal and offer new culinary avenues to explore.

As science continues to examine and study fungi in their vast and far-reaching uses, there has been a resurgence of interest in the role of psychedelics in medicine. As neuroscience advances to better understand the workings of the human brain, psilocybin-containing mushrooms are moving to the forefront of research on neurological treatments. Pharmacological treatments have been largely ineffective for many psychological disorders such as treatment-resistant depression, anxiety, PTSD, addiction, anorexia and end-of-life transitions.

But, as science is finding out, and maybe as shamanic tribes have known all along, the person suffering from these conditions is often unable to shift out of a negative thought cycle

and into positive actions. Yet, studies on psilocybin treatment are showing that it may be possible to rewire the neurons in the brain, creating new connections, instilling a new perspective on the world, and helping the patient break through old thought patterns. Combined with mindfulness, a physician's approval, and the guidance of a therapist, psilocybin can be a powerful and effective tool for our most common health issues. It is important to note that the use of psilocybin treatment is illegal in some countries and certain areas of the United States, and it can be dangerous if used under inappropriate conditions; you will need to do your research (and seek appropriate professional advice) before you introduce any form of psychedelics in your diet. That said, just as other medicinal mushrooms help rebalance our immune systems, psilocybin mushrooms may help to rebalance our psychological state of mind as well, bringing us back to a feeling of centeredness and connection to the universe.

Our Place in the Universe

In the same way that mushrooms can heal and nourish us, we also know that the hunt itself can be a therapeutic process. After a traumatic divorce, I had lost my way. I found myself alone and without a support network. Only after spending days in the forest did I ask the trees for their guidance on how to navigate the tumultuous path I was on. It took time and years of wandering through these complex landscapes to find myself again. Through these dark days, I started to notice the little things in nature that begged for my attention, which prompted me to ask questions about each new thing that I encountered. It started with the plants. But quickly, I was drawn to the ephemeral quality of fungi because they pulled me deeper into the forest, again and again.

That time in the forest was healing—whether it was my quest for mushrooms or simply the nurturing power of the forest community around me. It was the only place I found refuge, a place where I no longer felt threatened, judged, or cast out. It was a place that felt familiar, and I grew to feel connected to it.

Over the years, when sharing my interests with other mushroom hunters, I have found that many people feel the same thing I do: a sort of connectedness, or oneness, that I had never quite felt before. This seems to be a common story among mushroom enthusiasts, hunters, and foragers: we returned to the forest and came to befriend the fungi after a challenging life event or just to find our place in an ever-changing world. It was a return to peace after straying into a disconnected, fast-paced consumerist life in the city. But for others, it was a lifelong connection that started with family members passing down family traditions and practices.

Maybe mushrooms aren't the magical panacea that they were once thought to be throughout history, but they do deserve attention. They offer ancient wisdom from the beginning of time and will carry on long after we're gone. And maybe along the way, we can learn a few things from them about being connected and working with each other for a brighter future.

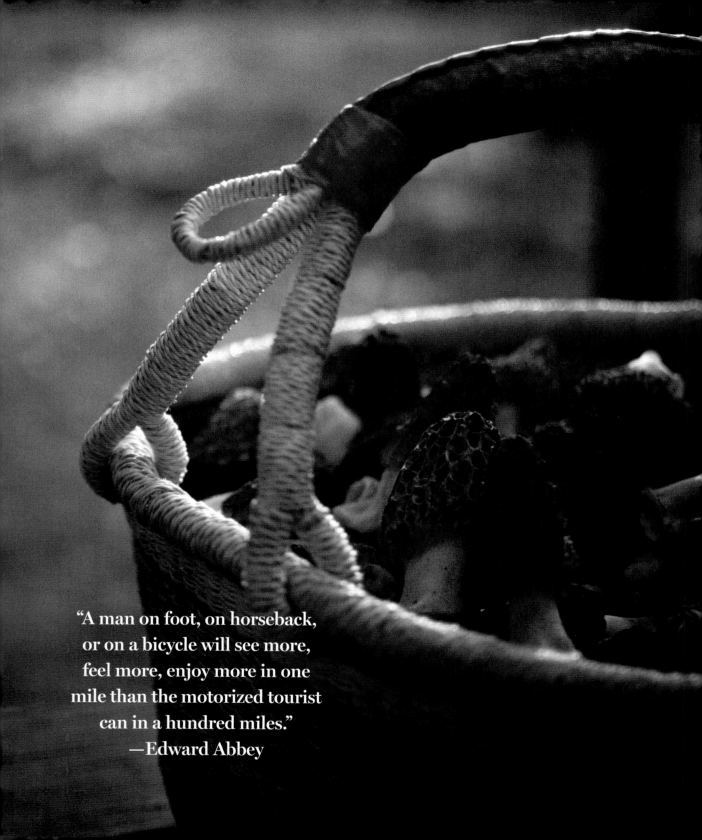

"A man on foot, on horseback, or on a bicycle will see more, feel more, enjoy more in one mile than the motorized tourist can in a hundred miles."
—Edward Abbey

In Pursuit of Fungi
FORAGING PRACTICES AND SAFETY

Mushrooms continue to enchant us and insist that we take a closer look, so naturally many of us turn to mushroom hunting for enjoyment or to gather culinary treasures. For some, eating from the landscape around us can seem like a foreign concept. On the contrary, we wouldn't be here today if our ancestors hadn't been skilled foragers who collected fruits, seeds, berries, herbs, and fungi from the land.

Indeed, there are key deadly species out there to be aware of, especially in the case of mushrooms. But if you're armed with enough knowledge, hunting mushrooms becomes an enjoyable way to seek out delicious and unusual foods that are new to us, increasing our intake of varied micronutrients. It does take many seasons and years to become acquainted with the plants and mushrooms around us, especially if one is just getting reacquainted with nature after spending adulthood foraging the supermarkets.

Mushroom identification can be more of a challenge to learn than plant identification. The nature of mushrooms is fleeting and seemingly unpredictable for the novice hunter. With plants, we can revisit the same tree, week after week, month after month, and even year after year, to learn its name, its biology, and how it changes through the seasons. On the contrary, mushrooms seemingly appear out of nowhere, show themselves for a few days, and then disappear again into the unknown with no guarantee of surfacing again in the same place. This makes them easy to miss and challenging when learning the varying morphology of just one species.

Starting out slow, one or two species at a time, is a good way to ease into foraging. Take the time to learn important host plants, the ideal environment in which desired mushrooms will grow, and individual characteristics of a species. Venture out into the woods and get to know your mushroom wonderland. No matter where you choose to start, this chapter will guide you through foraging etiquette, identification techniques, and preparedness tips, so you can set out hunting with the best information at your fingertips.

Respecting the Land

Mushroom hunting does have an impact on our wild lands, but it doesn't have to be a negative one. With knowledge, practice, and mindfulness, foraging can be done safely and with respect for the land around us. The fungi invite us to interact with them in exchange for our aid in dispersing their spores. By picking a mushroom, putting it into our baskets and carrying it home, we help it to continually release its spores as we wander through the woods, increasing its likelihood of propagating in a new environment.

But know that our wilds are dwindling fast as urban expansion is eating up mushroom habitat faster and faster every year and hunting grounds are disappearing across the country. There is a network of patient mycelium under your feet, waiting for ideal conditions to send up mushrooms, so step wisely—each step compacts the soil more and more, making the environment less favorable.

Embracing the Season

Like most things in nature, mushrooms are seasonal, appearing usually in the spring or fall when weather is ideal—not too cold, not too hot, and with a little bit of rain to help them along. In North America, however, because we have so many different climates,

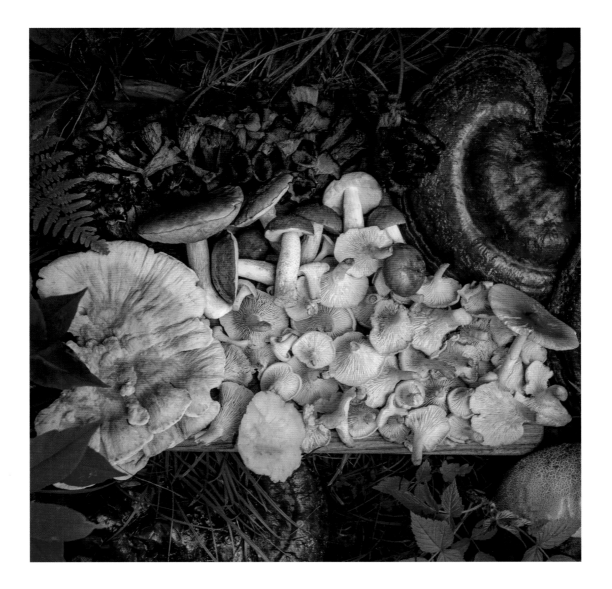

it is possible to hunt them all year long, following their seasons.

When I first started mushroom hunting, I was still juggling a busy desk job and going to school. Mushroom season would come and go sometimes before I could get out into the forest at the right time. But now I know to take advantage of mushroom season; everything else will be there when I get back. Before long, I was rescheduling appointments and frivolous activities in the city to make room for mushroom hunting. I even reimagined my entire lifestyle so I could adapt when necessary and catch the next flight out to a

happening spot. After all, the mushrooms don't wait for us.

Naming Names

In an attempt to understand mushrooms, we name them and put them into categories. We describe them and group similar mushrooms together. For centuries, taxonomists and mycologists have been challenged with sorting though these endless variations, digging deeper to figure out the best way to make sense of fungi's relationships to each other and their environments.

At the beginning, all mushrooms were in the same classification as plants and known as *Agaricus* or *Boletus*—the only differentiation being that fungi have either gills or pores. Over time, as the study of mycology evolved, different genera were created for different forms. Classification seemed to make sense when placing them into groupings based on visual characteristics and habits. But then DNA analysis was introduced and everything shifted considerably, alerting us to the fact that not everything is as it appears to be. Mushrooms with pores weren't always related to other mushrooms with pores. This revolution in taxonomy tore apart what was previously known and reclassified seemingly unrelated groups and families.

Fungal taxonomy continues to be an ongoing exploration into the interconnectedness of our invisible world. Categorizing the natural world is a human concept and our way of trying to understand the mysterious and the unknown wilderness. If it has a name and a place, we feel that we understand it. But how much can a name and a category tell us about a mushroom? Much like when we are introduced to our new friend Bill. We know his name and maybe where he lives. When others ask us if we know Bill, we can say assuredly yes, we know him. But do we really? Only by sharing time and space together can we get to know what Bill likes to eat, how he behaves, and even the friends he associates with.

This is also how we get to know the mushrooms and the plants and the environment they associate with. It is one thing to memorize a name, but only after we share time and space with something do we truly get the privilege to know it. Naming and categorizing in the natural world is a good place to start though, so in each mushroom profile in this book, you'll find colloquial titles, as well as latin species and genus names for each fungus. But it should be recognized that there is much more to a mushroom than its title.

Seeing and Observing Fungi

Memorizing Latin names and identification terms can be overwhelming with the seemingly infinite variation in mushroom species. But having a few characteristics to look for can help speed up the identification process. It's important to note that there is no one-size-fits-all rule with mushrooms. There is no "if it has this it means its poisonous." Each species is unique. From visual cues of color and endless variations in texture to alluring aromas and deterring odors, you'll even find a full spectrum of flavor that somehow drags us

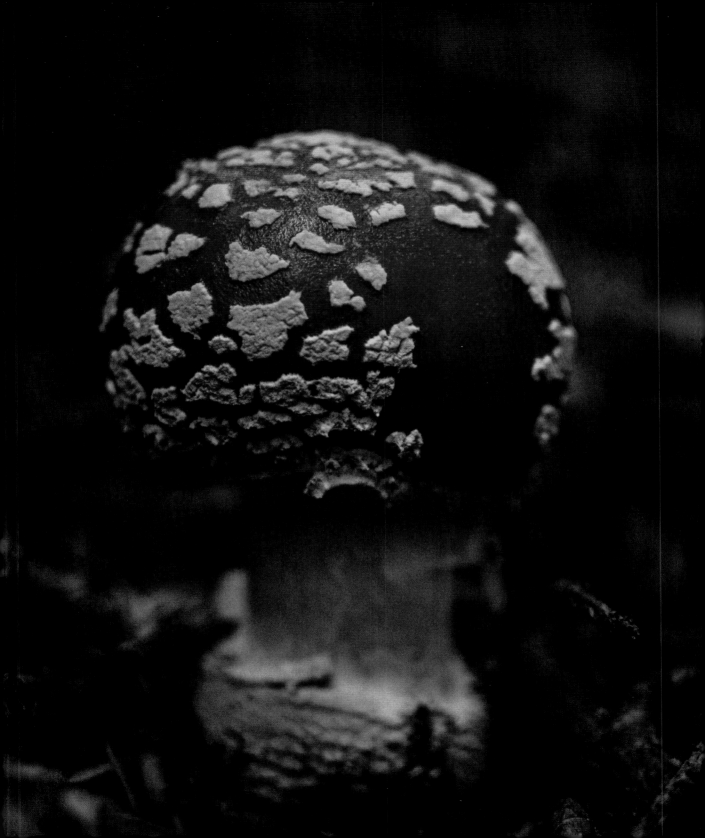

from the enchanting forest back to our kitchens and frying pans.

At the beginning, mushrooms just look like, well, mushrooms. Some are quite obscure and don't seem to fit in. But this is just an invitation to take your time and examine with all your senses. Mushrooms are not poisonous to touch—even the most deadly ones—and can be used for tactile identification and educational purposes. Touch the surfaces to examine textures and the way they respond to your touch. Do they bruise? Do they ooze a latex when cut? Smell the mushrooms for familiar aromas. And, if you're experienced, taste them.

If you gently remove the entire mushroom from the ground, being careful not to disturb too much of the mycelium and the surrounding environment, you'll even find identification clues at the base. Some have long tap-root like structures, some are round and bulbous, and others truncate and blunt. Try to unearth the mushroom without damaging it.

It can be tempting to flip through a field guide to match the orange mushroom you found to one in the book, but then there are several orange mushrooms and at first glance they all might seem the same. One of the best ways to learn mushroom (and plant) identification is to use a key. Not all guides have these, but some of the best ones do. Let's look at a few features and key words you'll need to know that are also used in the rest of this book.

FRUITING BODY: Another term for "mushroom," it is the reproductive structure of fungi that releases spores. This is the structure we see emerging from the host that is the most common part used for food and medicine.

MYCELIUM: The true organism of fungi that grow underground or within their host. It is a complex network of branching thread-like cells known as hyphae.

HYPHAE: The filamentous threads that make up a mycelial structure.

CAP: Top part of the fruiting body, which has the spore-releasing tissue.

STIPE: Also referred to as a stem. This is the sterile structure that lifts the spore-bearing surface from the host.

GILLS: Plate-like structures beneath the cap of a mushroom that produce and release the spores. These can vary in how they are attached, or not, to the stipe. They also can change colors as they release their spores (such as in *Agaricus*, which has pink gills but will turn brown due to brown spores).

PORES: Found on the underside of polypore mushrooms, tiny holes that release spores. Some are very tiny and require close observation to see them, as in *Trametes versicolor*.

TOOTH/TEETH: Some fungi, instead of having pores or gills, have small structures known

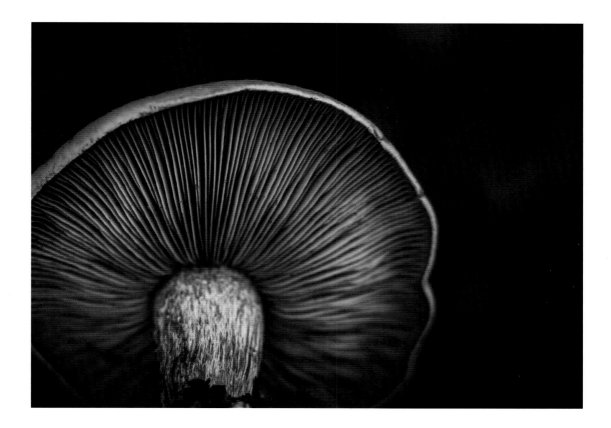

as teeth, from which they release their spores. A good example is the *Hericium* species.

SPORES: Typically single-celled reproductive structures released from the mushroom that can develop into new, separate organisms. Sometimes discharged by an internal force of pressure or an external force such as wind or raindrops.

CORTINA: A web-like partial veil that covers the spore-bearing surface, usually disappearing at maturity. Most commonly found in the namesake *Cortinarius* species.

RING/ANNULUS: A remnant of partial veil tissue that remains after it has broken. Sometimes it disappears with age or by being handled.

PARTIAL VEIL: The tissue that covers the gills or pores underneath the cap. This is what often leaves hanging tissue at the edge of the cap, and/or a ring around the stipe.

UNIVERSAL VEIL: The tissue that covers and protects the entire fruiting body as it emerges from the ground, eventually breaking and leaving behind veil remnants and volva. Common on *Amanita* species.

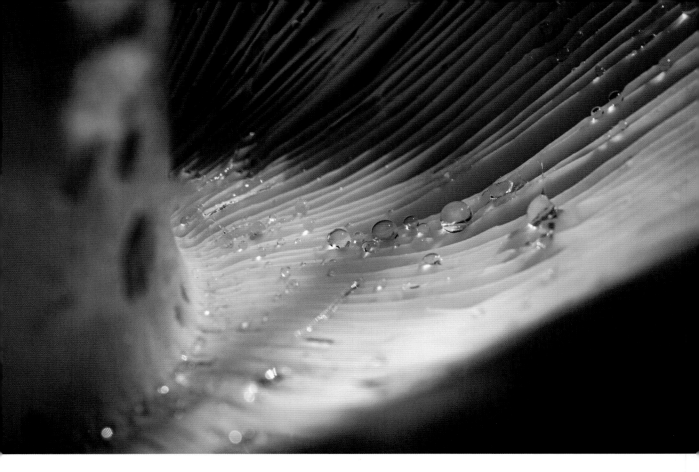

VOLVA: The lower remains of the universal veil, usually cup-like.

Fungi Habitats

Fungi are found on every continent in the world, with an array of adaptations and creative methods of reproduction. They can be categorized by morphological features, physical characteristics in shape, spore dispersal, spore color, and, ultimately, DNA analysis. But another great identification tool is the study of the main way mushrooms interact with their environment.

Knowing how and where a particular mushroom likes to grow will be a good start in wandering the woods. You'll have more focus and attention to certain clues on your hunt. Studying the fruiting habits of fungi is like studying any other type of relationship. They thrive in particular environments and not so much in others.

As we know, the mycelium (the true organism of fungi) exists nearly everywhere on earth. However, the mycelium requires certain variables in order to fruit: temperature, moisture, and nutrients. Becoming aware of a

mushroom's ideal microclimate will increase your chances of finding them. I have noticed over the years, though, that fungi have not taken the time to read any field guides on themselves and therefore do not necessarily follow the "rules." In rare cases, they may be found where or when you least expect them; they are opportunistic organisms that take advantage of ideal conditions.

Traditionally, fungi have three environmental classifications: mycorrhizal, saprophytic, and parasitic. Much like animals, they rely on their surroundings for nutrition. They are specialists in their environment and expert survivors regardless of what comes their way. While plants have the ability to create their own food through photosynthesis, they lack the ability to uptake necessary nutrients from their surroundings. But this is the mushroom's area of expertise, and plants rely on the presence of mycelium to assist in that nutritional category.

Some fungi have developed sophisticated nutrient transportation and support networks for the forest. They rely on the underground network of the tree roots to thrive, so by supporting the trees, they are supporting their future.

MYCORRHIZAL FUNGI envelop themselves in the root system of plants, which then become hosts. The plant and mushroom share a symbiotic relationship in which the fungi create an intricate soil web responsible for transforming nonorganic material into consumable nutrients for their host plant. They do this by expanding the root system's absorptive surface area, thus allowing the plant to take in water, nitrogen, phosphorus, and other nutrients more effectively than it would if it were to do so on its own. In exchange, the fungus receives necessary carbohydrates from the plant as a product of photosynthesis. This symbiosis allows the plant to grow faster and more efficiently over time, while also supplying the fungi with energy to continue its work. These symbiotic relationships are formed in environments where both the fungi and the plant are dependent on each other, such as oaks and chanterelles or truffles, or conifer and matsutake. The relationship also helps feed the entire ecosystem from the ground up, cycling nutrients throughout the soil. At least ninety percent of plants share a mycorrhizal relationship with fungi.

SAPROPHYTIC FUNGI are the decomposers and recyclers of the fungi world. They obtain their nutrients by breaking down dead or decaying organic matter and even nonorganic manmade materials. Some lie in wait, dormant on the surface of living organisms, activated only when the organism dies and the fungi can begin to take in nutrients from the corpse. Throughout the decaying process, different species of saprophytic fungi will take over in succession, consuming nutrients that the body had left behind until the decaying object has finally been returned to the earth in its entirety, feeding the very environment that had fed it during its life.

Saprophytic fungi (also known as sapro-trophs, saprobes, white- or brown-rots) are incredibly resourceful and can even make a meal out of persistent pollutants, petroleum products, and industrial waste. They are responsible for the breakdown of organic material in the forest, maximizing the available nutrients for themselves and every other organism in the environment. Then, once the certain nutrients they require are used up, they move on, spreading their spores to find a more suitable meal, allowing other specialized fungi to move in to break down the remaining organic nutrients. Common saprotrophs are oyster mushrooms, chicken of the woods, and hen of the woods, which all grow on dead or dying trees.

PARASITIC OR PATHOGENIC FUNGI infect living hosts, digesting and colonizing their victims. This is a stark contrast with our mycorrhizal friends, who have a symbiotic relationship with their hosts. A good example of nonsymbiotic fungi, cordyceps are parasitic fungi (see page 151) that infect insect hosts and begin to consume them from the inside out, affecting the nervous system and eventually killing the insects and sprouting fruiting bodies from their remains. While the *Cordyceps* is a type of parasitic fungus, it is not one that affects humans. However, parasitic fungi are responsible for infections of *Candida albicans* (a normal common yeast in humans that causes disease when overabundant), athlete's foot, ringworm, and others. Parasitic fungi also cause disease in plants in the form of rusts, mildew, and molds.

Where to Hunt and Forage

Walking out into the woods to look for dinner used to be a normal way of life. But with the increasing population and the loss of wild habitats, it is becoming more of a challenge to find legal and acceptable places to hunt for wild food. It is illegal to pick mushrooms in many public areas, such as state and county parks, although in some areas, you can apply for a permit. Check with local authorities to find out the rules or, maybe more importantly, the consequences.

It is also important to keep in mind that mushrooms bioaccumulate toxins in their environments. This is a good thing for restoring and cleaning up toxic areas by way of mycoremediation, but not a good thing for the dinner table. It would be a good idea to check where the water is coming from in that drainage ditch before collecting the oyster mushrooms that grow there. Fungi take up heavy metals that are not safe for consumption in high amounts, and just because they are growing in an area that does not indicate a healthy substrate.

If you have access to private property, whether it is your own or a friend's, get to know the seasons there and what mushrooms pop up. More often than not, we may have walked by them many times and never paid attention. I was pleasantly surprised when I moved into a new house to find that the edible wood blewit mushrooms (*Clitocybe nuda*) grew in abundance under the pomegranate trees. There are a lot of edible urban

mushrooms that can be found when taking the time to slow down and observe.

Foraging in the market for your mushrooms is always a safe and reliable option as well, especially when you are just learning about mushrooms and how to cook with them. They are also available throughout the year at grocery stores, so you don't have to wait until mushroom season to try out a new recipe. Many stores are beginning to supply a wider selection of cultivated fungi and even locally sourced wild mushrooms such as morels, chanterelles, and lobsters when in season. Prices can vary widely, but shopping for mushrooms can be a great learning experience until you find your own foraging spots.

The Forager's Toolbox

There's little worse than finding yourself in a wonderland of mushrooms, only to have no way of bringing them back with you. Of course, there have been times where I had to be creative in my methods of carrying them home. I wear a bandana or hat often, which is not just a fashion statement but more so a practical means of having a backup foraging basket always at the ready. In my van I always have a basket, a knife, and containers to properly bring home the bounty from my adventures.

Paper or cloth bags kept in a hiking backpack work well too. Even during walks through my neighborhood, I bring a cloth bag with me, just in case I happen to come across an overly abundant fruit tree hanging over the sidewalk or some mushrooms popping up at the park. While the only necessary tools for gathering mushrooms are your hands, these extra items make the process easier and more efficient.

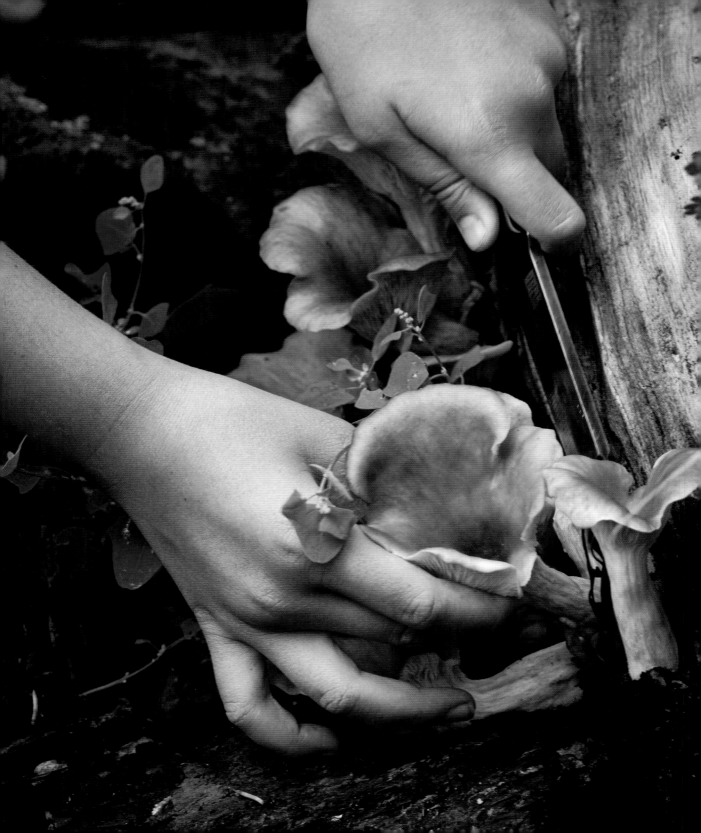

Keep the Dirt in the Forest, Not on Your Plate

When harvesting, it is helpful to clean your mushrooms in the field as you collect them. By keeping your mushroom basket free of dirt and debris, processing them in the kitchen becomes an easier task.

In addition, despite how tempting it may be to check out the mesmerizing gill pattern underneath, keep the gills facing down until you've cleaned and trimmed up any debris on the stipe. When dirt (or worse—sand) falls into the tight spaces between gills, it makes it much more difficult to clean, and you may end up with unpleasant grit in your mushroom risotto.

FIELD GUIDES: The most important tool for the beginning hunter is a good field guide. This guide will have clear photos of the mushroom and all of its key identifying features and is focused on the local region in which you intend to hunt. It is impossible to have every species documented, especially since the science is changing every year, but some guides try to get fairly close. Photographing your finds is a good practice when you are starting out, to learn the different features as you go along. Also, posting your finds to online forums can be helpful, although not fail-safe. See Resources (page 195) for a list of recommended field guides.

KNIVES: To get you started, any knife will do, from a folding pocketknife to a fixed blade, a specialized mushroom knife to a pair of child's scissors (great for quickly harvesting an abundance of morels or other small stemmed mushrooms such as *Psilocybe cyanescens*). The goal is to cut the fruiting body cleanly from the base without disturbing the soil or getting dirt in your basket.

As you become more experienced, consider purchasing a specialized mushroom knife. This handy tool is designed specifically for harvesting mushrooms. On one end is a small brush and on the other is a hooked blade. The blade helps to make a clean cut close to the ground and trim off remaining dirt or tough flesh easily from the stipe. Any ordinary knife will do, of course, but the handy brush at the end is helpful for cleaning off debris efficiently without damaging the mushroom.

BASKETS: Once you've cleaned up your mushrooms as best you can, you'll need an

To Cut or to Pull?

This is a heated debate among new and seasoned hunters alike. Studies done over many seasons have debunked the idea that plucking the fruiting body from the ground is disturbing to the underground network of mycelium. There was no notable difference between either method, neither cutting nor pulling, in these studies. However, one benefit of pulling, especially when you are starting out in mushroom hunting, is that it allows you the chance to examine the base of the stipe, an important identifying feature, especially for the deadly *Amanita* species. This feature is often hidden under the soil. Otherwise, the best method is to make the least impact on the environment when harvesting—leave no trace, don't disturb large areas of leaf litter, cover any holes left, and please, don't leave any trash behind.

effective way to bring them home. Wicker baskets have always been the ideal choice; as they are roomy enough to keep everything from getting squished while allowing air to circulate. In a pinch, paper grocery bags will work too. Avoid using plastic bags as much as possible. These easily crush the mushrooms and increase moisture, which will speed up decay, leaving you with a soggy, squishy mess at the end of the day. For bringing home multiple specimens for study, I have seen folks use tackle boxes to separate each unique species of mushroom they find.

ATTIRE: Wearing long pants and boots is helpful to protect the shins while walking through the forest. Insects are also of concern, especially ticks, which can carry lyme disease, a bacterial infection that can cause chronic health issues. Be mindful of walking through tall grasses and brushing up against foliage, as ticks can quickly and easily hop a ride on your clothes or exposed skin, even dropping from above; they can sense your approaching body heat. Check your clothing and skin after a wander through the woods. If you get bitten by a tick and notice signs of infection, it is important to get treated immediately by a medical professional.

NAVIGATION: Most importantly, have some sort of GPS device, and download or carry maps. A nondigital compass is also helpful if your battery dies. Set your GPS to where you parked your car and be sure to bring a

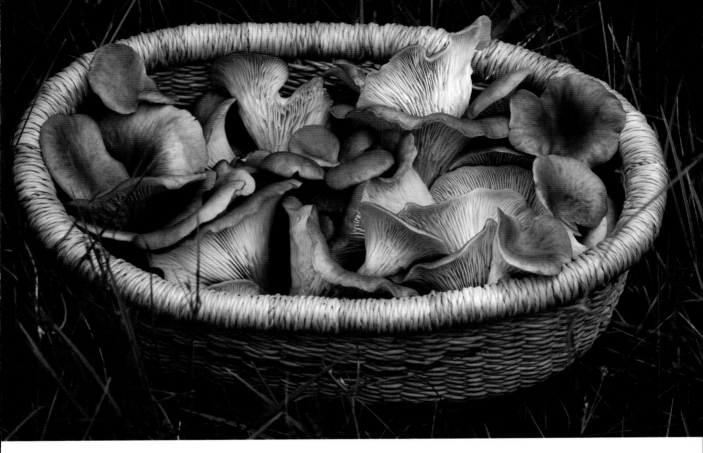

backpack with water, food, and an emergency blanket. I used to think that I was great at wayfinding and prided myself in always knowing my way on the trail. That all changed quickly after I started mushroom hunting. It is extremely easy to get lost when looking at the ground, eyes darting from log to log, following a new direction on a whim, or sprinting across the forest to check a yellow speck on the ground, and then another and another. Before long, the way back doesn't look the same.

I've heard many stories of mushroom hunters getting lost over the years. It happened to me. I had intended only a quick thirty-minute check of a spot at sunset, not bringing my backpack or anything besides my knife, a paper bag, and my cell phone. The chanterelles were out and they lured me deeper than I intended into the forest. In the twilight, with temperatures dropping quickly, I was certain I knew the way back. But I saw a big patch of beautiful golden chanterelles and I couldn't pass up the opportunity.

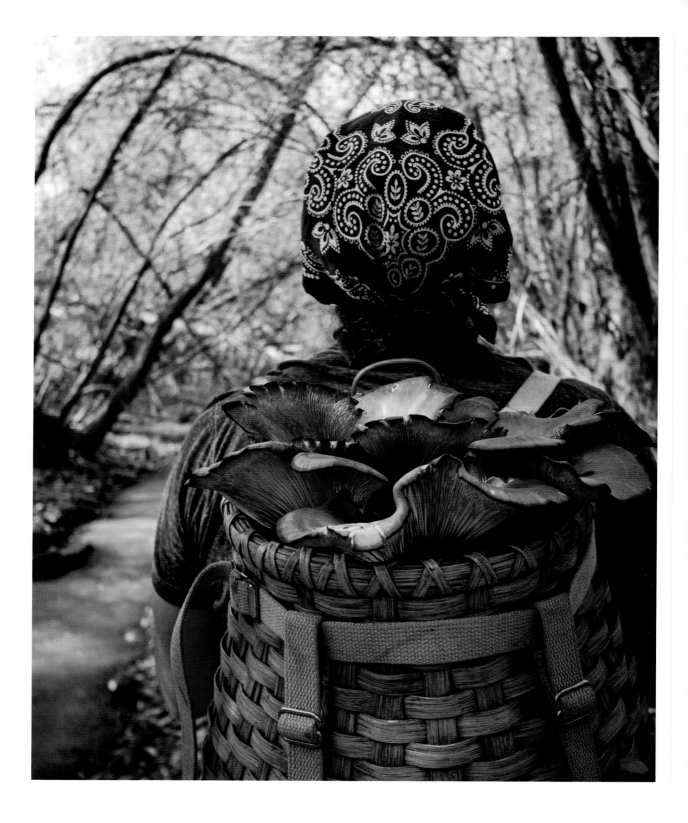

After collecting them, I charged off in the direction of what I thought was the trail. But it ended up being a creek that I had not seen before. With darkness settling in, I used the flashlight on my phone to navigate through the thick, wet, and muddy brush, but the battery was dwindling quickly. The maps would not load and did not show enough detail to help me figure out where I had wandered off to. Luckily, I still had 10 percent of the battery life on my phone and one bar of signal, so I decided to set aside my ego and call for help. I spent several hours sitting in complete darkness, my clothes soaked, waiting for the sound of the rescuers trying to locate me off of my GPS signal.

It was a pair of deputies from the local police department who finally came, with a blanket, flashlights, and water. The amusing twist to this story, though, was that after we united and attempted to follow their GPS back to the trail, we again became lost and a third deputy was called out to the woods to rescue the rescuers. As entertaining as the story is to tell now, getting lost is serious and doesn't always result in a happy ending. Enrolling in a few survival skill workshops would be a wise investment, just in case you find yourself in a situation you didn't plan for in the forest.

The forest is an exciting and welcoming world of wonder for us to explore. With this knowledge, basic skills, and simple preparations, a mushroom-hunting adventure can be a safe and rewarding experience for curious folk and mushroom hunters alike.

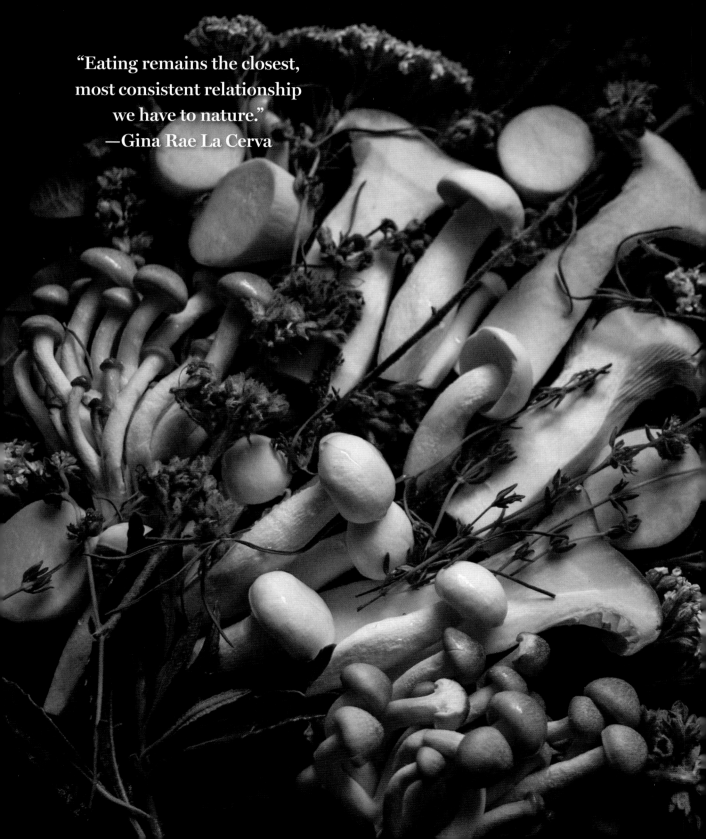

"Eating remains the closest,
most consistent relationship
we have to nature."
—Gina Rae La Cerva

The Forest on Your Plate

COOKING AND PRESERVING MUSHROOMS

There should have been another chapter, or at least a footnote, in Dale Carnegie's *How to Win Friends and Influence People*. It could even be elegantly entitled, "The Art of Gifting Wild Mushrooms." Want to impress your next date? A generous offering of freshly picked morels should do the trick. Need to get on the good side of your neighbors? Some chanterelles every now and then make a good investment. That friend who says you never give them anything? When you can't stand to eat anymore, it's a great time to offer up the rest of the giant puffballs. Short on cash to pay your rent? Time to deliver some porcini. Maybe. Still working on that last one.

In any case, fresh wild mushrooms make a great and memorable gift to friends, family, and unsuspecting neighbors. Otherwise, if you prefer to hoard your bounty (and I don't blame you), there are some ways to preserve them later on in the chapter. First, let's figure out what to do when you return from a successful mushroom adventure.

Cleaning a Mushroom

Whether you find your mushrooms in the forest or at the market, there are ways to properly prepare them to maximize their flavor. If your mushrooms were forest grown, chances are they will need to be cleaned soon after harvest for the best longevity. Even the most prime specimens can carry microbes or little critters that also want to make a meal of your prized forest finds. You'll want to evict them soon before they get too cozy and invite all their friends. Even just one larvae-ridden shroom in a basket can quickly infect the rest of the bounty, leaving you with a gooey, stinky mess instead of a five-star dinner. This was a difficult but important lesson to have learned first-hand.

The first year I found a decent haul of prized king boletes in the Rocky Mountains, I was thrilled to bring them back home to California to share with my family and friends. I had spent a nice long weekend filling my basket with the most perfect little buttons at every venture into the forest, spotting many from the road and stumbling upon prolific patches of them. I carefully packed up my treasure into my overpriced cooler with plenty of ice for the 14-hour drive back through the mountains and deserts.

But by the time I got home, I found that one mushroom had completely been decimated by maggots (likely the one that started it all) and the rest had been quickly infected, reducing my haul down to only two partially salvageable specimens. It was nothing short of heartbreaking. For all the hours and effort spent traveling, hunting, and collecting, it had me questioning whether it was even worth the trouble and money for such a trip. (Of course, the answer is always yes—for there are always lessons to be learned on every adventure into the woods, such as this one).

Coming back from a successful trip with baskets full of mushrooms is a wonderful feeling. However, it also means a whole lot of processing must be done quickly and efficiently. If you're not going to cook your bounty right away, the best practice would be to wipe them clean of any extra dirt, trimming away areas that have begun to decay. The brush on a mushroom knife also works well here for the stuck-on bits. It's a good idea to check the stems of seemingly pure boletes for bug tunnels, an indication that they will continue to take over your mushroom even while it's stored in the fridge.

There is some debate on how to properly clean a mushroom before cooking. Some people avoid water altogether, claiming that it makes the mushrooms soggy or waterlogged, while others generously soak fungi in a water bath, even adding salt to evacuate any insects. Cooking can evaporate any of the water left

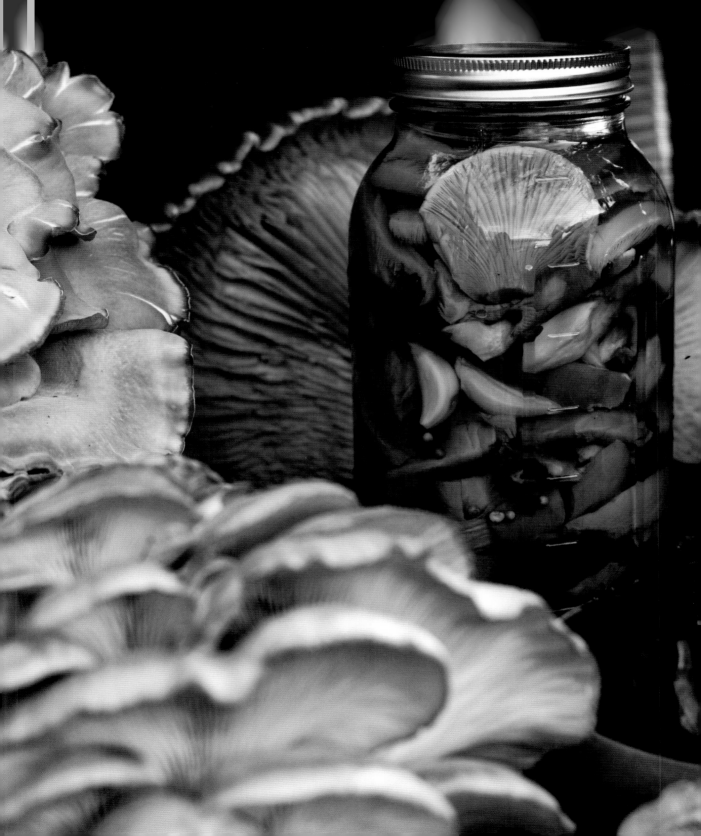

over from a good washing, but it seems a little excessive to soak them. Either way, I don't like grit in my porcini pasta. Cultivated store-bought mushrooms are usually very clean and can be easily wiped down with a damp cloth, if needed, and rarely need to be washed with water.

Storing Mushrooms

As mentioned in Chapter 3, when collecting mushrooms, plastic bags and containers are the death of fungi. Mushrooms are made mostly of water and need air circulation to keep them fresh. Plastic creates an overly humid environment that increases the rate of decay. Mushrooms should be stored in a closed paper bag in the main compartment of the refrigerator to keep fresh. The paper bag will allow for air circulation, which slows the decay and growth of mold and bacteria. If the mushrooms won't be used right away, be sure to clean, remove any critters, and trim away soft, slimy, or questionable spots. As I found firsthand, one rotting mushroom can spoil an entire harvest. Some species will stay fresh longer than others, such as chanterelles, which can last for weeks. But others, like inky caps (see page 189) may last only a day before deliquescing into a puddle of inky goo (which is still culinarily viable for adventurous chefs).

What About the Bugs?

We're not the only ones who find fungi to be an exquisite culinary experience. It is quite common to find insect larvae chomping away at our favorite fungi. It can be very disappointing to slice open your porcini or inspect your morels just to find you were the last one invited to the party and all that remains are leftovers no one else wanted.

However, a few extra morsels of insect protein certainly won't hurt you. In fact, insects were a considerable part of the human diet not too far in our distant past. Entomophagy (eating bugs) is still part of many cultures around the world and an important source of protein and nutrients. The Food and Drug Administration allows commercial foods to contain a percentage of insects and insect parts—just under the amount that we would notice.

So if you're worried about those tiny little larvae burrowing through your boletes, either evacuate them gently or toss the whole lot into the frying pan or dehydrator. If your mushrooms are looking more like a high-rise hotel with a flashing "no-vacancy" sign out front, it may be better to toss it in the compost pile. But, I know folks who still don't mind. To each their own.

More Than One Way to Cook a Mushroom

Generally speaking, all mushrooms should be cooked or treated with heat before consumption. This includes the bland white variety you find in every salad bar across the country, but this baffling practice has now become generally accepted, resulting in spongy, bland missed opportunities of flavor.

Mushroom cell walls are primarily composed of an indigestible polysaccharide fiber known as chitin. This is the same substance

that gives structure to the exoskeleton of arthropods (crustaceans and insects) and is only broken down by the application of heat. Within these cell walls lie all the beneficial compounds that have attracted the interest of scientific researchers. If these walls aren't broken down, all that good stuff remains encapsulated in the cells and passes directly through the digestive system without being metabolized. There are a few exceptions, but for novice mycophagists, it's always best to cook wild mushrooms thoroughly.

Cooking also kills any bacteria or pathogens from the forest that may be attempting to hitch a ride on your shrooms to your table. Some species need special preparations to render mushrooms edible, some need extended cooking times to break down any potential toxins, and a few can be prepared raw and ceviche style, such as porcini and some edible Amanitas. Experimental mushroom cuisine is an adventurous and avant-garde pursuit as chefs are rediscovering and inventing new and exciting ways to use fungi in the kitchen. For specific preparations for different species, refer to the culinary notes in the mushroom profiles in Part 2. However, here we're going to stick with the basics for a few foolproof techniques for most mushrooms, including those foraged from the supermarket.

DRY SAUTÉ

For the most part, mushrooms are made mostly of water and the best way to concentrate their flavor is to reduce as much moisture as possible while retaining texture. One way to do this is to dry sauté.

After you have cleaned up your finest specimens, add them directly to a preheated skillet (I prefer a well-seasoned cast iron) without any butter or oil. Mushrooms are generally up to 95% water by volume. By adding them without any oil, the mushrooms are able to release much of this water, thus intensifying their flavors. Only after they have wilted and reduced their size do you add your preferred fat—whether it is grass-fed butter, oils, or other cooking fats—to finish cooking and browning them. The amount of fat doesn't need to be excessive; keep in mind you still want to taste the nuances of your fungi. Turn them occasionally to prevent them from burning.

Where to go next with your sautéed mushrooms? Many of them pair well with heavy creams, sauces, and cheeses. Vegan folk don't need to feel left out, though; many of the plant-based dairy replacements these days make excellent stand-ins, and mushrooms are already texturally and nutritionally important in a plant-based diet.

WET SAUTÉ

Some thicker and denser mushrooms, such as chicken of the woods, brown quickly before they are cooked thoroughly. In this case, it can be helpful to add some water to the skillet with the mushrooms (no oil or butter yet), and allow them to simmer until the water has evaporated to help extract and intensify the flavor and ensure they have been cooked

evenly. This process can be done multiple times, as you add more water to the pan and allow it to evaporate again. Once all of the water has evaporated, add your oil or butter, and continue to let them brown, developing a crispy sear.

WHOLE-ROASTING MUSHROOMS

As a long-time follower of a mostly plant-based diet, I often noticed that the big, showy centerpiece of a traditional meal was missing in plant-based cuisine. Whether it was a roasted turkey or a holiday ham, I wondered how mushrooms could take that center stage as well. Working with supermarket cremini mushrooms, or even a portobello, yielded dishes less than worthy of a centerpiece.

It wasn't until a friend and I harvested a single 15-pound cluster of oyster mushrooms one winter that I found success with whole-roasting mushrooms. As the cluster sat, perfectly perched up in its host tree a good ten feet off the ground, I recalled that it looked much like a turkey, with its shelf-like caps flared out like feathers. Normally these would be cut into smaller pieces and fried. But the turkey reference kept nagging at me until I realized that the entire cluster could be stuffed between the caps and oven-roasted just like a holiday turkey.

After cleaning the harvested mushroom cluster well, I put together a mixture of roasted walnuts, wild rice, and traditional spices and then stuffed this mixture between each of the tightly layered caps. Then the entire mushroom cluster was covered tightly in aluminum foil and placed in the oven at 375° for about an hour. The foil helps to keep the temperature consistent while roasting, so the mushroom can cook all the way through to the center (an important step for wild mushrooms). Then, towards the end, I removed the foil. Any excess liquid released was then used to baste the layers of stuffing.

This mushroom "turkey" had earned its place as a spectacular centerpiece for a holiday meal with friends. Not all specimens would work as well for this application, but they can still be roasted whole in a similar manner. While oyster mushrooms have worked well in this case, I imagine other similarly shaped mushroom clusters could be used, such as hen of the woods. Other large and robust mushrooms can also be seasoned and oven-roasted whole, from the enormous chanterelles along the California coast to slices of lion's mane or puffball.

Preservation by Dehydration

If you're lucky enough to stumble upon an abundance of fungi in the forest, you'll want to preserve your bounty. That is, unless you're planning on eating mushrooms for breakfast, lunch, and dinner (which might not be a bad thing). Freshly harvested mushrooms typically have a short shelf life and must either be consumed in the next few days or preserved properly for later use. Luckily, most mushrooms preserve well if processed properly and can be enjoyed throughout the year.

One of the easiest and most convenient ways to preserve a bountiful mushroom harvest is to dehydrate them to be rehydrated later or ground into powder. The dehydration process extracts the water from the mushrooms, concentrating their flavors while allowing them to then be stored in an airtight container without chance of spoiling for many years. Some will dry very quickly, such as turkey tails or black trumpets, with minimal chance of spoilage when simply left out on the countertop or in a sunny spot to air dry for a few days. Others with higher moisture content, such as fresh lion's mane or oysters, will take a few hours to completely dry in an electric dehydrator.

Once properly dried, they can be reconstituted in place of fresh mushrooms for many recipes. Powdering dehydrated mushrooms can also be useful for adding flavor to dishes, as is the case with porcini, which offers an earthy umami taste.

EQUIPMENT: It is convenient to have a multiple tray food dehydrator with forced air, but it is not necessary. Alternatively, a simple screen from the hardware store set in a warm, dry area away from pests can be used instead. I've even seen folks slice up their porcini and set them on the dashboard of their car for an on-the-go makeshift dehydrator. It works well.

PROCESS

1. Clean and sort your harvest before dehydrating; anything that is still attached to the mushrooms will be dried into its flesh and difficult to remove afterwards. Discard any infested or past-their-prime specimens. Thicker, meatier mushrooms should be sliced into smaller pieces so that they will dry quickly and evenly.

2. Arrange the mushrooms on the screen without overlapping or touching to ensure that there is enough air circulation between them. Crowding the mushrooms can result in uneven drying.

3. Drying times depend on the initial moisture content of the mushrooms. Some, especially ones that are thinly sliced (porcini) or naturally contain less moisture (black trumpets), will take an hour. Others that you're drying whole, or are naturally thicker, may take several hours (large whole morels, hen of the woods, large oysters). Check your dehydrator's

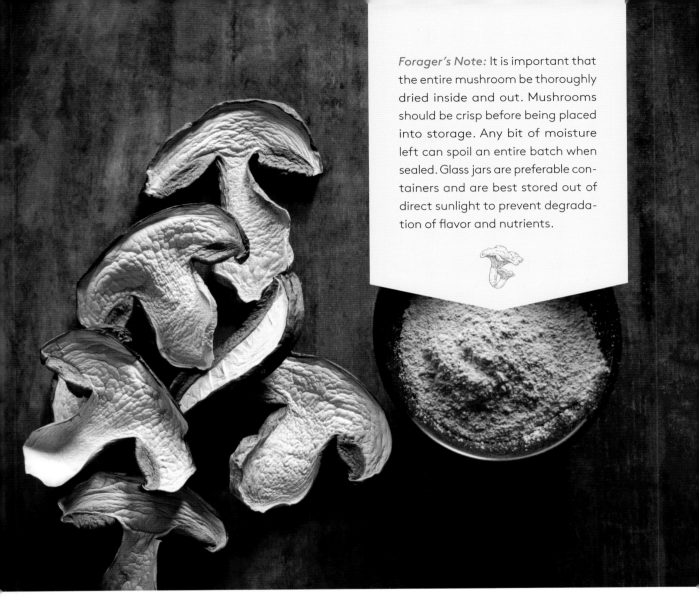

Forager's Note: It is important that the entire mushroom be thoroughly dried inside and out. Mushrooms should be crisp before being placed into storage. Any bit of moisture left can spoil an entire batch when sealed. Glass jars are preferable containers and are best stored out of direct sunlight to prevent degradation of flavor and nutrients.

instruction manual for recommendations on time and temperature. A good starting point is 120° F for 3 hours.

4. The preserved flavor and aroma of the mushrooms will change a bit, depending on the temperature. Lower temperatures will preserve the original aroma, whereas higher temperatures will tend to cook the mushrooms a bit and slightly alter the flavor.

Mushroom Jerky

If you have a dehydrator, this is a great way to extend the life of many mushrooms. It can also turn them into savory and chewy jerky-like snacks to bring with you on your next wander in the forest. The type of mushrooms can be interchangeable with most edible mushrooms, such as oysters, hen of the woods, and shiitake, serving as tasty treats.

INGREDIENTS

2 pounds mushrooms

¼ cup Bragg's Liquid Aminos (or your other favorite soy sauce)

1 tablespoon coconut sugar or maple syrup

1 teaspoon smoked paprika

½ teaspoon garlic powder

¼ teaspoon chipotle powder

Juice of ½ lemon

PROCESS

1. Steam the mushrooms for about 10 to 15 minutes (some wild species, such as chicken of the woods, may need to be cooked longer to avoid any digestive issues). Try to squeeze out as much excess moisture as possible. This helps the mushroom absorb the added seasonings.

2. Mix the remaining ingredients in a large bowl. Combine the steamed mushrooms with the marinade and mix well, ensuring that all mushrooms are coated with the flavors. Allow the mushrooms to marinate for up to a few hours or overnight in the refrigerator.

3. Spread the mushrooms evenly onto dehydrator trays and dehydrate at 120° F for 4 to 6 hours or until chewy. Dehydrate longer for a crispier snack.

Preservation by Pickling

Pickled mushrooms are a tasty way to preserve your bounty and also make great gifts for family and friends. The flavors can be adjusted and customized based on personal preference. Pickled mushrooms are also a traditional part of many international cuisines.

You can pickle just about any culinary mushroom; however, it is best to stick with ones that are firm and will hold up after being steamed and then brined. Firmer mushrooms make a better pickle. You can start with white button or cremini mushrooms from the market, but shiitake, wild oyster mushrooms, young porcini, chanterelles, saffron milkcaps, and the edible *Amanita* species (such as *Amanita vernicoccora* and *Amanita calyptroderma*) make great options.

This recipe is for a method known as "quick-pickling," which does not result in a shelf-stable jar, but they can be stored in the refrigerator for up to three months—if you don't end up eating them sooner!

For pickling, it is best to use mason jars. This is because they have been specially designed to withstand quick temperature changes when you add the boiling brine to the jar.

INGREDIENTS

1 pound mushrooms

½ cup water

2 cups apple cider vinegar

2 to 3 garlic cloves

½ bunch dill

1 bay leaf

1 tablespoon sugar

1 tablespoon salt

1 tablespoon whole peppercorns

1 árbol chile or other hot pepper of your choice

½ cup white wine

PROCESS

1. Sanitize your mason jar by filling a large pot with water and bring to a boil. Submerge the jars and lids under the boiling water for 10 minutes, then remove carefully with tongs.

2. Starting with clean mushrooms, steam them for 10 to 15 minutes. While steaming, bring the water and vinegar to a boil in a pot, then add the garlic, herbs, sugar, and spices.

3. Once the mushrooms have finished cooking, pack them loosely into the jars, then cover with the brine and top off with white wine. Seal tightly, place in the refrigerator once cooled, and enjoy after three days.

Preservation by Fermentation

Recipe adapted from my friend, Pascal Baudar

With its long history of use, fermentation is another method of preservation that can yield delicious results. Many different species can be fermented, but it's best to select a type of mushroom that remains firm and holds its shape after steaming. Some good options are chanterelles, chicken of the woods, hen of the woods, lobster, morel, shiitake, oysters, and many others. Fermentation invites other organisms into the digestion process, becoming a collaborative process while also contributing to the microflora of the gut. The addition of honey here helps feed the lactobacteria with sugar.

INGREDIENTS

- 1 pound mushrooms (see left for suggestions)
- 2 to 3 garlic cloves
- 2 teaspoons salt
- 1 teaspoon thyme
- ½ teaspoon smoked paprika
- ½ teaspoon chili flakes
- 2 teaspoons local raw honey
- ½ cup water
- 3 tablespoons culture starter (liquid from a previous sauerkraut or other fermentation project)

PROCESS

1. Steam the mushrooms and allow them to release as much liquid as possible as they cool to room temperature. Add mushrooms and all remaining ingredients together, mixing thoroughly in a jar and closing the lid tightly. Shake again to evenly distribute the ingredients.

2. Place the jar on a countertop and shake a few times a day, keeping the brine distributed over the mushrooms. The mushrooms will begin to ferment actively over the course of 24 to 36 hours. It is important to loosen or completely open the lid daily to release the gasses of fermentation that build up in a sealed environment. Continue this process for 7 to 10 days and then store in the refrigerator for another week to age. Fermented mushrooms can be enjoyed on their own or added to other dishes.

Medicinal Mushroom Cocoa Latte

Mushrooms and chocolate seem to be a strange pair, but they go together very well, with their rich earthiness. This mushroom-infused hot chocolate drink is a delicious way to start the day and add nutritional benefits to your morning routine. Other medicinal mushrooms can be added or combined here as well. Reishi or cordyceps are good options, depending on your needs. Reishi is bitter, so a little more sweetener would be complementary.

INGREDIENTS

1 cup milk of choice (dairy, almond, hemp, oat, etc.)

1 tablespoon cacao powder

1 teaspoon powdered turkey tail mushroom

1 teaspoon powdered lion's mane mushroom

Sweetener of choice (I prefer a few drops of stevia extract or a swirl of local honey)

PROCESS

Heat the milk gently. Combine with the cacao powder and sweetener in a high-speed blender and blend until smooth and creamy. Add a dash of cinnamon or cayenne to spice it up!

Mushroom Broth

A rich and flavorful mushroom broth on hand can be a game changer in the kitchen. Use it in place of water for cooking grains or instead of vegetable broth in soups. I like to save leftover water from steaming mushrooms to use here instead of water from the tap.

You can plan this recipe ahead of time by saving all your mushroom scraps and trimmings, especially pieces like stems that are too tough to eat but still have some value left in them. While you're at it, save your vegetable scraps as well, whether that be carrots, celery, onion, or garlic skins, and add them to your broth for fuller flavor. Collect a variety of these over time in the freezer, and once you have a few cups worth, start cooking.

INGREDIENTS

2 cups mushroom stems and trimmings

2 cups vegetable trimmings and scraps

3 to 4 garlic cloves

1 bay leaf

8 cups fresh water or leftover mushroom cooking water

Salt and pepper to taste

PROCESS

1. Combine the mushroom trimmings, vegetable trimmings, garlic, bay leaf, and water together in a large pot and bring to a boil. Reduce the heat and cover for 40 minutes. Then, simmer for another 20 to 30 minutes uncovered. Add salt and pepper to taste.

2. Let the broth cool and strain, pressing the mushrooms and vegetables to extract all of their flavors and juices. Reserve the broth and discard the vegetables and mushrooms. Use right away in your next recipe, or preserve by freezing in measured portions.

Cream of Wild Mushroom Soup

This is a basic recipe that can be adapted to whatever mushroom you are working with. Try it with chanterelles, porcini, or lobster.

INGREDIENTS

1 tablespoon avocado oil

1 yellow onion, chopped

4 garlic cloves, minced

1 tablespoon fresh thyme

2 pounds mushrooms (try chanterelles or porcini)

2 tablespoons Bragg's Liquid Aminos (or your other favorite soy sauce)

1 cup cashew milk or heavy cream

1 cup mushroom broth or water

¼ teaspoon chili pepper (optional)

Salt and pepper, to taste

PROCESS

1. Combine the avocado oil, onion, garlic, and thyme in a large pot and sauté until translucent, about 5 minutes. Add the mushrooms and soy sauce, cover with a lid, and allow to cook for 10 minutes, stirring occasionally, allowing the mushrooms to release their water.

2. Remove the lid and cook for another 5 minutes, letting the excess water evaporate, and sauté the mushrooms until they have a nice sear. Add a splash of mushroom broth, about a ¼ cup, to deglaze and lift all the browned bits of flavor at the bottom of the pot.

3. To a high-speed blender, add the mushrooms and remaining ingredients and puree until smooth. An immersion blender can also work directly in the soup pot. Return to the pot, reduce heat to simmer for another ten minutes to warm thoroughly, and combine the flavors. A few sautéed mushrooms, fresh herbs, and chili oil make a nice garnish.

Candy Cap Syrup

This is a great pantry item to have on hand to dress up drinks and desserts, or even to add to savory dishes. Try it in your coffee, add it to mixed drinks, or drizzle it over ice cream to impress your adventurous fungi-curious guests.

A simple syrup is easy to make, especially when using white sugar. However, with the negative health effects that processed and refined sugar can have on the body, there are easy and healthy substitutions that don't cause systemic inflammation or disease. Honey is an excellent substitute because of its many healing properties—just be sure to warm at a low heat so as not to degrade the natural enzymes.

INGREDIENTS

1 cup agave, honey, or coconut nectar

1 cup filtered water

¼ cup dried candy cap mushrooms

PROCESS

1. Combine the agave (or other sweetener) and equal parts water in a saucepan. Add the dried candy cap mushrooms, stir well, and warm gently on the stove for 10 minutes or until sweetener and water are well combined. Allow the aroma of the mushrooms to infuse into the syrup as it cools.

2. After infusing, the mushrooms may be discarded, or, to intensify the flavor and add more earthy and mushroom notes, blend them with the syrup in a high-speed blender.

3. The syrup will keep in the refrigerator for at least two months.

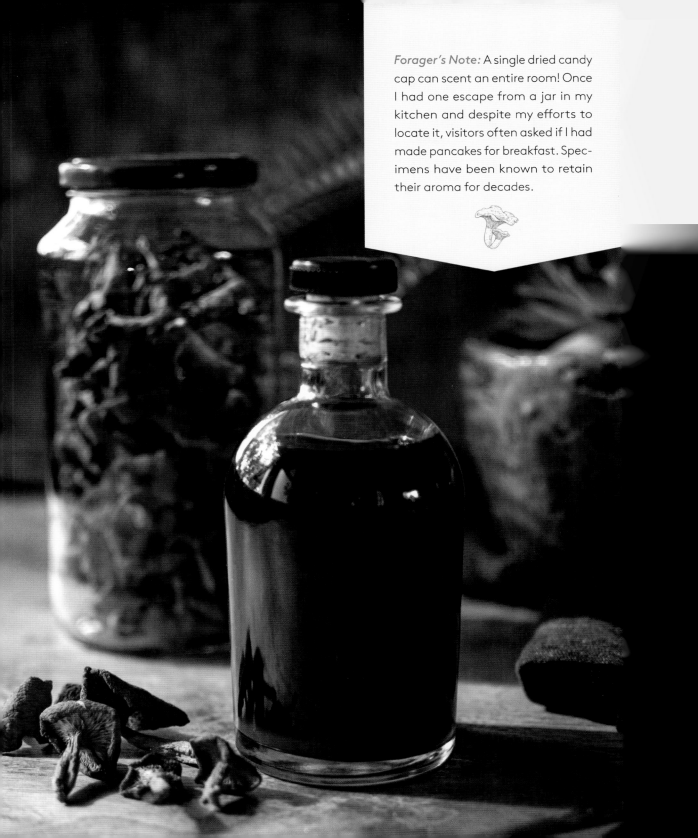

Forager's Note: A single dried candy cap can scent an entire room! Once I had one escape from a jar in my kitchen and despite my efforts to locate it, visitors often asked if I had made pancakes for breakfast. Specimens have been known to retain their aroma for decades.

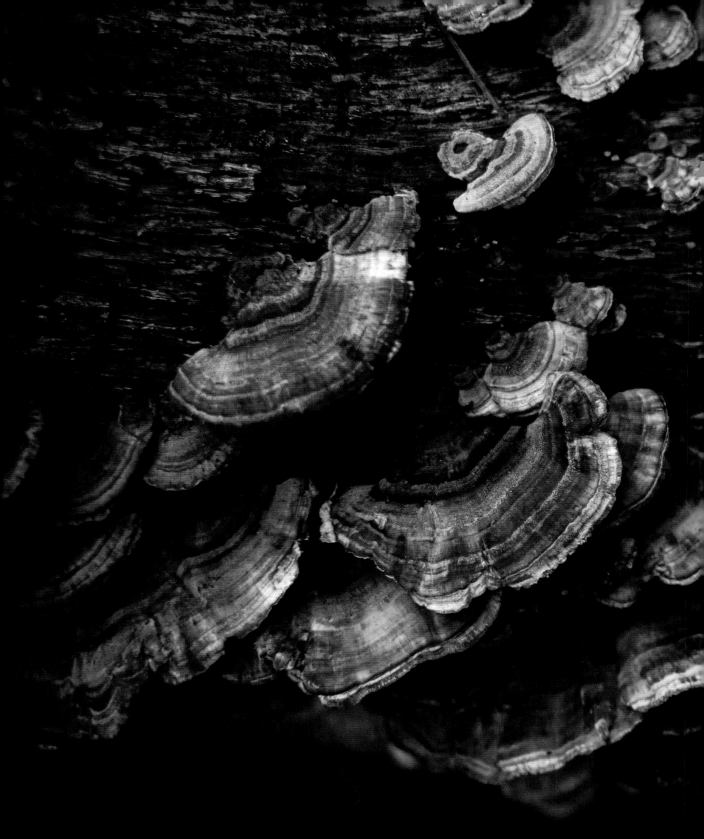

Meet the Mushrooms

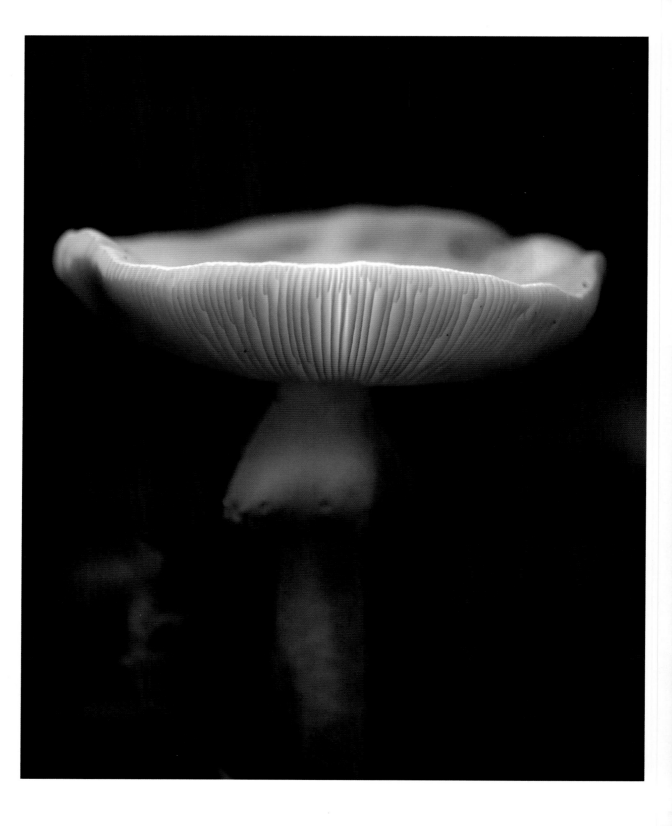

There are many ways to categorize mushrooms, whether it's their overall shape, how they release their spores, their DNA analysis, or even what environment they can typically be found in. Of course, there are always exceptions and blurred lines to be aware of. For the purpose of this book, mushrooms are divided into four main categories based on their usage: Culinary, Medicinal, Toxic, and Other. This, again, has some overlap, as most culinary mushrooms can be considered medicinal and many mushrooms (minus the small percentage that are deadly poisonous) are technically edible but not necessarily delicious.

This guide introduces you to some of the most interesting, notable, and recognizable mushrooms you may encounter during a wander in the woods. By no means is this a comprehensive identification guide to all known fungi species. This book is also not meant to replace identification with a local field guide or confirmation by an expert. Do not consume any wild mushroom without proper and confirmed identification.

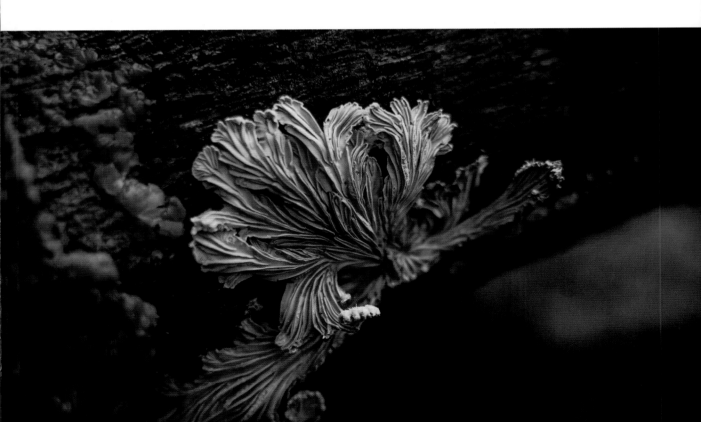

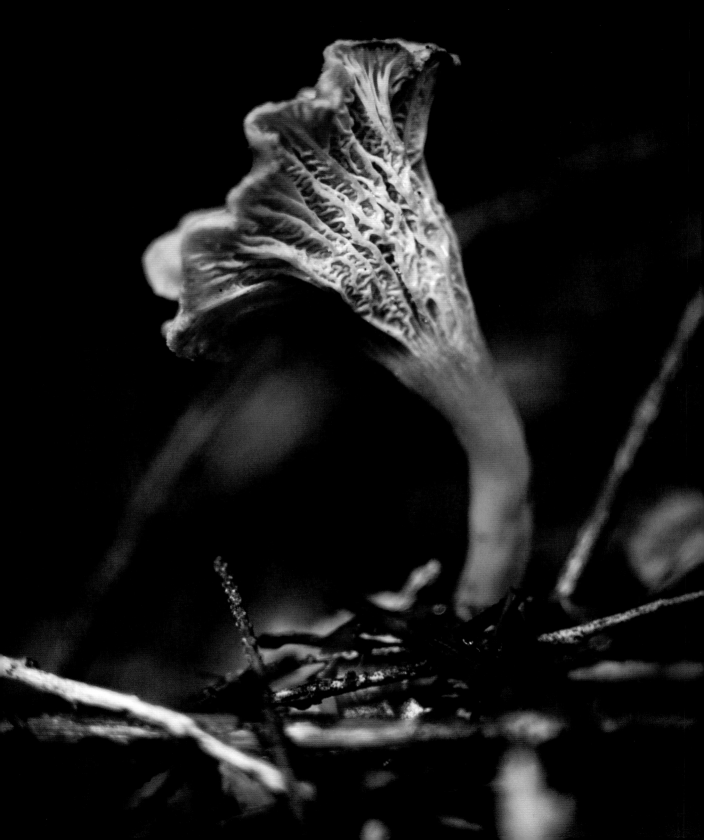

Culinary Mushrooms

The mushrooms featured in this section are highly sought after and considered to be some of the top culinary fungi suited for the table. Organized here from least to most coveted, some of these fungi fetch high prices on the market when they're in season and can be difficult to find the rest of the year. Most are mycorrhizal, which means their fruiting depends on a very specific environment. They are unwilling to be tamed and difficult or impossible to be cultivated, which adds to their mysterious and exotic nature.

Meadow & Prince Mushrooms

Agaricus campestris, A. arvensis, A. bisporus & A. augustus, etc.

Whether you're foraging your mushrooms at the supermarket or in the wild, you're bound to find *Agaricus*. It is the genus of the common white button, cremini, and portobello mushrooms—all of which are the same species, the infamous *Agaricus bisporus*. This familiar mushroom was the first to be cultivated in France as early as the 18th century and is now mass marketed, the star product of the $16.7 billion cultivated mushroom market.

It is the mushroom most Americans have experienced, although it may be the root of a cultural distaste for mushrooms. With so many poor preparations of these mushrooms in the mainstream (sliced raw at salad bars, canned, pickled, etc.), it's no surprise that edible fungi don't make the list of many Americans' favorite foods. But *Agaricus bisporus* is not one to be overlooked. When prepared with care, these mushrooms can result in delicious flavors and hearty meals. In fact, it's an excellent place to start for those who are especially new to eating fungi. The common white buttons are an abundant and affordable way to start learning culinary techniques to coax out the flavors of this underused food.

When venturing into the field, beginner foragers may find it difficult to identify this family of mushrooms due to the subtle differences between species and the fact that many toxic ones resemble the button mushroom. However, there are some fantastic edible ones in this group, with the prince (*Agaricus augustus*) being a star in terms of flavor. The common meadow mushroom (*A. campestris*) and similar species can be quite tasty as well.

Local pastures, meadows, and fields can be great places to start hunting for these mushrooms and learning their morphology and the subtle differences and similarities between wild and cultivated species. It is unfortunate that field mushrooms are no longer as abundant as they used to be. With the increasing use of pesticides, herbicides, and synthetic fertilizers in landscaping, their frequency is declining.

IDENTIFYING FEATURES: This commonly encountered genus of mushrooms has a wide variation of color, size, and features, but is generally represented by their easily recognized cultivated member, *Agaricus bisporus*.

Overall colors range from white to cream to tan, and brown on the cap and stem with a dark brown spore print. Their gills generally start out as pink and turn dark brown as spores mature. They tend to have evidence of a partial veil (ring around the stalk), but this feature can disappear over time. Some species stain yellow or red when bruised or scratched but others do not stain. Some have an aroma reminiscent of almonds or anise while some have a phenol smell. Identifying *Agaricus* species is an excellent example of using all your senses when meeting new mushroom species.

HOSTS & ENVIRONMENT: As a saprophytic fungi, *Agaricus* species are most commonly found in disturbed and urban areas, including parks, lawns, meadows, pastures, gardens, and trails. Some are found scattered in woodland habitats, associating with a variety of hardwood or conifer trees, depending on the species. The *Agaricus arvensis*, and other mushrooms, may often be found in fairy rings.

SEASON: They can be found in the spring, summer, or fall, depending on the species, but in areas regularly irrigated with mild temperatures, they're present nearly year-round.

CULINARY NOTES: A great way to start working in the kitchen is to try out different cooking techniques with the common white button mushroom. The wild species of *Agaricus*, such as the meadow mushroom (*A. campestris*) and horse mushroom (*A. arvensis*) have similar yet richer, complex, and nutty flavors that can be used in similar ways. They also lend themselves to unique and creative applications. Their robust caps hold up well when stuffed and baked. They can also be added to omelets, pastas, pizzas, and stir-fries. With its strong almond flavor, the Prince mushroom has been used in sweet dessert recipes such as cakes.

NUTRITIONAL VALUES: Cultivated *Agaricus* species are notably high in protein (approximately 29.14 percent) and carbohydrates (51.05 percent) with lower levels of fat (1.56 percent). These mushrooms contain all required amino acids in the human diet, comparable to that of animal proteins, making them a suitable meat replacement in a plant-based diet. Despite being low in fat, they contain essential fatty acids, such as linoleic acid, which aid in the production of hormones, regulating many processes in the body. As with all mushrooms, they contain significant amounts of dietary fiber due to the presence of chitin, with twice as much found in oyster and shiitake mushrooms. *A. bisporus* contain mostly potassium and phosphorus, but also notable amounts of calcium, magnesium, sodium, iron, and zinc. Niacin is the most prevalent vitamin in these mushrooms, followed by riboflavin, with the portobello variety being rich in folic acid. Wild mushrooms have significantly more vitamin D than their cultivated counterparts; however, this can be increased by exposing them to ultraviolet light.

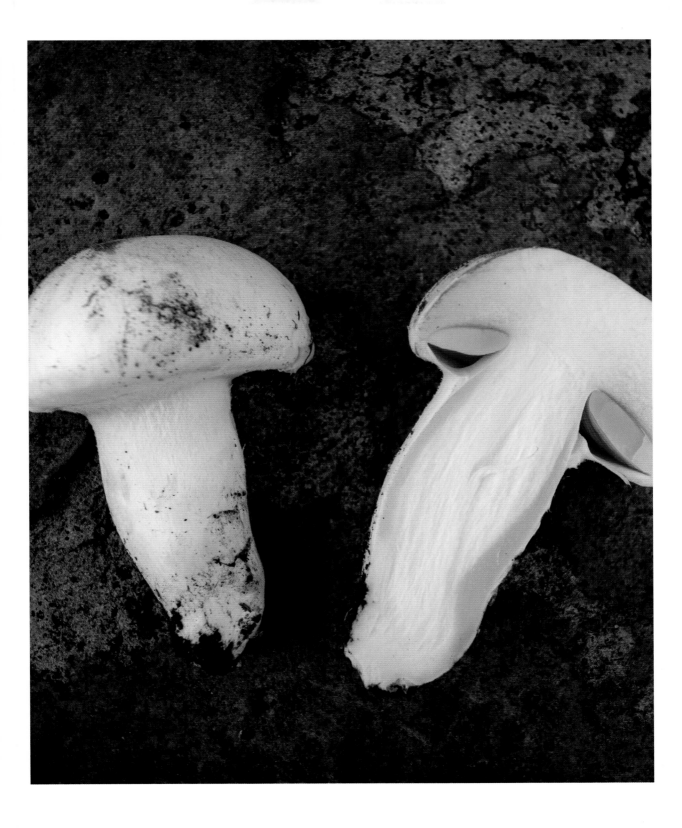

MEDICINAL PROPERTIES: As one of the most cultivated species, it also has been studied extensively for its medicinal properties as it has been used in many traditional practices around the world. *Agaricus* species have been used in traditional Chinese medicine to address spleen, stomach, and intestinal issues, ease digestion, and remove excess phlegm from the body while increasing qi.

Current research has found *A. bisporus* to have anti-cancer, anti-hyperlipidemic, anti-diabetic antioxidant, and antimicrobial potential.

LOOK-ALIKE SPECIES: To the untrained eye, white-colored *Agaricus* mushrooms can look very similar to toxic and deadly *Amanita* mushrooms. Avoid any *Agaricus* that stain yellow when bruised (*Agaricus xanthodermus* group) or have a phenol smell rather than the almond scent many in this group have. The *Chlorophyllum molybdites*, which is also found often on lawns and urban areas, has green spores and is toxic, with a reputation that has given it the name of "the vomiter." All gilled white mushrooms should be avoided for consumption by novice foragers until confidently identified.

⚠️ **CAUTIONS:** *Agaricus* can be a difficult group of mushrooms to identify for beginners. Consult a field guide and an expert for proper identification. To prevent risk of illness, *Agaricus* mushrooms should be cooked thoroughly before consuming, despite the practice of including sliced raw, cultivated white button mushrooms in salads.

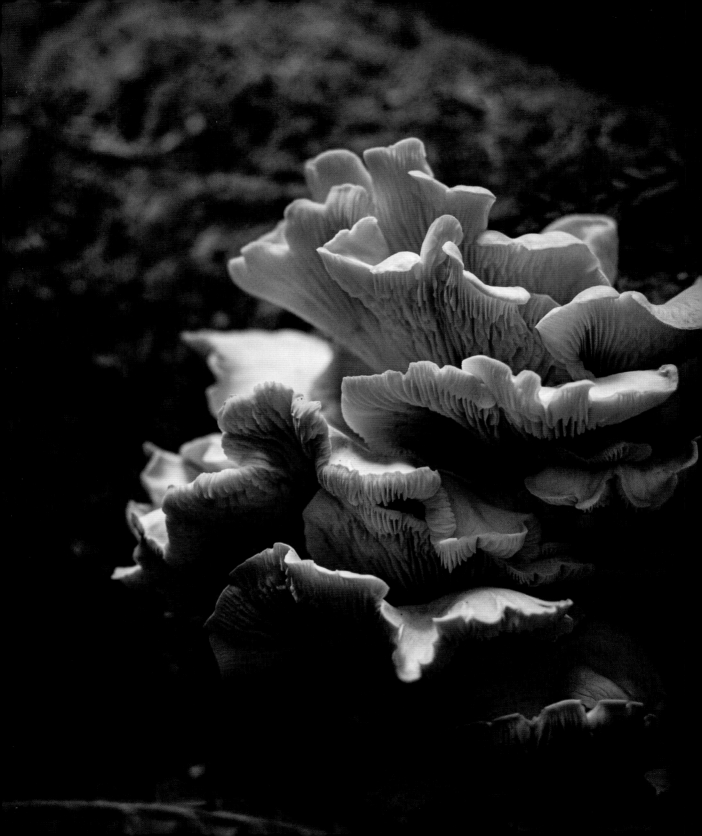

Oyster

Pleurotus ostreatus, P. pulmonarius, and *P. populinus.*

There's something hauntingly ghost-like about the oyster mushroom—they erupt poetically, fanning sideways and upwards in layered shelves from the sides of fallen, diseased, or burned trunks, almost as an usher of the underworld, coming to gently guide the tree back to the earth. This apparition's role in the forest is not far off from this metaphor: it breaks down dead and decaying hardwoods, returning their nutrients to the soil. As a result, it is a target species for research on mycoremediation—the study of utilizing fungi to digest toxins from the environment.

In a forest recently burned, they can appear in great quantities, with many clusters showing up repeatedly throughout the end of fall—a time when the leaves have all gone and an eerie quiet has fallen on the land. Not only does this mushroom feast on the dead, it also hunts for its prey by snacking on living nematodes for added nitrogen, since this nutrient is lacking in decaying organic matter.

It may take years for the oyster mycelium to break down a tree, but this results in reliable fruiting, season after season.

Oysters are a widely cultivated fungi, versatile in the kitchen, and a great mushroom for beginners. They are the star fungi in the variety of grow-your-own kits, coming in a range of colors from pink to blue to yellow, and white. Their mild flavor makes a great base for recipes, easily substituted in dishes calling for conventional white button mushrooms.

IDENTIFYING FEATURES: Ranging from gray to tan, and off-white, oyster mushrooms

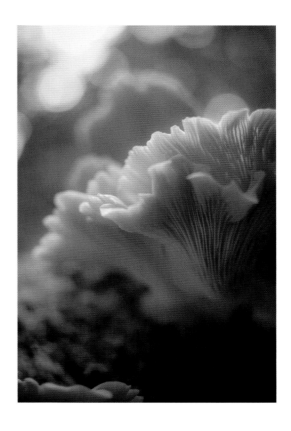

have an offset stipe (or none at all) with decurrent gills. They attach laterally to the sides of trees, generally in clusters and occasionally, solitary. Their size drastically ranges from 2 inches up to 12 inches or more, depending on growing conditions. Several nearly indistinguishable species are included in the *Pleurotus* group, including *Pleurotus ostreatus*, *P. pulmonarius*, and *P. populinus*.

HOSTS & ENVIRONMENT: Oyster mushrooms are hardwood tree-dwelling fungi. They tend to prefer dead or dying oak, elm, birch, poplar family trees, and, less frequently, conifer. A good time to look for them is a few years after a wildfire, where they can be abundant as they decompose the dead trees. As some of the easiest mushrooms to cultivate, they favor straw, sawdust, coffee grounds, and cardboard as suitable substrates.

SEASON: Just after the first sufficient rains in the fall, oysters will make their appearance. They will continue to fruit into spring as long as conditions are favorable. Varieties of cultivated oyster mushrooms are available year-round.

CULINARY NOTES: Oyster mushrooms are extremely versatile in the kitchen. The unique clustering "shelves" or "leaves" of the oyster mushroom offer something a little different to work with for the chef. These can be deep-fried whole and eaten similarly to a "blooming onion," where the leaves can be pulled apart and dipped into a sauce. Likewise, large clusters (I've found some to be up to 15 pounds) can be marinated, filled with stuffing in between the leaves, and then baked and "carved" much like a turkey for a holiday celebration (see page 64). They are also excellent substitutions for pulled pork in a sandwich, or marinated and dehydrated as a jerky. They also make great pickles!

NUTRITIONAL VALUES: Cultivated oyster mushrooms have higher levels of copper and zinc than other commercially available species. They also contain protein (16.07 to 25.15 percent), fat (0.64 to 2.02 percent), ash (2.1 to 9.14 percent), total carbohydrates (65.66 to 82.47 percent), fiber (6.21 to 54.12 percent), and energy (342.20 to 394.30 kilocalories/100 grams). Oyster mushrooms also contain high levels of some vitamins of the B group, vitamin D, iron, zinc, copper, and selenium. Sometimes nutrients vary between the stipe and cap in mushrooms; for example, *Pleurotus eryngii* contains more beta-glucans (responsible for anti-inflammatory and other health benefits), but these are more concentrated in the stipe.

Protein content and amino acid profiles are found to vary, depending on species and strain, stage of harvest and location, part of the fruiting body, and most specifically the substrate composition. Specimens grown on wheat stalk substrate yield lower amounts of protein than those collected in the wild.

The essential amino acids found in oyster mushrooms meet the required needs for adults, children, and adolescents. The most

prevalent is glutamic acid, necessary for protein synthesis and also as a neurotransmitter that facilitates digestion and liver function.

MEDICINAL PROPERTIES: Out of all related species tested, *Pleurotus eryngii*—the king oyster—has demonstrated the highest amounts of beta-glucans, the compound responsible for immune modulating and antitumor effects.

A hot water mycelial extract of *Pleurotus ostreatus* has shown significant activity against diabetes by increasing glucose tolerance.

In children with recurrent respiratory tract infections, a randomized, double-blind, placebo-controlled study from 2014 found that the beta-glucans isolated from oyster mushrooms demonstrated an anti-allergenic effect.

Oyster mushrooms naturally contain high levels of lovastatin—a compound used pharmaceutically to lower LDL cholesterol. Other studies have explored the use of oyster mushrooms to reduce weight, inhibit histamine release in cases of rhinitis, and elicit antibiotic and antitumor activity when studied in lab rats.

LOOK-ALIKE SPECIES: There are only a few look-alikes that can be mistaken for the edible oyster mushroom. They erupt from the sides of trees laterally, creating shelf-like structures with an off-center stipe, if any at all.

The similar "angel wing," *Pleurocybella porrigens*, is a controversial edible due to reports of fatalities in Japan. Another

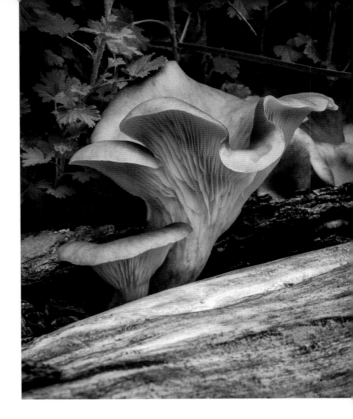

look-alike, although an unrelated species, is the *Crepidotus* genus, which has a brown spore print rather than the white or lilac spore print of *Pleurotus*. The common split gill (*Schizophyllum commune*) mushroom can also be mistaken for an oyster mushroom.

⚠ **CAUTIONS:** Because of its incredible ability to absorb nutrients from its environment, oyster mushrooms accumulate heavy metals—most specifically in the spore-producing structures of the mushroom. While this may be beneficial in mycoremediation of soils, it can be detrimental for those wanting to collect wild mushrooms for the table. Always be aware of the possible toxins in an environment when foraging.

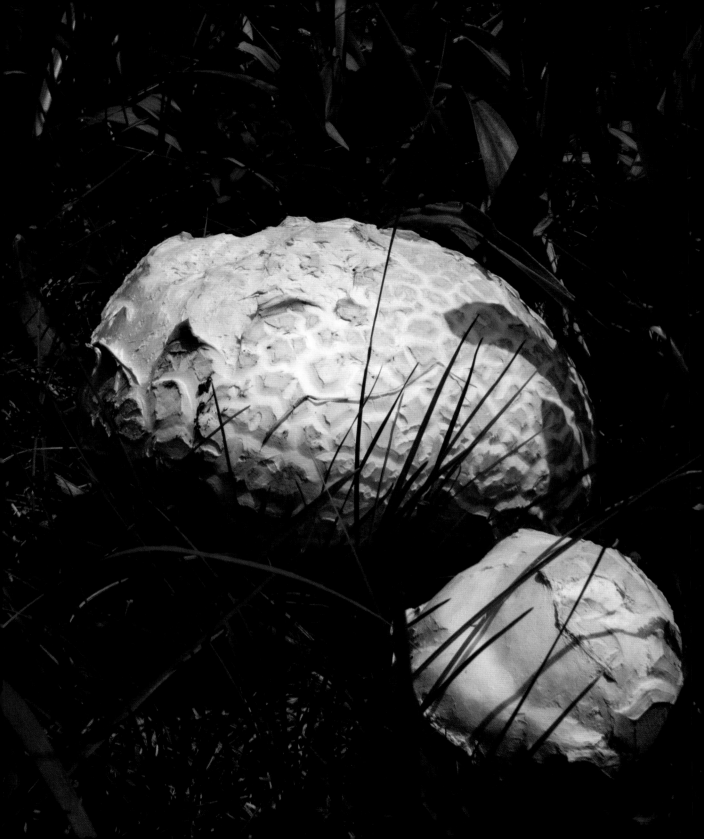

The Puffballs

Calvatia species, *Lycoperdon* species, and others

From the giant soccer ball-sized *Calvatia gigantea* to the spiked *Calvatia sculpta*, which resembles a medieval weapon, to small gem-studded forms of *Lycoperdon perlatum* dotting the forest floor, puffballs may be a child's first introduction to mushrooms in the field. When they are kicked or stepped on, they erupt into a dusty cloud of trillions of spores, making a walk through an open meadow in summer an exciting but also useful expedition for helping the fungi spread its spores.

The thick outer casing of the puffball protects the developing spores until they have matured. Unlike other mushrooms that forcibly eject their spores, puffballs invite the aid of rain, wind, and animals to break them apart. Or in the case of *Lycoperdon*, which will develop a small hole at the top, a gust of wind or a single drop of rain is all that is needed to disperse the spores.

Puffballs are termed "gasteroid" fungi—meaning "stomach," referring to their round shape. They are full of spores produced completely inside the fruiting body, unlike most other mushrooms. The largest puffball found on record was mistaken for a sheep, at 64 inches, in 1877. Some specimens can weigh up to 50 pounds, but 4 to 8 pounds is a more typical weight.

The Latin name of one genus of puffballs, *Lycoperdon*, literally means "wolf-fart," and puffballs have been associated with flatulence since ancient times. Other common names for puffballs, such as "puckfist" or "fairy fart," reference the mischievous Gaelic fairy, Puck.

Although this mushroom is lacking a strong, distinct flavor and aroma, it does have culinary uses. Its spongy texture can be used to absorb your favorite marinades and sauces, making it quite versatile in the kitchen.

Some American Indian tribes used dried puffballs as tinder or incense for ceremonies and to dispel evil spirits.

INDENTIFYING FEATURES: Depending on the species, their size can vary from small, inverted pear-shaped mushrooms to impressive soccer ball-sized specimens. When cut open, the interior is uniform in a range of colors, depending on its age. They are at their prime and ready for the table when they are pure white. Spore prints are not possible with puffballs, but the spore color can be determined on mature specimens.

HOSTS & ENVIRONMENT: Puffballs are saprophytic, breaking down organic material

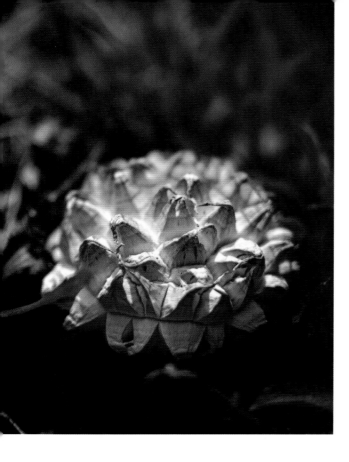

CULINARY NOTES: If many edible mushrooms are considered to resemble meat, with complex flavors and textures, the puffball would be tofu: mild in flavor and spongy in texture. With earthy tones, the entire immature spore mass is edible, including the tougher outer layer, though some remove it. Treat it like tofu and marinate it in a variety of Asian sauces for sautéing or roasting, or dredged in batter and fried.

The giant puffballs, *Calvatia gigantea*, also slice up in nice, thick uniform sizes, giving way to creative opportunities. Grill the slices as a mushroom steak or burger, batter it and press it into a waffle iron for savory waffles, incorporate it into pizza crust, or coat it in egg and spices to fry it like French toast and then drizzle with maple syrup. (I have yet to be convinced on the last one, after a disastrous failed attempt, but I have heard more than one account of folks having success.)

Because the giant puffballs are so, well, giant, even just one can be challenging to enjoy in its entirety before it goes bad. Fortunately, they can be cooked and frozen or dehydrated and powdered for later use, but the texture is best when used fresh. Or, better yet, send the rest as a fun gift to your unsuspecting friends and neighbors!

NUTRITIONAL VALUES: The smaller, pear shaped puffballs, such as the *Lycoperdon* species, are excellent sources of protein (41 percent) and carbohydrates (38 percent), while low in fat (21 percent). They contain oleic,

in the environment. They fruit in unsuspecting harsh environments and their white forms are easy to spot in meadows, alpine tundra, and even high deserts. *Calvatia* species, *C. booniana* in western North America, and *C. gigantea* in eastern North America, are found in semi-arid areas such as pastures, meadows, foothills, and open woodlands. *Lycoperdon perlatum* grows on soil in conifer and hardwood forests, whereas *L. pyriforme* grows in clusters on rotting wood.

SEASON: Puffballs generally appear in late summer and early fall, some into winter.

palmitic, and stearic acids. They also contain all nine essential amino acids.

MEDICINAL PROPERTIES: Many American Indian tribes such as the Lakota, Cree, Cheyenne, and others used dried puffball spores to dress wounds, slow bleeding, and prevent infection. Spores were also used to make baby powder to prevent rashes.

In Chinese herbalism, the spores are blended with honey to address infections and inflammation of the throat, coughs, tonsillitis, and laryngitis. The spore powder has also been used for hemorrhoids, varicose veins, and nosebleeds.

Calvacin, a unique compound found in *Calvatia gigantea*, was one of the first anticancer compounds isolated from a mushroom.

LOOK-ALIKE SPECIES: Trickier for beginners, there is the potential to mistake a deadly *Amanita* button, stinkhorn egg, or a Scleroderma for one.

⚠ CAUTIONS: When collecting puffballs to eat, check to make sure that the entire inside of the fruiting body is pure white. Discard any that have begun to turn tan, yellow, or brown, because that means they have begun to produce spores and are no longer edible. Also, some *Amanita* or stinkhorn "eggs"—those that are still encased in their universal veils—can be mistaken for small puffballs. Cut the mushroom lengthwise to check that it has a uniform texture and not a developing shape of an immature cap-and-stem mushroom.

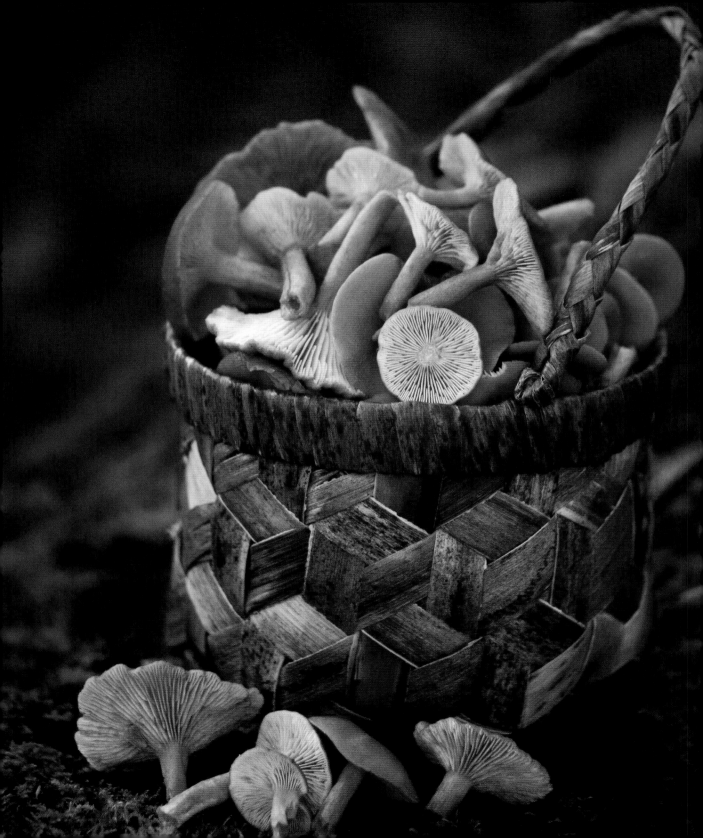

Milk Caps & Candy Caps

Lactarius rubidus, L. fragilis, L. deliciosus, L. indigo, etc.

When people think of dessert, "mushroom flavor" isn't usually the first thing that comes to their mind. However, one unusual group of milk cap mushrooms has the overwhelming aroma of maple syrup—a single dehydrated candy cap mushroom (*Lactarius rubidus, L. fragilis and L. camphoratus*) can scent an entire room. A little definitely goes a long way. They are used for flavoring many culinary treats such as ice cream, cookies, cheesecake, and sauces. Candy caps are also used to flavor alcohol, such as vodka, by infusing dried specimens for a length of time. They can be foraged on both the West and East Coasts or at specialty markets online.

Another species of *Lactarius* worthy of note is *Lactarius deliciosus*, the saffron milk cap. While the name may imply that this would be a highly sought-after specimen, it is of mediocre taste and texture compared to other more desirable mushrooms. However, its contrasting colors of orange and green make it an interesting find for the forager's basket. There are also the remarkable and otherworldly Indigo Milk Caps (*Lactarius indigo*), which have unusual indigo blue-colored flesh and ooze a bright blue latex when cut, as the name implies.

Some milk caps are edible and delicious, some are poisonous, and others are downright distasteful. It is important to research and learn the subtle differences between the species.

IDENTIFYING FEATURES: The *Lactarius* genera of mushrooms exhibit a common feature: When cut, they generally ooze a milky substance from their gills, hence their name "milk caps." This can also be an identifying feature between species. For example, the highly sought after *L. rubidus* exudes a thin latex reminiscent of skim milk as compared to the toxic *L. rufus* or "red-hot milk cap," which has a thicker and pure white latex. Cap and stipe colors can vary widely depending on the species, from reds, oranges, yellow, tan, even blue. Aroma is also an important aspect when identifying many mushrooms, and in this case, the candy cap species will exhibit an unmistakable, powerful, and lingering scent, especially when dried.

HOSTS & ENVIRONMENT: Being mycorrhizal, they are found growing from the ground near host trees, which can range from oak, birch, and conifer, depending on the species.

Candy caps (*Lactarius fragilis* var. *rubidus*) are found on the West Coast in California with the *Lactarius fragilis* var *fragilis* and *Lactarius camphoratus* on the East Coast. *Lactarius indigo* and *L. deliciosus* are more commonly found on the East Coast, but ranges can vary and extend into Mexico.

SEASON: *Lactarius fragilis* var. *rubidus* is common in winter and early spring in California. *Lactarius indigo* generally fruits in summer and fall on the East Coast.

NUTRITIONAL PROPERTIES: With 38 calories, *Lactarius deliciosus* mushrooms have 2.35 grams protein, 1.04 grams fat, and 5.17 grams carbohydrates per 100 grams. They have notable amounts of polyphenols such as flavonoids responsible for their anti-oxidant activity.

CULINARY USES: These edible species of *Lactarius* contain sesquiterpenes in their latex, which give them their pungent taste. *Lactarius camphoratus*, the curry-scented milk cap, can be used to flavor curry dishes when powdered. Candy caps develop their aroma typically only after they have been dried. This is because an amino acid in the fresh mushroom converts to a volatile compound known as quabalactone III when dried. When this compound is introduced to water, it is again converted into another compound known as sotolon. The resulting compound is used in commercial artificial flavors. Interestingly, none of these chemicals are found in natural maple syrup.

Use candy caps to flavor sweet desserts or enhance savory dishes when used fresh, but with restraint. Only a few small mushrooms are needed to flavor an entire dish—adding more than necessary can create an undesirable bitterness. Only one or two are needed for most applications. They can be infused in liquids such as cream, milk, or alcohol to impart the aroma and be discarded or blended into the final dish. Add them to the wet ingredients of the recipe, which enhances their powerful smell to get the most out of the candy cap aroma.

L. camphoratus, the spicy milk cap, contains the same sesquiterpenes that give black pepper and cloves their spiciness.

MEDICINAL PROPERTIES: The spicy milk cap, *L. camphoratus*, contains anti-carcinogenic compounds. The compound rufuslactone in the red-hot milk cap has been noted as a potential anti-fungal for agricultural purposes. Research suggests that several *Lactarius* species have potential in cancer prevention and the inhibition of tumor growth.

⚠ **LOOK-ALIKE SPECIES & CAUTIONS:** There are many non-edible and toxic species of *Lactarius*. When hunting for the candy cap, it can be confused easily with the "red hot milk cap" *L. rufus*. This toxic species exudes a white latex and has an acrid peppery taste. *Lactarius vinaceorufescens* (and *L. xanthogalactus* on the West Coast) has a latex that quickly

turns yellow when exposed to air and should be avoided. Only collect those that exhibit the translucent latex that resembles "skim milk."

⚠ **CAUTIONS:** Avoid *Lactarius* that have an acrid and peppery flavor and latex that turns yellow. *Lactarius* mushrooms can be challenging for new hunters to identify to their species level. Because some of these species are poisonous, you should be completely certain of your identification of any mushroom before consumption.

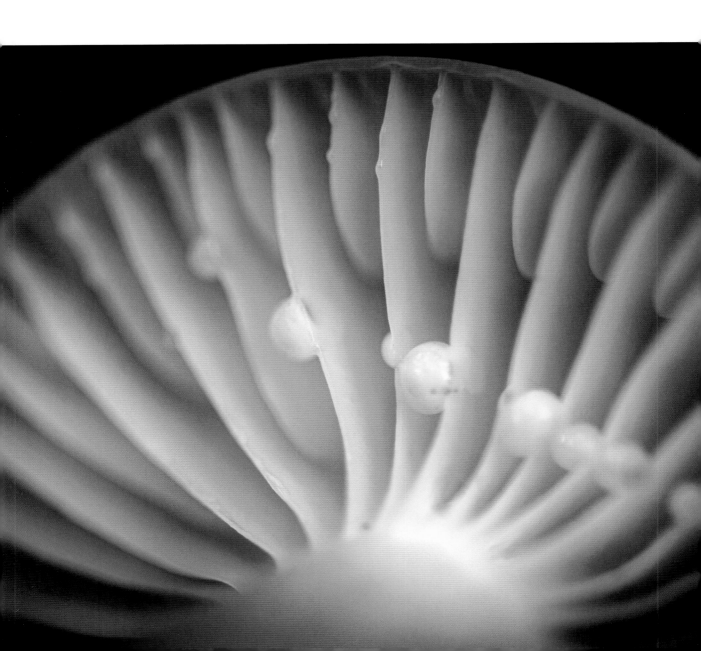

Chicken of the Woods

Laetiporus sulphureus, L. cincinnatus, L. gilbertsonii, L. conifericola

Imagine the joy of vegans and vegetarians worldwide upon discovering a mushroom that has the same texture and, as many claim, nearly the same taste as chicken. This vibrantly hued mushroom, also named Sulfur Shelf because of its color, is a rewarding find in the forest, but also abundant in urban areas. It's a great dinner centerpiece especially if the specimen is young and tender. As it ages, it becomes tougher, chalky, and odorous—these are less suitable for the table, smelling much more like a dirty chicken coop than chicken dinner.

With their Latin name meaning "bright pores," these mushrooms can be found in impressive quantities—a single cluster would make enough dinner for a family of four with some leftovers to put in the freezer, while a whole tree trunk covered in them would fill your friends' and neighbors' freezers as well.

IDENTIFYING FEATURES: The multiple large and brightly colored, overlapping fan-like shelves of the *Laetiporus* species can be seen from a distance and are easy to spot. Colors vary between species, but it can be bright yellow or orange overall with the top surface becoming orange as it matures; it dulls and eventually whitens when old. The underside has tiny pores. The underside pore surface is yellow in most species; *L. cincinnatus* has white pores that grow at the base of trees on the soil. All species will have a white spore print. Finding evidence of an old chicken of the woods is a good indicator for coming back to the same tree the following year, as they will continue to fruit for a few years as it breaks down the host tree.

HOSTS & ENVIRONMENT: *Laetiporus* species is a brown rot fungal infection in the heartwood of a living tree, and the presence of its fruiting bodies signals that that the tree has already been severely infected. The fruiting bodies can grow on living or dead trees, with species related to the host tree. *L. gilbertsonii* is found mostly on oak or eucalyptus and *L. conifericola* on conifers, both on the West Coast. *L. cincinnatus* and *L. sulphureus* grow on hardwoods on the East Coast. The individual species vary across North America, feasting on a variety of trees, from conifers to hardwoods.

SEASON: Late summer into fall on the West Coast and late spring into late fall on the East Coast. It even shows up in Southern California during the hottest and driest time of year.

The appearance of this impressive mushroom is the harbinger of fall and the coming season of mushroom hunting.

CULINARY NOTES: *Laetiporus* has long been used in Japanese, Thai, and North American cuisines. While some folks may disagree about the similarity of its taste to its namesake, it definitely has a similar texture to cooked chicken. Some species taste better than others, with *L. cincinnatus* the most likely award winner. These mushrooms are notoriously challenging to digest, so longer cooking times (at least 30 minutes or more) are highly recommended to break down its high amounts of fiber.

Simmer this mushroom with water or broth, allowing the moisture to evaporate, then sear with butter or oil and flavorings. I like to add lemon juice to enhance its slightly natural lemony taste, then combine it with fresh herbs like rosemary and thyme for a lemon herb "chicken." Try them breaded and fried like "chicken" nuggets or as a fried "chicken" sandwich. It also does well cooked *sous vide* to keep it tender and juicy with an extended cooking time. These do not dehydrate well, but can be cooked and frozen for later use. Be wary of sticks or stones embedded in the flesh that were swallowed up by a rapidly growing mushroom.

NUTRITIONAL VALUES: *Laetiporus* has caught the attention of researchers for its ability to meet many of our nutritional requirements. Chicken of the woods is rich in carbohydrates and protein, as well as being high in vitamin C, vitamin A, and potassium.

MEDICINAL PROPERTIES: *Laetiporus* has been used in traditional folk medicine in Europe. Rich in antioxidants, it has been studied for its potential healing qualities, and a few studies have suggested they may have anti-tumor and antibiotic properties.

LOOK-ALIKE SPECIES: Chicken of the woods is quite distinctive, but can be confused with other colorful or large shelf fungi, such as the northern tooth fungus, *Climacodon septentrionalis*. And while their names are similar, chicken of the woods is not related to, nor to be confused with, hen of the woods (*Grifola frondosa*), which has a neutral gray and brown coloring.

⚠ **CAUTIONS:** This mushroom is known to cause gastrointestinal upset (vomiting in particular) in some individuals. It is important to cook this species thoroughly to avoid sickness. *Laetiporus* species contain tyramine, which can cause potentially fatal interactions with MAO inhibitors.

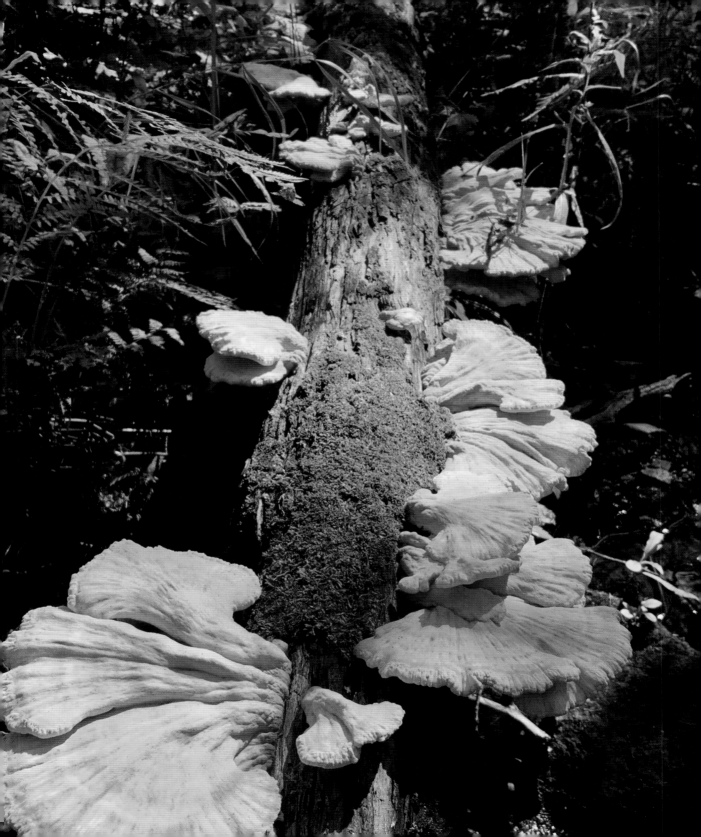

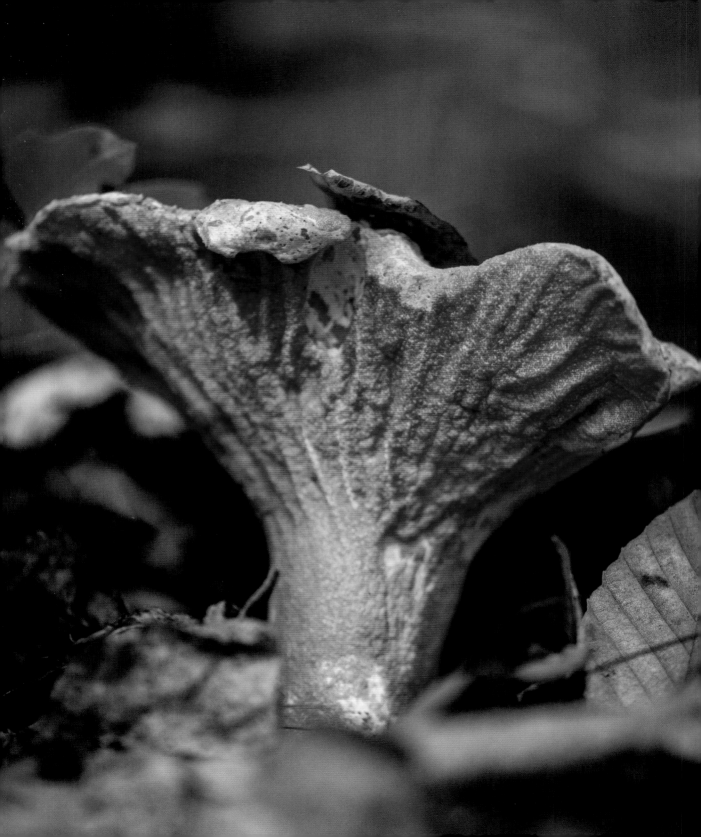

Lobster

Hypomyces lactifluorum

Resembling the bright orange color of a freshly cooked lobster, the lobster mushroom is in fact not a true "mushroom" at all. In fact, the name *Hypomyces* means "mushroom underneath," indicating its true identity. It is not a true mushroom but rather a fungus that has taken over the form of another living fungal fruiting body, such as *Lactifluus piperatus* or *Russula brevipes*, which is generally of little culinary value in its original form.

The invading fungus, *Hypomyces lactifluorum*, parasitizes the host mushroom's tissues and completely transforms the flesh and even the DNA of the inedible mushroom until there is little to no physical evidence of it left other than the crude and deformed shape of the original mushroom. Only a faint resemblance of the gills may remain as bumpy ridges. Even the chemical composition of the mushroom is altered significantly, tripling in amino acids (responsible for that umami flavor) and increasing in lipids. The now-transformed mushroom is classified as a lobster mushroom and has become edible.

These mushrooms can generally be found in abundance if conditions are favorable, filling up the shelves in specialty markets and securing a spot on the menu in upscale restaurants. There is a slight concern that the fungus may infect other inedible or toxic mushrooms, but there has not been any evidence of this and lobster mushrooms have been consumed for hundreds of years.

IDENTIFYING FEATURES: Bright orange to orange-red, often deformed in shape,

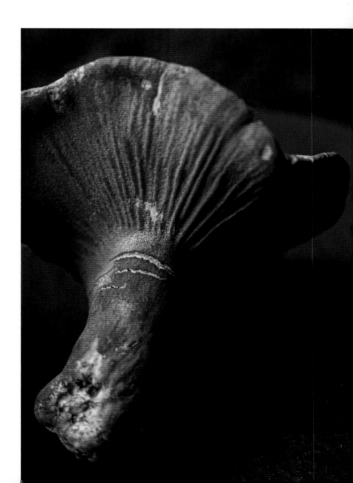

showing evidence of the original shape of the host mushroom. The surface texture is firm, rough, and finely bumpy. The flesh is white to cream-colored and dense.

HOSTS & ENVIRONMENT: It grows on *Lactifluus piperatus* (previously known as *Lactarius piperatus*) or *Russula brevipes* mushrooms near conifers and hardwood trees such as birch, beech, and oak on the East Coast. On the West Coast, it grows near spruce. It is found wherever milk caps (and the related *Russula* genus) appear throughout most of North America. With a good amount of moisture to spur the growth of their host fungi, lobster mushrooms can be found abundantly in old growth forests.

SEASON: Midsummer through fall on the East Coast and Rocky Mountains and early fall into winter on the West Coast.

CULINARY NOTES: This densely fleshed mushroom is prized for its unique texture. Some report that it has a seafood-like flavor, but that can be subjective. Some chefs use this mushroom as a seafood replacement in chowders or "lobster" bisque. They do well sautéed, sous vide, grilled, braised, or infused to create a brightly colored compound butter.

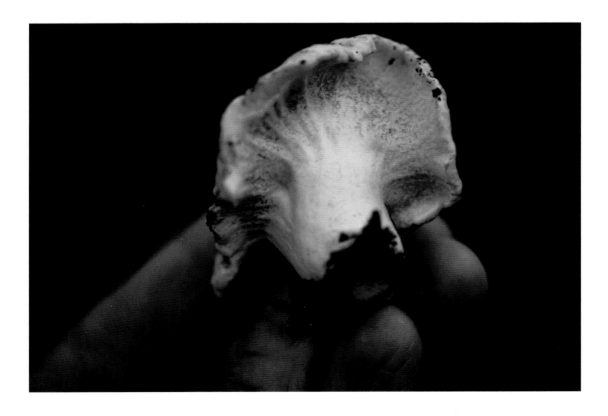

Lobster mushrooms tend to be rather dirty, with bits of debris stuck to their flesh. Be sure to clean well with a brush and/or spray with pressurized water. Their flavors can be preserved (and possibly improved) by dehydration or you can cook and freeze them for later use.

NUTRITIONAL VALUES: Lobster mushrooms are high in iron and contain notable amounts of calcium and protein. They also contain vitamins A, B-complex, and C.

MEDICINAL PROPERTIES: *Hypomyces lactifluorum* has not been currently studied for medicinal properties.

LOOK-ALIKE SPECIES: Lobster mushrooms are quite distinct and have no close look-alikes, as their dense and rough texture set them apart from most other mushrooms.

⚠ CAUTIONS: Lobster mushrooms are suspected to contain significant amounts of iodine. Individuals with a sensitivity or allergy to shellfish may be allergic to lobster mushrooms.

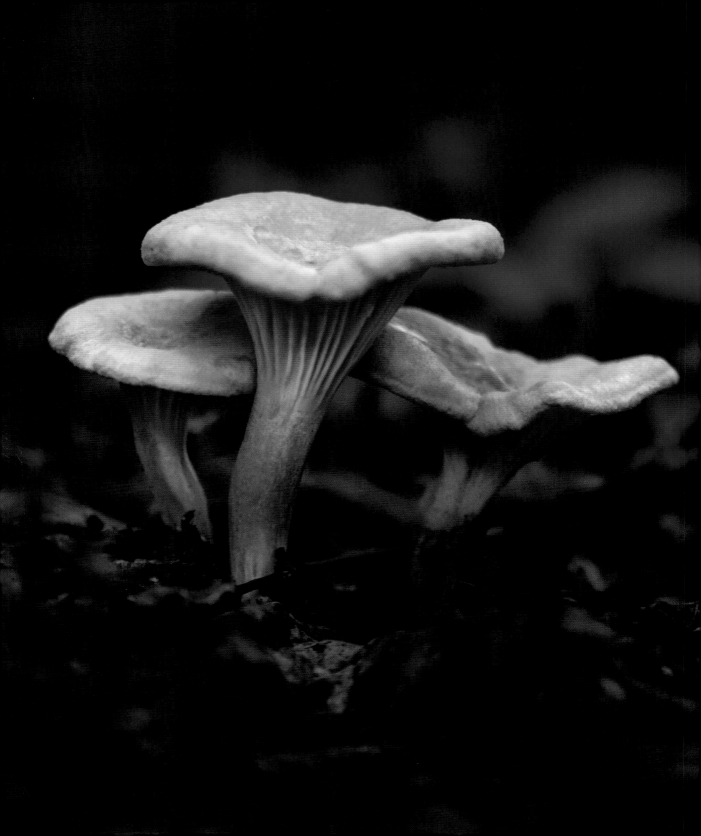

Chanterelle

Cantherellus cibarus, C. formosus, C. californica, etc.

The ever-elegant chanterelle, with a name derived from the Greek word for "chalice," resembles a revered vessel, with its tall stem and curving looped handles, known as a cantharus. This golden-hued mushroom, with neither gills nor pores, has smooth ridges that run down the length of its stipe, making it an easy mushroom for novice hunters to identify. In most regions, it thrusts forth from the forest floor, easily spotted like golden treasures glimmering among the moss and greenery. The exception to this rule is in California, where chanterelles are known as "mudpuppies," pushing up from beneath all the damp earth under the oaks after the winter rains, sometimes never revealing their girth, which hides in the thick layers of oak duff and mud.

But for what it lacks in cleanliness, this West Coast species makes up for in its enormous size. The *Cantharellus californicus* is the largest chanterelle in the world. A single mushroom can weigh in at over several pounds. If there's one around, there's usually more, making it easy to fill up your biggest basket under one well-producing tree.

While it is one of the few mushrooms that escapes the appetite of insects, it is also one that has very few adequate methods of preservation, inviting its human consumers to take advantage of its decidedly ephemeral nature. Some claim it to have a distinct fruity or apricot aroma when cooking, which can be emphasized for both savory and sweet applications.

IDENTIFYING FEATURES: Chanterelles can be distinguished by the unique presence of their "false gills," which are simply ridges that run down the length of their stem, sometimes with cross veins. As with true gills, this is the surface responsible for spore production and dispersal. The margins, or edges of the cap, are wavy and roll inward. The color varies between species but ranges from white, light yellow, and dull orange to deep golden hues. In the southeast, the *C. persicinus* is a peach-pink color.

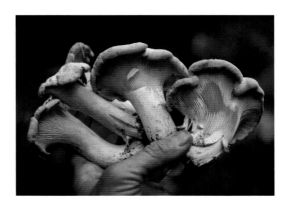

HOSTS & ENVIRONMENT: Chanterelles are ground-dwelling mycorhrrizal fungi found in broadleaf and conifer forests, also under oaks. On the West Coast, they prefer a variety of live and deciduous oaks, tanoak, redwood, and hardwood forests near the coast. They will grow solitarily or sometimes fruit prolifically in rings around the host tree.

SEASON: On the West Coast, they can be found abundantly during a wet winter and spring. Rocky Mountains and East Coast seasons are earlier, with hunters collecting them during summer and into fall.

CULINARY NOTES: Some say chanterelles have a woodsy, fruity, or apricot scent; others

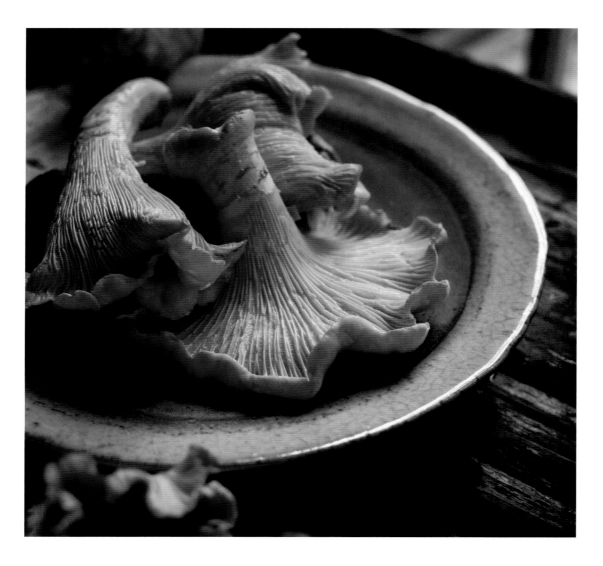

report a nutty flavor. However, they drastically lose their distinctive aroma when dried, so it is best to either cook them fresh or preserve another way. In other words, don't waste your money on buying dried chanterelles. If you have an abundance of chanterelles, they will keep fresh in the refrigerator longer than other, more delicate mushrooms, but they can also be cooked and then frozen for later use. Their firm texture makes them excellent candidates for pickling or a nice, simple sauté to appreciate their delicate and unique flavors. Some chefs have even ventured into the dessert realm with chanterelles—candying them, pairing with fruits, and adding to cheesecakes. Chanterelles infuse well in vodka, extracting their delicate, slightly fruity flavor.

When the more choice species are unavailable, *Cantharellus tubaeformis* can be substituted in recipes. These are known as the "winter chanterelle," "yellow foot," or "trumpet chanterelle."

NUTRITIONAL VALUES: Chanterelle mushrooms contain notable amounts of vitamin D, niacin, pantothenic acid, and riboflavin. They also boast nearly half of the daily requirement of copper, along with iron, manganese, and potassium per one hundred grams of raw mushroom. They are low in calories and fat, and yet they contain protein and high amounts of fiber.

MEDICINAL PROPERTIES: Researchers found that *Cantharellus cibarius* exhibited neuroprotective qualities, indicating it could be helpful in neurodegeneration caused by trophic stress, excitotoxicity, and antioxidative stress.

Cantharellus cibarius is also promoted to enhance the ability of human natural killer cells to detect cancer cells in the lungs and colon. It was concluded that consumption of *C. cibarius* can be helpful in stimulating the immune system.

An extract of *C. cibarius* was found to be antibacterial, including for *H. pylori* bacteria. Similarly, because of its resistance to hungry insects, it has gained interest for researchers to investigate the mushroom's insecticidal properties.

LOOK-ALIKE SPECIES: One of the most commonly mistaken mushrooms for chanterelles is the jack o' lantern mushroom (*Omphalotus illudens* or *O. olivascens*), which is toxic. The non-toxic false chanterelle (*Hygrophoropsis aurantiaca*) is also easily mistaken with its similar yellow color; however it has gills rather than ridges and lacks the flavor and aroma of the true chanterelle.

⚠ **CAUTIONS:** Like many other mushrooms, chanterelles can accumulate toxins from their environment. Be wary of pollution where you are collecting.

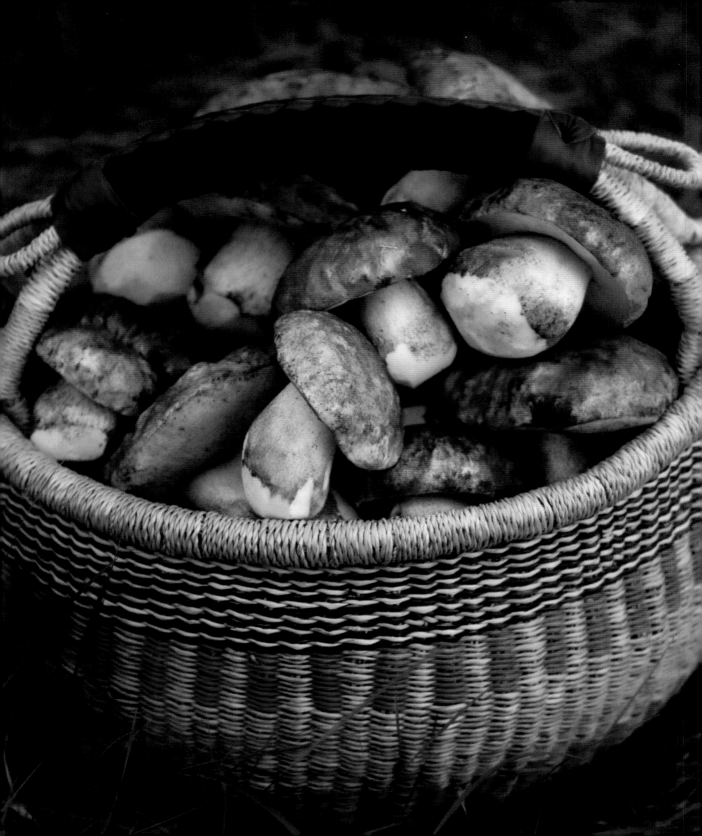

Porcini

Boletus edulis, Boletus rex-veris, Boletus rubriceps

Imagine a mushroom so delicious Ancient Romans could assassinate politicians by sneaking poisons into them. Revered as the most preferred wild mushroom in Europe—known as porcini, king bolete, cep, and penny bun, among many other regional names—the *Boletus edulis* is considered a top culinary mushroom in every region of the world that it grows in. In the United States, it is collected across the country nearly year-round. Its hefty and robust stature, possibly inspiring its Italian name meaning "little pig," makes one good-sized specimen fit for a meal, while an overflowing basketful will stock a pantry for the season—adding that rich umami flavor to soups, stews, sauces, and more.

Unlike other cap-and-stem mushrooms, the "bolete" group has the key identifying feature of a porous, sponge-like layer under the cap for its spore dispersal—as opposed to gills. The color of some boletes rapidly changes to blue right before your eyes when its flesh is exposed to oxygen after being cut or bruised. This, unfortunately, is not an indicator of edibility. While some blue-staining boletes, such as *Butyriboletus appendiculatus*, the "butter bolete," are rather delicious, other blue-staining boletes, such as the *Rubroboletus eastwoodiae* (or the similar *R. santanas* in Europe)—the Satan's bolete—are toxic. However, this blue-staining characteristic is an important feature to note for identification.

Finding porcini seems like it would be an easy task due to their girth and size. However, many never break the surface of the forest floor. The only evidence revealing their location is a curious "shrump" pushing up from underneath fallen leaves and debris.

And it's not just humans who have a preference for this outstanding mushroom—so

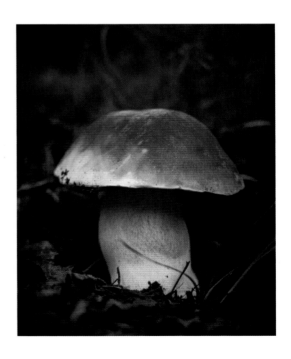

do squirrels and bugs. It is quite the tragedy to come upon an impressively sized bolete only to unearth a soggy, insect larvae-ridden mass. While it may be tempting to seek out the largest specimens, bigger isn't always better when it comes to foraging boletes—the smaller "buttons" are preferred because they are young, firm, and less likely to have been infested with insects.

IDENTIFYING FEATURES: The porcini is a short, squatty, and robust cap-and-stem mushroom that has a layer of pores instead of gills under the cap. Depending on the species, the bun-shaped cap can vary in color from brown to tan to reddish-brown, or even dark red. The pore surface underneath the cap is white and turns yellowish with age. The stipe is stout, usually with a distinctive, reticulated web-like pattern, and does not turn blue when cut.

HOSTS & ENVIRONMENT: Porcini tends to grow on the ground in conjunction with conifers and hardwoods. This mushroom is found worldwide, but is common in western North America. Porcini is another choice edible that is not currently cultivated due to its complex mycorrhizal relationships to the forest.

SEASON: For California, different varieties of boletus can be found nearly year-round, with the spring kings (*Boletus rex-veris*) fruiting from spring into early summer and again in the fall and winter (*Boletus edulis* var. *granedulis*). In the Rocky Mountains, *Boletus*

rubriceps fruits in late summer and early fall. The *Boletus clavipes* of northeastern United States fruits from June through November.

CULINARY NOTES: Many different edible species of bolete mushrooms are found around the world and are specific to their region. They offer an array of different flavors and aromas, but they can be used interchangeably in recipes calling for "porcini." These are one of the few wild mushrooms that can be eaten raw in small amounts. Try them shaved thinly over salad, or prepared like ceviche with lemon juice, a drizzle of olive oil, and some salt and pepper. It is also the traditional mushroom used in mushroom barley soup.

Bolete mushrooms dry well, can be powdered, and are tasty when rehydrated, and possibly even better than fresh. When rehydrating porcini, be sure to save the soaking water to add to soups or flavoring other dishes.

NUTRITIONAL VALUES: Unusually high in protein compared with other mushrooms, *Boletus edulis* also contains notable amounts of B vitamins and amino acids, selenium, sodium, iron, calcium, and magnesium, but this can vary depending on the soil they were growing in. These mushrooms have a tendency to accumulate heavy metals, mercury in particular, from their environment. While this is a beneficial attribute for mycoremediation, hunters looking to collect these for the table should be cautious about harvesting in contaminated areas.

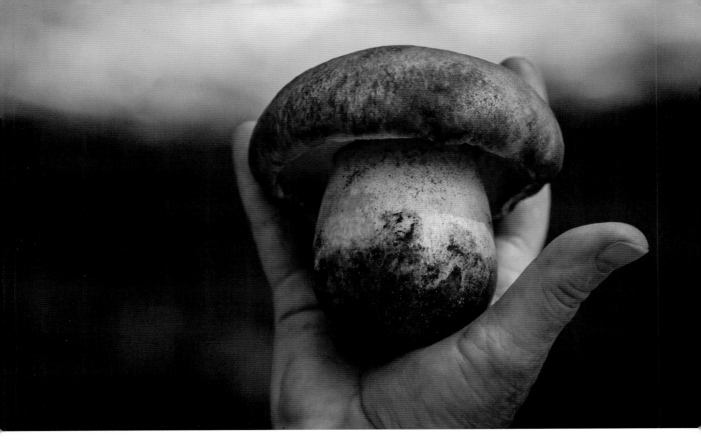

MEDICINAL PROPERTIES: While this mushroom has reigned as a top culinary mushroom, contemporary research has explored its possibilities for therapeutic use. According to Pliny the Elder, a Roman naturalist and philosopher, *Boletus* mushrooms were good for the digestive system. They were also historically believed to be helpful in removing blemishes from the skin and treating dog bite wounds when made into a topical salve. Studies have shown their potential efficacy against breast and colon cancer tumor cells without any damage to normal cells. The polysaccharides of *Boletus edulis* were found to have anti-inflammatory properties that may be helpful in certain asthma cases.

LOOK-ALIKE SPECIES: The bitter bolete, *Tylopilus felleus*, is easily mistaken for a porcini; however it has a dark reticulation pattern on the stipe. Despite its bitter taste, it is not poisonous. Bolete mushrooms belong to many genera and can sometimes be a challenge to identify, but there are many that are delicious edibles.

⚠️ **CAUTIONS:** There are some studies that confirm *Boletus* mushrooms as a possible allergen.

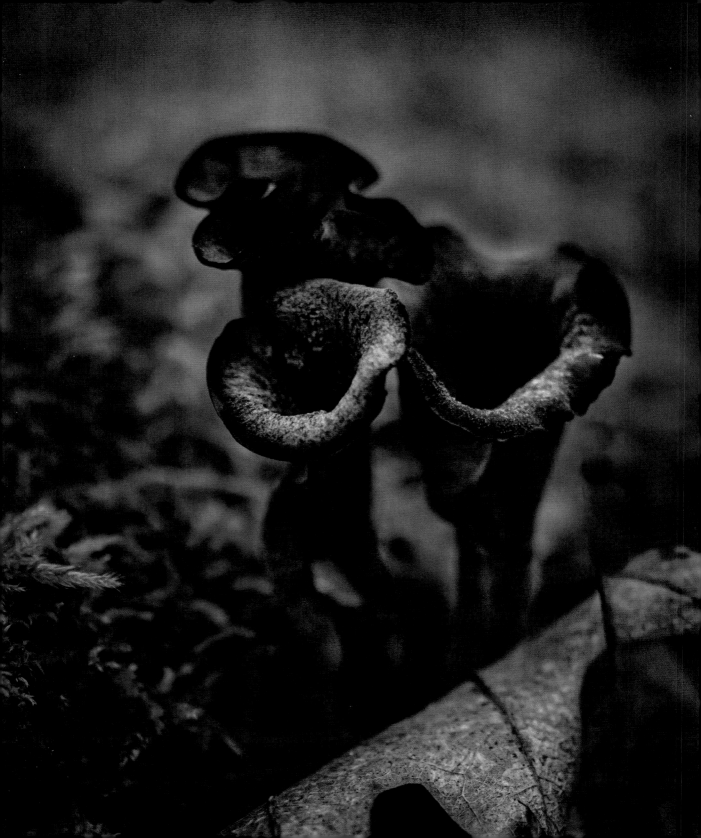

Black Trumpet

Craterellus cornucopioides, C. fallax, etc.

The tall, dark, and mysterious cousin to the chanterelle is the black trumpet, *Craterellus cornucopidoides.* These elusive and challenging-to-find mushrooms have an earthy and woodsy taste similar to morels. Rich with a strong cheese-like funkiness and nearly smoky aroma, they add an intriguing depth to many culinary adventures.

They grow either solitary or in compact clusters, making them the perfect gothic bouquet to fit their French epithet, *trompette de mort,* the "trumpet of death." Despite such a name, this mushroom is not toxic. Sometimes hiding in plain sight, they blend into the forest floor among the dirt and fallen leaves, looking like nothing more than shadows. Sometimes there will be a few here and there; other times they will carpet the ground between the trees, insisting you step mindfully.

Relatively easy to clean, they have a good shelf life and improve their flavor over time, making them a good mushroom to keep in the pantry for a special occasion or just to fancy up an everyday meal.

IDENTIFYING FEATURES: Funnel-shaped with a curved and wavy margin, they have a distinctive, smooth, spore-bearing surface lacking gills or pores. The top or center of the funnel shape is a darker black, bluish, or sometimes brown, contrasting with the outside, which is a muted gray.

HOSTS & ENVIRONMENT: Black trumpets are found scattered or in groups growing from the ground in decayed leaf litter, generally near hardwood trees in damp areas.

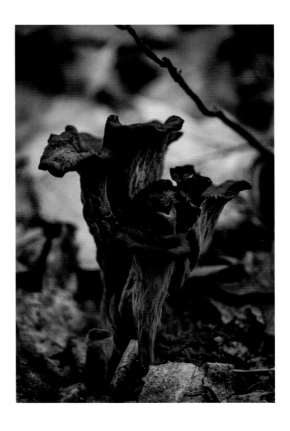

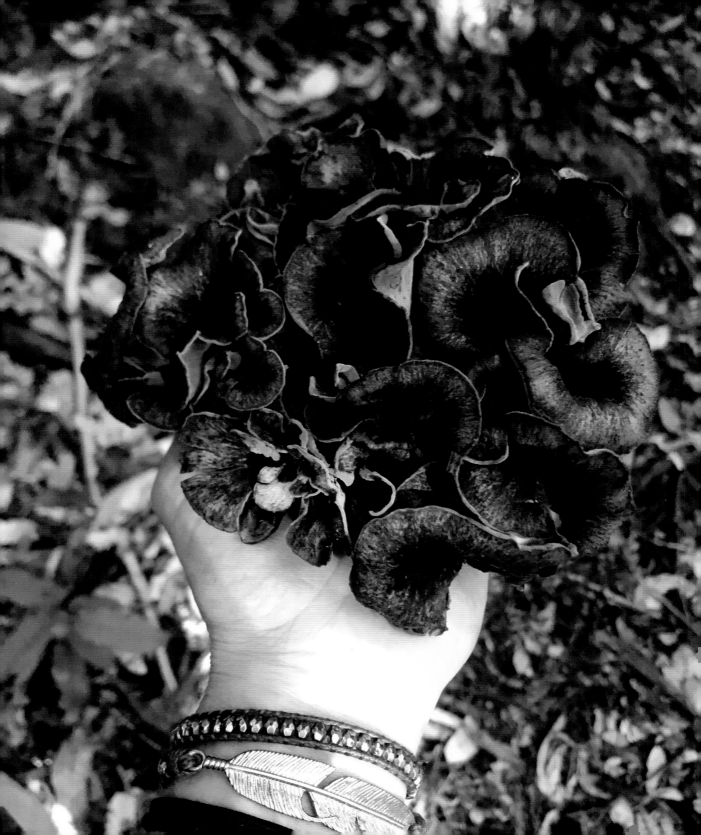

SEASON: Summer into fall for eastern North America and through winter into spring for the west.

CULINARY NOTES: Black trumpets are used wherever a little depth and luxury are desired, especially in their dried state, when their flavor contains notes of black truffle. Add them to creamy sauces, omelets or other egg dishes, pasta, grains, cheese, chicken, veal, or pork. They can be simmered and reduced to a sauce or sautéed and crisped almost like bacon to garnish a dish. Black trumpets dehydrate well and can be powdered and added to seasoning blends or flavored salts, which are great to have on hand. Closely related to the chanterelle, they are mostly bug-free, but sometimes collect bits of dirt, sand, or debris that get lodged inside the mushroom or stuck to the base. Be sure to cut or tear open lengthwise to clean thoroughly.

NUTRITIONAL VALUES: When dehydrated, black trumpets are up to 50 percent protein, which may be why they pack so much flavor into such a thin and delicate form. Black trumpets also contain considerable levels of vitamin B12, which is typically only found in animal proteins.

MEDICINAL PROPERTIES: Black trumpets have not been studied too extensively for medicinal properties, but they do contain antioxidant compounds that protect against oxidative stress. Black trumpets are also rich in polysaccharides that have an immunoregulatory effect. However, they are lower in ergosterol, the compound found in mushrooms responsible for their vitamin D.

LOOK-ALIKE SPECIES: There are no poisonous look-alikes of the black trumpet; however, it has a few variations in species (*Craterellus calicornucopioides* on the West Coast) or the rare *Polyozellus multiplex*. Additionally, there is the black chanterelle, *Craterellus atrocinereu*s, which is also an excellent edible.

 CAUTIONS: None.

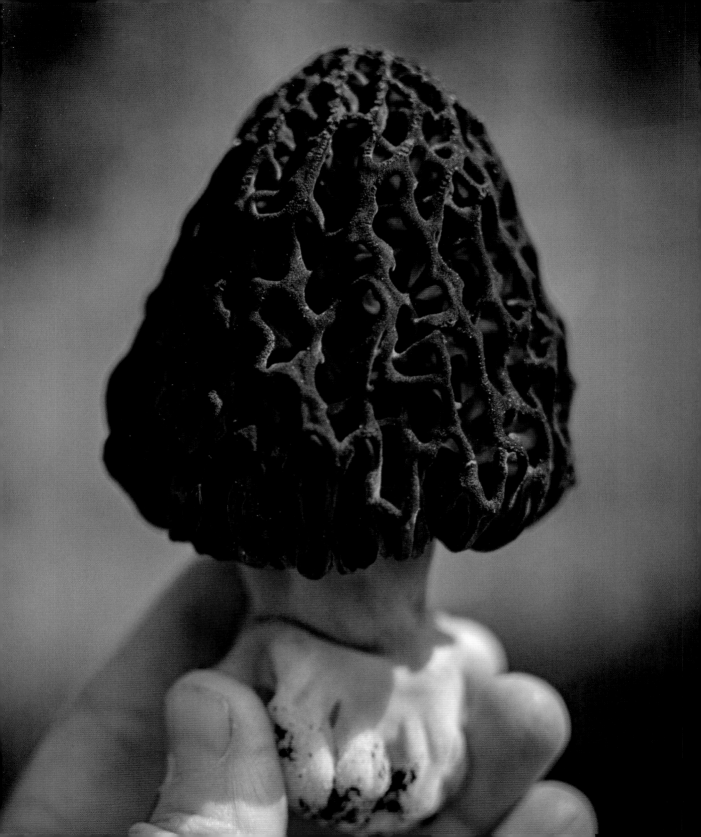

'Morel

Morchella species

A coveted culinary mushroom with a rich and complex umami flavor, morels are by far one of the most desired delicacies for the table worldwide, responsible for a multimillion-dollar industry. These celebrated, mysterious, and elusive mushrooms are excellent at camouflaging themselves against the ground, appearing not unlike fallen pinecones. They can be found in incredible abundance if the right circumstances prevail. Morel patches are often a mushroom hunter's best kept secret, notorious for leading the curious astray with false information.

The name of the genus *Morchella* has a few possible origins of French and Italian, meaning "blackish." Alternatively, it may also come from the German word, *morchel*, simply meaning "mushroom." The genus type species "*esculenta*" in Latin means "edible," which is nearly an insult to such an esteemed culinary treasure. Regardless of its name, it is truly a treasure to taste.

Morels are found generally in the spring as harbingers of the season. Many traditional hunters rely on specific natural occurrences to signify the start of the season. These occurrences can sound somewhat mystical and esoteric. In the case of morels, the blooming of the vibrant red snow plant (*Sarcodes sanguinea*) indicates that the temperature and daylight conditions are ideal for fruiting. Occasionally, it is possible to encounter morels in other seasons, as in gardens, but typically in sparser numbers.

IDENTIFYING FEATURES: Ranging in size, color, and shape, these polymorphic fungi generally have a light-colored and smooth, textured, and/or wrinkled stipe with a conical, deeply pitted cap that varies from black to brown to light cream. There is much debate over the number of species of morels or whether

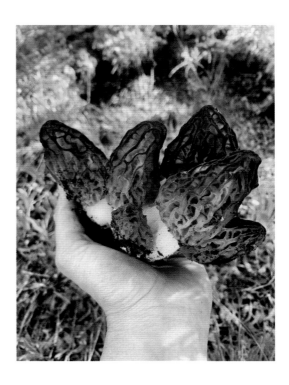

they are simply variants of the same few species. Some say there are only three (black, yellow, and "half-free"), while others argue there may be upwards of 30 to 50 distinct species. Many are endemic variations found in specific regions of the world. The black and yellow species are self-descriptive of their cap colors while the "half-free" species have a cap that is only attached by the upper one-third or two-thirds to the stipe, leaving a bit of a skirt.

The morel's textured stipe and cap are always hollow when cut longitudinally. Avoid any that do not have a hollow stipe and lack the deep honeycomb-shaped cap, as they may likely be highly poisonous "false morels," *Gyromitra esculenta*. They are potentially fatal if eaten raw and still contain harmful toxins after cooking, despite some reports claiming their edibility.

HOSTS & ENVIRONMENT: Morels can be either mycorrhizal or saprophytic, depending on the species. Yellow morels are found mostly under deciduous trees such as ash, sycamore, elms, cottonwood, and old apple orchards, while black morels are found under conifer trees such as pine, fir, and larch. Due to their mycorrhizal nature, these species are not easily cultivated. Conifer forests that have recently been burned by wildfire can stimulate an abundant flush of "burn morels." *Morchella rufobrunnea*, the landscape morel, is saprophytic and can be found in gardens and wood chips.

SEASON: Morels typically are found throughout spring and into summer months across North America.

NUTRIONAL PROPERTIES: Despite their low calories, per 100 grams fresh, morels contain considerable amounts of protein (3 grams), iron (12 milligrams), vitamin D (206 micrograms), calcium (43 milligrams), copper (.625 milligrams), magnesium (450 micrograms), and potassium (411 milligrams), supplying up to one half of daily requirements in some minerals. They also contain seventeen amino acids.

CULINARY NOTES: One of the most highly regarded wild mushrooms, their earthy and almost meaty flavors are used commonly in rich and creamy dishes, often paired with meats. Try stuffing them with cheese and baking or frying. Since many other wild spring edibles are

showing up at the same time, they are naturally paired with fiddlehead ferns, ramps, and nettle. Or, try combining with some peas, artichokes, or asparagus from the farmers' market.

Morels aren't overly dirty, like many other mushrooms, but they should be cleaned thoroughly, inspecting their many pits and grooves for sand or little critters hiding in the hollow of the center cavity. These mushrooms dehydrate and rehydrate very well for future culinary creations, so if you have more than you're going to eat immediately, preserve the bounty for later by drying them while they are still fresh. Be sure to cook thoroughly—morels are slightly poisonous when raw.

MEDICINAL PROPERTIES: For more than 2,000 years, *Morchella* species have been used in traditional Chinese medicine for the treatment of many diseases, imbalances, and common ailments. This species is used to regulate the flow of energy and vitality in the body while treating excess phlegm. Like most mushrooms, morels contain active compounds such as polysaccharides, which are complex carbohydrates that have been found to contain antioxidants, inhibit inflammation for both acute and chronic conditions, and have immunostimulatory and antitumor properties. The mycelium is also known to be rich in antioxidants, which prevent the cell damage that plays a role in diseases such as cancer and heart disease, among others. The fruiting body of *Morchella esculenta* is high in antioxidants and may possibly offer tumor-resistant properties.

An in vivo study suggests that *M. esculenta* may help protect the liver against alcohol-induced liver injury due to the modulation of antioxidative and anti-inflammatory pathways.

Morels have also been clinically shown to reduce fatigue and anemia, lower cholesterol and blood sugar levels, and help with sleeping problems.

LOOK-ALIKE SPECIES: *Gyromitra* species, also known as "false morels," will not have a hollow stem and the cap will have a brain-like structure rather than a pitted and honeycomb surface. The related *Verpa conica* also have a similar appearance and are also edible; however the *Verpa bohemica* is toxic. Please refer to a local field guide for further identification.

⚠ **CAUTIONS:** While morels are choice edibles, some people can be allergic to them. They also contain toxins, such as hydrazines and small amounts of hemolysins, that can cause illness if eaten raw or undercooked. There was one possible fatality in Europe caused by morel poisoning. There are also some reports that there are compounds in morels that, if eaten in large quantities, can cause delayed (up to 6 to 12 hours post-consumption) benign and transient neurological effects in some people, such as ataxia and visual disturbances. Be aware, too, of the potential for confusion with the highly poisonous "false morel," *Gyromitra esculenta*, which may be fatal if eaten raw, as discussed above, and contains harmful toxins even after cooking.

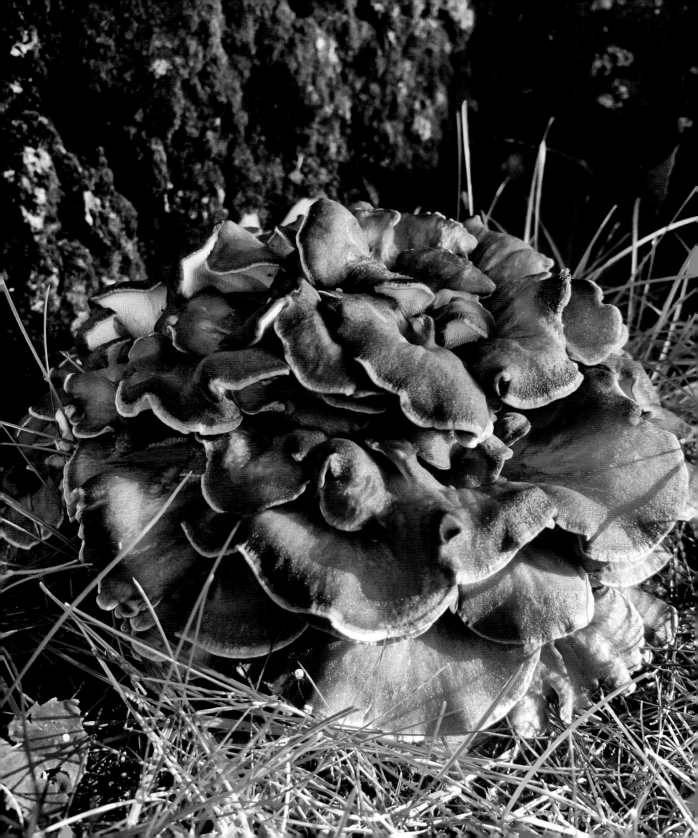

Hen of the Woods

Grifola frondosa

In Japan, this mushroom is named *maitake*, meaning "the dancing mushroom," possibly inspired by its ability to make its discoverer dance with happiness or its resemblance to the whirl of a dancer's dress. In North America, it is also known as hen of the woods, as it resembles the plumage of a hen. Its Latin nomenclature, *Grifola frondosa*, means "intricate leaf" or is possibly related to the word "griffin," the mythical eagle and lion hybrid. No doubt this mighty mushroom is worthy of mythical lore.

Specimens can weigh up to 50 pounds (with some even nearing 100 pounds in Japan). Occasionally, several separate mushrooms will fruit from a single tree, and it is not uncommon for a forager to harvest an abundance of these during a season, selling to many local restaurants. Once a hen is found, a forager can return to the same tree year after year, as the mushroom is more likely to continue fruiting in the same area. They are better when picked small and fresh before anyone, or any critters, get to them.

This grand mushroom has a recent history of cultivation starting in Japan in the 1980s and is typically grown in bottles to limit their size, so they can fit in standardized packaging. But as mushrooms are becoming more popular with the home cook, they are increasingly available fresh from many specialty markets year-round. Some say that the cultivated variety are just as tasty as the wild ones, although I personally say it lacks the taste of the hunt.

Not only delicious and nutritionally beneficial, it has been researched extensively for its bioactive properties, extracted and powdered to support certain cancer treatments, and believed to help, modulate the immune system and lower blood sugar levels. Not a bad way to take your medicine.

IDENTIFYING FEATURES: *Grifola frondosa* is a large polypore mushroom that has numerous overlapping grayish-brown, leaf-like caps that emerge from a central branched base attached to the bottom of oak trees. The caps are velvety and firm, with an underside pore surface that is white to cream-colored, with a white spore print.

HOSTS & ENVIRONMENT: It is a parasitic and saprophytic fungus that grows at the base of hardwoods, in particular oak trees in eastern North America. It is not found on the West Coast or the Rocky Mountain region, but is common elsewhere.

SEASON: Late summer through fall, rarely during midsummer.

CULINARY NOTES: As with other large culinary mushrooms, hen of the woods can be challenging to enjoy in their entirety. Luckily, this mushroom can be preserved in many different ways, from dehydrating to making jerky to freezing or pickling. Small specimens can fit well in your oven, but even the larger ones do well roasted whole or sliced and grilled. Their flavor is rich, earthy, and rather nutty, with a firm texture that can hold their form however they are prepared. This is an excellent mushroom to make the leap from the common white button mushrooms into more exotic mushroom flavors and can be substituted as such.

NUTRITIONAL VALUES: Hen of the woods is one of the wild mushrooms, with some of the highest levels of vitamin D (5.2 to 28.1 µg/100 grams), which exceeds the required daily value at 140 percent. It also contains 4 percent of protein and notable amounts of all nine essential amino acids. It also contains phosphorus, potassium, zinc, selenium, copper, iron, magnesium, and manganese.

MEDICINAL PROPERTIES: The beta-glucans in *Grifola frondosa* have been studied extensively for their antitumor properties, and may, when used in conjunction with chemotherapy, improve the effectiveness of treatment for breast, prostate, and colorectal cancers. It has been suggested that the use of *G. frondosa* lowered the blood glucose levels of diabetic patients up to 25 percent, a potential treatment for insulin-dependent diabetics. There is some evidence that *G. frondosa* may reduce hypertension.

LOOK-ALIKE SPECIES: Similar species include the black-staining polypore (*Meripilus sumstinei*) and the umbrella polypore (*Polyporus umbellatus*), both of which are also edible, with the umbrella polypore being on par with hen of the woods as a desired edible but much less often encountered.

⚠ **CAUTIONS:** Hen of the woods contains tyramine, which can have potentially fatal interactions with MAO inhibitors.

Matsutake

Tricholoma magnivelare, T. murrillianum

Imagine a mushroom so prized that it's gifted at weddings as a symbol of fertility, good fortune, and happiness. Revered for millennia, this mushroom was believed to wield so much spiritual energy that its name was forbidden to be spoken in the Imperial Court of Kyoto in the 11th century. Matsutake was hunted and preferred by the samurai. With ceremonies and rituals surrounding this inconspicuous mushroom known for its "autumn aroma," it is still a traditional delicacy today, not only enjoyed and coveted in Japan and also by American hunters and mycophiles.

However, this ectomycorrhizal mushroom, likened to that of the black truffle, has mostly been unsuccessful in cultivation. And because it's becoming harder to find, with temperatures changing and insect infestations killing host trees, there's also been a rise in its market price.

No need to travel to Japan to hunt these delicacies—they can be found hiding under the pine duff deep in the woods of either coast of North America. Once they break the surface and their caps open up, revealing their gills, they begin to lose their aroma and lose their desirability, but that doesn't make them inedible.

The matsutake, also known as the pine mushroom, is picked when it is small and the cap has yet to open, which releases its unique and sought-after cinnamon-like—or some liken it to bergamot—aroma. Picking them before their caps have opened is ideal and preferred at the market because they are graded by size and purity, retailing anywhere from $60 to nearly $800 per pound for grade-one mushrooms. Some pristine specimens cost several hundred dollars a piece, surpassed only by truffles. The mushrooms are brought

to market as if they were just plucked from the earth with remnants of dirt and sand still clinging to their base, as trimming them or cleaning them up lessens their value.

IDENTIFYING FEATURES: *Tricholoma magnivelare* is a robust, all white to creamy mushroom with brownish scales and a thick and cottony veil covering its crowded white to tan gills. It has a dense, tapered stipe that ends at a point with orange to brownish scales. The aroma can be pleasant to some, likened to musty cinnamon, but to others, it's more reminiscent of a sweaty sock.

HOSTS & ENVIRONMENT: In Northeastern states, matsutake (*T. magnivelare*) is found under pine and hemlock, typically with a clay and sandy layer of soil. Matsutake favors conifer forests and is associated with fir and pine on the West Coast (*T. murrillianum,* which mycologists consider a separate and distinct regional species of matsutake).

SEASON: September through November

CULINARY NOTES: Japanese traditions include preparing matsutake as a broth with yuzu or cooked with rice in a dish called matsutake gohan. It also pairs well with fish. The matsutake's unique aroma demands it be the star of the meal. Cook it with a minimum of other ingredients so these additions can support the matsutake's aroma rather than cover it up or clash with it. A light grilling is all you need to enjoy this traditional

delicacy, as the aroma is destroyed in more intensive treatments such as sautéing or adding excess flavorings or spices. Preservation is difficult, especially dehydration, because the mushroom loses its flavor quickly in the process. Cooking and freezing is an option, but fresh is best when it comes to matsutake.

NUTRITIONAL VALUES: The matsutake is very high in protein, with up to 20 grams per 100 grams of mushroom with 5 grams of fat and 36 grams of carbohydrates. The mushroom also contains large amounts of amino acids, most notably glutamic acid, alanine, aspartic, and leucine. The amount of minerals and trace minerals depend on the environment, but these mushrooms are known to contain calcium, phosphorus, iron, manganese, copper, and zinc in varying amounts.

MEDICINAL PROPERTIES: As with other mushrooms, *Tricholoma magnivelare* has been studied for its antitumor properties. It was found to have a similar tumor inhibition rate to shiitake. The mycelium was also found to possess immune-modulating alpha-glucans and there's evidence that it may inhibit the growth of certain tumors of the colon.

LOOK-ALIKE SPECIES: Some look-alike and less-valuable species are sometimes used as stand-ins in the marketplace and should be avoided; the lack of aroma is likely a giveaway that you've found an impostor. This

most commonly happens with *Catathelasma ventricosum*.

Great care should also be taken not to confuse these mushrooms with Amanitas (such as *Amanita ocreata* or *A. smithiana*, which can lead to kidney failure and death if exposure is not treated promptly).

⚠️ **CAUTIONS:** As with other all white gilled mushrooms, be certain of the identity, as matsutake can look similar to deadly *Amanita* mushrooms. The *Amanita* genus contains the most deadly species, which look dangerously close to the edible ones (see Death Cap on page 177 and Destroying Angels on page 175).

On Eating Amanitas
Amanita calyptroderma, A. velosa, A. vernicoccora, **and** *A. jacksonii*

The journey into mycophagy (the practice of eating mushrooms, especially wild) is a popular one with mushroom hunters. Many brag about unique species they have eaten and some of the lesser-known fungi can indeed offer unique explorations into uncharted culinary territory.

Looking past the mycophobic British influences in the United States, there are many unique mushrooms that have graced the tables of cultures worldwide. Some species of *Amanita* mushrooms are eaten regularly in Europe and considered a delicacy. As the practice of eating *Amanita muscaria* (see page 159) is becoming more popular among hunters and mycophiles, other species of *Amanita* are finding a more regular place at the table, as are others with unknown or questionable edibility or a lack of flavor. This culinary adventure does come with high risks and is not recommended for novice mushroom hunters without adequate research, but it is worth the effort.

A few edible Amanitas worthy of pursuing are Fall Coccora *Amanita calyptroderma,* Springtime *Amanita velosa,* Spring Coccora *A. vernicoccora,* and American Caesar *A. jacksonii.* Each has their own distinct flavor, but they have mild, subtle, nutty notes and require little cooking, if any. For example, the American Caesar Amanita can be sliced, salted, and rinsed, then served raw with a drizzle of olive oil and a squeeze of lemon juice.

Medicinal Mushrooms

The use of mushrooms as medicine is evidenced throughout human history. They have been used to treat ailments for thousands of years all over the world, from Asia to Europe to the Americas. Traditional medicines have historically been used in conjunction with spiritual and religious practices, but they are now crossing over into the realm of modern science, as well—despite criticism from the pharmaceutical industry and some medical doctors. As researchers continue to delve into the extensive task of clinical and placebo-controlled studies, more and more evidence of the efficacy of medicinal mushrooms has supported their use in human health care. In fact, many present-day pharmaceuticals were originally derived from fungi, with the most significant of these being penicillin: a fungi-based antibiotic that revolutionized modern medicine. Mushrooms, like many herbal medicines, may help bring the physical body, mind, and spirit into balance. Daily stresses and the complications of modern life certainly have us falling out of balance more often than we'd like to admit, and adding mushrooms to a healthy diet can help bring us back into alignment.

As health-oriented companies jump on the medicinal mushrooms bandwagon, these products are becoming more widely available in health food stores and even mainstream markets, where you can find extracts, blends, and powders that can be added to a health-focused routine, though caution is always appropriate since these products are largely unregulated. While supplements are convenient and easy to integrate into a daily practice, obtaining quality products can be pricey. By foraging and preserving your own wild medicinal mushrooms, you can affordably build an apothecary of healing mushrooms to use in teas and foods.

Many edible mushrooms can be considered medicinal and vice versa. The culinary star hen-of-the-woods, for example, is packed with compounds that may slow the growth of certain tumors. These mushrooms enhance any meal they are added to but can also be dried and, if not contraindicated, taken as a supplement. Likewise, research suggests the medicinal lion's mane may offer certain cognitive benefits; it also makes for a delicious gourmet mushroom dinner. A few medicinal mushrooms, however, such as reishi and turkey tail, are best left for the apothecary shelf. Other interesting mushrooms worthy of investigation are shiitake (*Lentinula edodes*), himematsutake (*Agaricus blazei*), enokitake (*Flammulina velutipes*), splitgill polypore (*Schizophyllum commune*), chaga (*Inonotus obliquus*), and witch's butter (*Tremella aurantia*).

While most medicinal mushrooms have been found to have few to no negative side effects, some may interact with your prescription medications or change the way your body responds to them. Always do your own research and consult your healthcare practitioner before adding therapeutic doses to your daily routine.

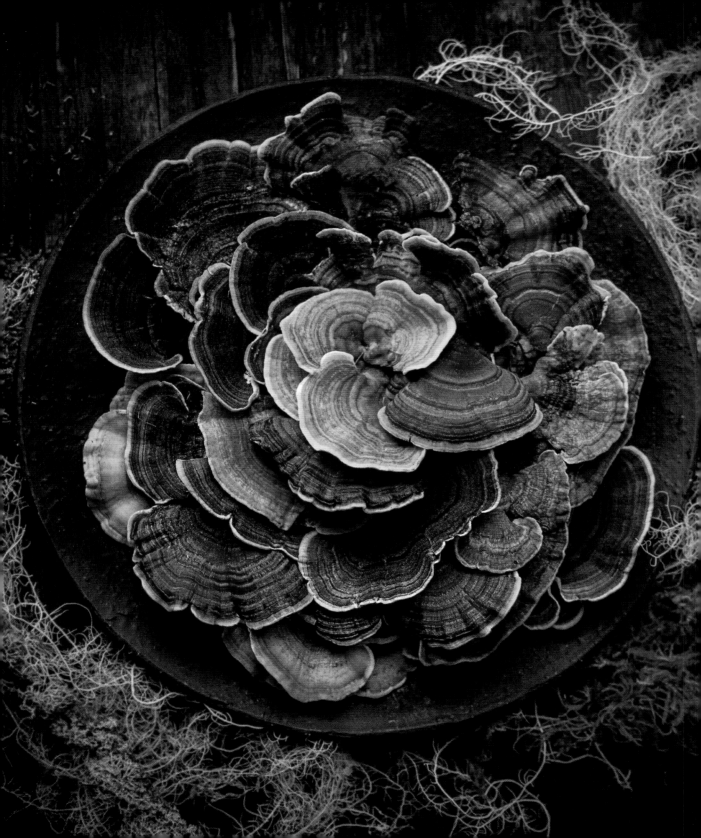

Turkey Tail

Trametes versicolor

Trametes versicolor is a medicinal shelf poly-pore fungus that grows on decaying wood. It's a fairly common sight in the forest or the woodpile. Sometimes colorful, sometimes subtle, its fan-like shape and autumnal hues can be reminiscent of a favorite Thanksgiving centerpiece's plumage. The multi-tier layers of this mushroom show off concentric bands of varying color, making it easier to catch than a holiday fowl.

This is quite a hardy species that can withstand being forgotten in the basket for a few days before it starts to decay. In fact, it will end up nicely dehydrating on its own without any extra effort when placed on your car's dashboard under the sun for a few days. However, throw it into the freezer after it has completely dried before storing in a glass jar in order to kill off any microscopic bugs or bacteria that want to make a snack out of your bounty.

Since the 1970s, turkey tail has been one of the most studied medicinal mushrooms in contemporary science. It is used in modern-day cancer treatments in the form of isolated polysaccharide-krestin (PSK) and polysaccharide peptide (PSP), and at one time, before taxol was discovered, it was the leading anti-cancer treatment. Extracts of this mushroom are also used in conjunction with certain chemotherapy treatment to help mitigate the negative effects of radiation therapy on the healthy cells in a cancer patient, while also apparently inducing direct cytotoxicity on tumor cells.

Not only medicinal, it makes a delightful tea and adds immune-boosting flavors to soups and broths, and it infuses well when cooking grains and legumes.

IDENTIFYING FEATURES: This thin and flexible, fan-shaped, multicolored polypore has a shelf-like appearance with a white underside

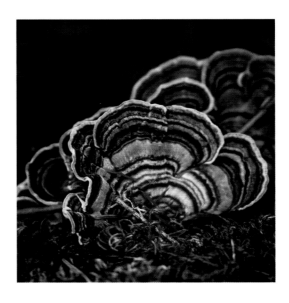

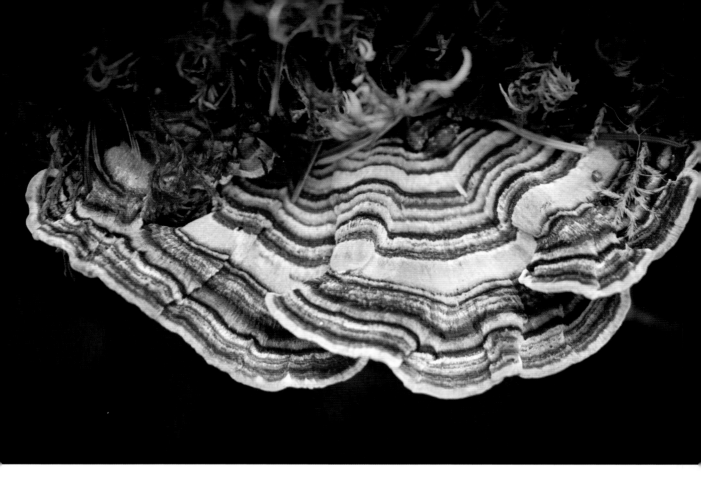

and tiny pores. The top has alternating zones of color that vary widely from tans, browns, oranges, blues, or grays and a velvet texture. Sometimes they can appear green on older specimens due to algal growth on their surfaces. The pore surface is bright white when fresh but can become gray, crumbly, and bug-infested as it ages. It has a distinctively earthy and musty yet pleasant aroma and a white spore print.

HOSTS & ENVIRONMENT: Usually found on decaying stumps, branches, and logs of hardwoods such as oak and tanoak, wide-spread across North America.

SEASON: Summer through fall. While this hardy annual species can be found dried up throughout the year still hanging on to their hosts, they're best harvested fresh after it rains, when they are plump and their undersides are still bright white.

MEDICINAL PROPERTIES: Known as *yun zhi* in traditional Chinese medicine, it has been used to treat infections and lung diseases

for hundreds of years. *Trametes versicolor* contains a polysaccharide compound known as PSK, which has been shown to have anti-cancer properties. This is a complex carbohydrate that has been used in cases of gastric, breast, colorectal, and lung cancer. Turkey tail is also known for its chemo-protective properties, which help protect the body during chemotherapy treatment.

For Western herbalists, it is an excellent mushroom used as an antifungal therapy for candida imbalance. This sounds counterintuitive, but mushrooms are, in fact, anti-fungal because they too are fighting for health and resources in the wild among thousands of other molds and fungi.

CULINARY NOTES: This isn't one you'd want to slice up and toss in the frying pan. However, this fungus has a deep, rich, earthy aroma that can be infused in soups, stocks, rice, grains, or legumes during cooking and then removed before serving. This infusion imparts not only its flavor but also the added immune-boosting benefits. It also makes a delicious tea alone or combined with other medicinal mushrooms or herbs, but be sure to simmer it for at least 20 to 30 minutes to effectively release its medicinal polysaccharides.

LOOK-ALIKE SPECIES: *Trametes betulina*, *T. hirsuta*, and *Stereum hirsutum* all have very similar shapes and sizes. None are toxic, but they do not have the same medicinal qualities as *Trametes versicolor*. To distinguish this fungus from a very common similar look-alike (the "false turkey tail" *Stereum hirsutum*), the underside of this fungus has a white porous surface rather than a tan or orange smooth surface. If you end up harvesting these instead, don't worry—they aren't toxic. It's more akin to eating cardboard-flavored fiber than anything else.

 CAUTIONS: None.

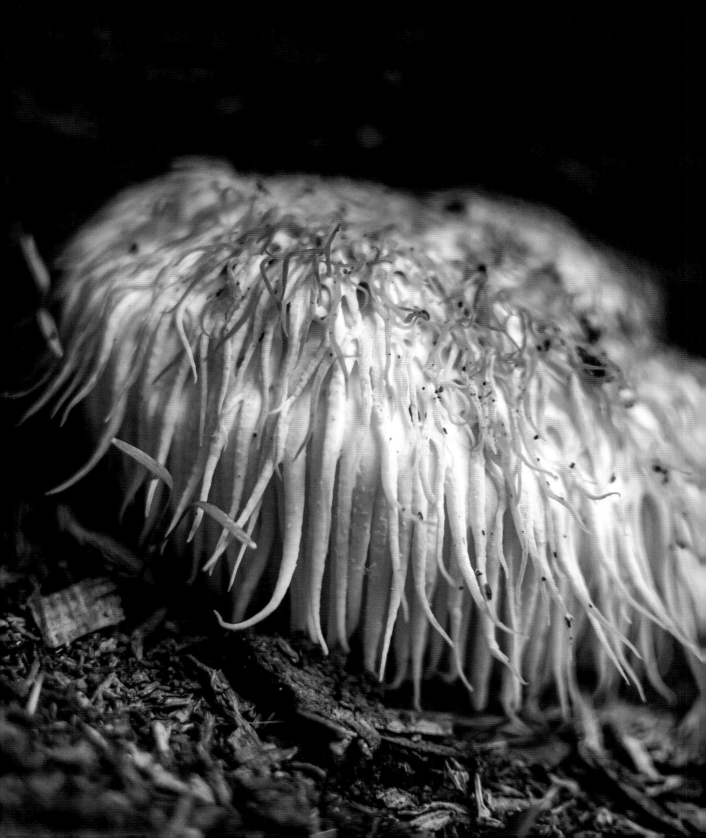

Lion's Mane

Hericium erinaceus, H. coralloides, H. americanum

Japanese mysticism tells us that this mushroom was responsible for keeping the spiritual mountain monks known as *Yamabushi* sustained. They restrained themselves from any indulgences through severe self-discipline, eating only from the land around them. They were thought to possess supernatural powers, which some suspect could be from the consumption of this mushroom. According to stories, they were able to regrow the mushroom by slicing it into thin pieces and inserting it into cut wedges of other trees, inoculating the new tree with the fungi and allowing for subsequent fruiting. The mushroom is known in Japan as *yamabushitake*, named after its physical resemblance to the traditional clothing of the mountain monks.

Although their ability to impart supernatural powers is only legend, the fungus may still be beneficial to the human body. It has gained the interest of contemporary medicine, with the latest evidence demonstrating that extracts of this mushroom benefit the nervous system. If that wasn't enough, it is also a prized culinary mushroom that some liken to the taste of seafood. With its meaty, crab-like flavor, it is a commonly eaten and commercially grown edible mushroom.

While lion's mane gets all the fame for its remarkable neurogenesis properties, its close relatives (*H. coralloides, H. americanum,* etc.) have also garnered the attention of researchers for their antioxidant and anti-aging potential. And again, this kin of lion's mane is also a tasty fungus fit for the table.

Hericium means "hedgehog," but it should not be confused with the "hedgehog mushroom," *Hydnum repandum,* another tasty, edible fungus. *Coralloides* means branched or coral-like.

IDENTIFYING FEATURES: The *Hericium* genus is rather distinct, with its pure white color and hanging icicle-shaped "teeth." Some are in one compact clump of long hanging

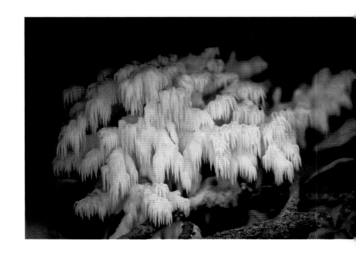

spines, as in true lion's mane, *Hericium erinaceus*; others are branched and forked with short spines coming from a single base, as in *H. coralloides,* the comb tooth or coral tooth fungus. The bear's head tooth fungus, *Hericium americanum*, is also branched and has longer teeth. As these fungi age, they turn off-white or brownish. All *Hericium* have white spore prints.

HOSTS & ENVIRONMENT: *Hericium* species are saprophytic, breaking down dead and dying hardwood trees, logs, and stumps, particularly oak, maple, walnut, and beech. They can also occasionally be found on still-living trees. This fungus is popular for home cultivators and can be grown on sawdust or outdoor logs.

SEASON: All *Hericium* species in North America are generally found in the fall, August through November, with *H. coralloides* appearing well into the spring season on the West Coast.

CULINARY NOTES: Many people liken this mushroom to seafood, specifically crab. It can be shredded and formed into "crab" cakes or sliced into thick steaks and grilled or sautéed with butter. Lion's mane can be added to other seafood dishes as well and absorb flavors with their sponge-like texture. This mushroom does well with a dry sauté to release its high water content and concentrate the flavors, adding the fat, such as butter or oil, after it begins to sear. It can also be roasted whole or as slices in the oven with a savory sauce. As a supplement, it is dehydrated and powdered and can be added to beverages such as lattes or smoothies.

NUTRITIONAL VALUES: Lion's mane contains 20 percent protein, 2.8 percent fat, and 70 percent carbohydrates. It is a good source of antioxidants and vitamins—notably folic acid, calcium, phosphorus, potassium, and magnesium.

MEDICINAL PROPERTIES: Lion's mane has been used in traditional Chinese medicine to benefit the heart, liver, spleen, lungs, and kidneys, and to promote digestion.

The polysaccharides in *Hericium erinaceus* have been studied for their effects on blood pressure, gastric ulcers, liver issues, diabetes, cholesterol, cancer, obesity, and neurodegenerative disease.

Current research shows promising results with depression, dementia, and Alzheimer's disease due to the presence of erinacine and hericenone compounds. These bioactive compounds potentially increase the neurogenesis of neurons in the brain and may repair neurological injury or trauma while also reducing depression and anxiety. The ability to stimulate the regeneration of neurons is a significant and unique function of this mushroom, and it has been shown to increase cognitive ability and enhance learning and recognition memory. Further research is warranted to determine how this mechanism works in the brain.

The related *H. coralloides* apparently also

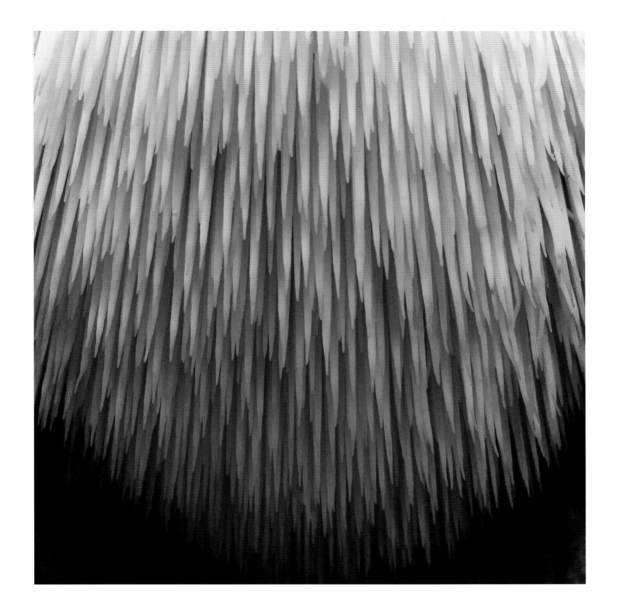

possesses comparable antioxidant and anti-aging bioactive compounds.

Among medicinal mushrooms, *H. erinaceus* contains the highest amount of lovastatin, a compound used to help support treatment of coronary disease by lowering cholesterol.

LOOK-ALIKE SPECIES: These tooth fungi are distinctive and have no toxic lookalikes. Always be completely certain of your identification before consuming a wild mushroom.

 CAUTIONS: None.

Cordyceps

Cordyceps militaris

The mushroom realm overall is a wonderland of interesting characters, fantastical colors and shapes, and unusual sights, but the fungus known as cordyceps is fit for a Hollywood horror.

This deadly parasitic fungus infects a living and mobile host through airborne spores. Its spores float through the air until they adhere to the exterior of an unsuspecting victim. As the fungus spreads and penetrates into the body of the host, it releases chemicals that alter the host's behavior, causing it to behave erratically or in a zombie-like fashion as it attempts to go on with its day-to-day business. This process is all in favor of the fungus' need to continue its lifecycle and reproduce. As the infection and mycelium spreads, the fungus is consuming the interior organs for nutrients and creating a fruiting body full of spores that erupt forcefully from the head, ready to infect the next passerby. Sound terrifying? Don't worry, as far as we know, cordyceps only infect insects.

The rare *Ophiocordyceps sinensis* parasitizes the larvae of specific moths in Tibet and is the source of the most valuable fungal medicine in the world. It has also been used as an aphrodisiac since 200 AD. While this fungus is deadly to its victims, it is consumed by humans mainly for medicinal purposes. The cultivated variety of *Cordyceps militaris* is used in modern times for athletic performance and stamina. In fact, it is farmed in mass quantities. But before the vegans out there stage a protest, no insects are used in the cultivation process; instead, it is grown on a plant-based substrate. Wild *Cordyceps militaris* and other similar parasitic species

can be found throughout North America, but it takes a careful and discriminating eye to find them.

IDENTIFYING FEATURES: *Cordyceps militaris*, one of the more common species found in North America, has a small 1- to 2-centimeter orange, speckled, yellowish club-shaped mushroom protruding from an insect cocoon, usually buried under the soil or decaying wood, either individually or in groups.

HOSTS & ENVIRONMENT: *C. militaris* is common across the northern hemisphere during a region's rainy season, but due to its size, it can be difficult to find. It infects lepidopteran (butterfly and moth) species that pupate underground.

SEASON: July through October on the East Coast, but rare on the West Coast and California.

CULINARY NOTES: It would be unrealistic to collect these in the wild for culinary use because of their tiny size and sparse numbers, but since these are a popular cultivated species, it is possible to find them either dehydrated or fresh from growers. The bright orange noodle-like fruiting bodies of fresh cordyceps can be added to salads, or sautéed with butter or oil and added to pasta. There is a bit of sweetness to them, which is why I've often used them dried and coated in chocolate for a unique and unusual presentation.

NUTRITIONAL VALUES: Cultivated cordyceps mushrooms contain essential amino acids, vitamins such as B1, B2, B12, and K, carbohydrates such as monosaccharide, oligosaccharides, and various medicinally important polysaccharides, proteins, sterols, nucleosides, and other trace elements.

MEDICINAL PROPERTIES: *Cordyceps sinensis* has a long history of use as a lung and kidney tonic and for the treatment of chronic bronchitis, asthma, tuberculosis, and other diseases of the respiratory system. It has been used in Nepal for headache, diarrhea, cough, and rheumatism.

Cordycepin and adenosine are two of the bioactive components in cordyceps. This mushroom has been used by long distance runners to enhance their performance through respiratory effectiveness and increasing oxygen consumption, which helps to improve stamina and reduce fatigue. Studies have found it to be more effective after long-term use.

It also has shown antitumor, anti-inflammatory, and antimicrobial activity. It has been used as a tonic for the hepatic, renal, cardiovascular, respiratory, nervous, sexual, and immunological systems.

There are some age-old claims about this mushroom's success as an aphrodisiac. In a human trial on *Cordyceps sinensis*, it increased fertility and desire among both men and women.

LOOK-ALIKE SPECIES: In the wild, cordyceps can look similar to a variety of small fungi such as club coral and fairy club fungi (*Clavaria* and similar).

⚠ CAUTIONS: There is suspicion that cordyceps may cause slow blood clotting or cause complications for individuals with bleeding disorders. Avoid use before surgery.

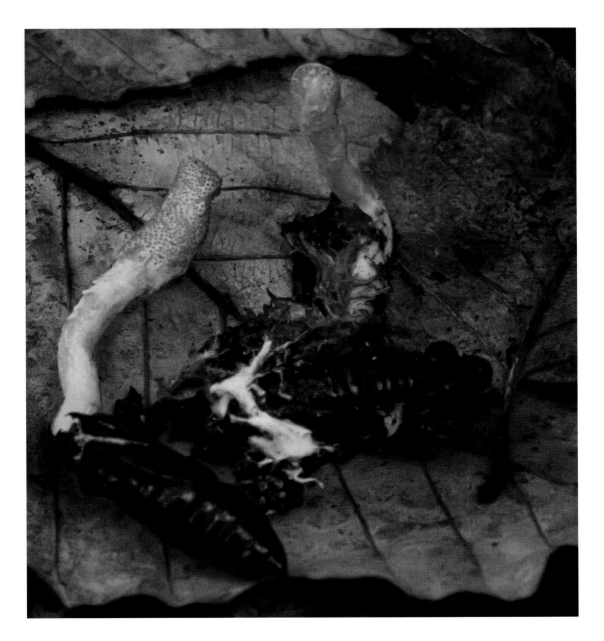

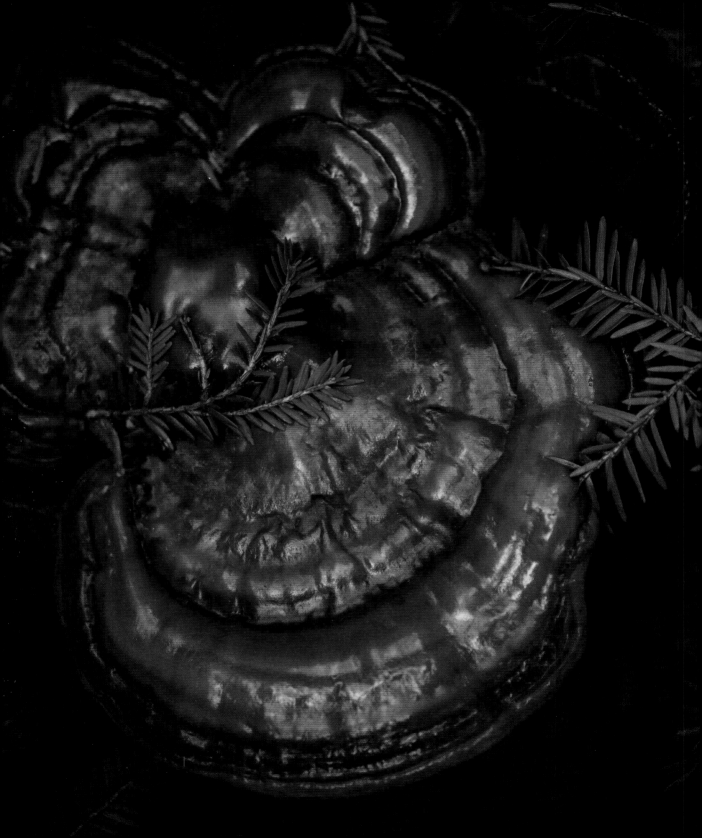

Reishi

Ganoderma lucidum, G. tsugae, G. oregonense

Associated with the divine and revered as the "mushroom of immortality," Reishi or lingzhi (*Ganoderma lucidum*) has been celebrated and used for millennia by Chinese Buddhists, in Japan, and in other Asian countries in their quest for health of the body and mind. Once only available to the wealthy and nobility in Asia, it was revered for its spiritual potency and as a symbol of success, vital energy, and longevity. It was even said that it would help its consumer eventually become a celestial being. Nearly considered a panacea, this mushroom is believed to address a range of issues, from cardiac function to anti-aging to memory enhancement. Other purported uses are for easing the mind and alleviating stress, ending dizziness, slowing heart palpitations, and relieving shortness of breath.

Since early times, reishi was a culturally significant fungus and appeared in ancient art, medicinal, and spiritual texts starting around 20 AD. It is still revered and used today, thanks to large-scale cultivation practices, curious researchers, and clever marketing. Despite centuries of anecdotal evidence supporting its medicinal uses, it hasn't been until the last several decades that this popular mushroom has begun to garner the attention of the pharmaceutical industry.

Much like all other mushrooms, reishi contains bioactive polysaccharides that are known to support the immune system, helping the body fight off infection. It is used by modern herbalists as an "adaptogen," helping to mitigate the effects of long-term stress on the body—a common occurrence in today's fast-paced world. Additionally, cosmetic companies are now adding this fungus to anti-aging serums with the intention of infusing

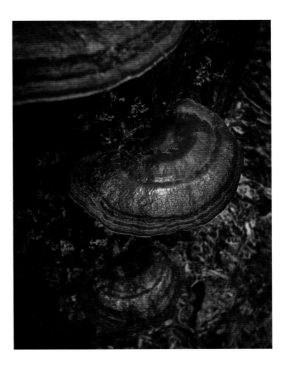

some of its "immortality" qualities. Further research with human trials is warranted for the many uses of *Ganoderma lucidum*.

If you're not planning a trip to Asia soon, don't fret; the elusive and prized fungi of the *Ganoderma* species are found worldwide. North American equivalents of *lingzhi* are *G. tsugae* and *G. oregonense*, which are found throughout the country on dead and dying hemlock and conifer trees.

IDENTIFYING FEATURES: This mushroom is a fan-shaped polypore with a reddish-brown, shiny surface appearing varnished (*G. oregonense*), sometimes with a light brown, orangish or white band at the margin (*G. tsugae*). In age it ends up looking dusty from spores but can easily be wiped clean. The underside pore surface is off-white, but turns brown when bruised and aged and has white flesh when cut open. At times, the fan-shaped polypore grows from a vertical stalk, which occurs more often in cultivation due to CO2 levels.

HOSTS & ENVIRONMENT: *Ganoderma tsugae*, the "hemlock varnish shelf," is a white rot fungus growing on dead and dying hemlock trees and stumps throughout the eastern Midwest ranges as well as in Arizona. *Ganoderma oregonense* grows on conifers in the Pacific Northwest and California.

SEASON: *Ganoderma tsugae* is found May through November and *G. oregonense* is found fall through spring.

CULINARY NOTES: Reishi's woody and tough nature, coupled with its distinct bitterness, can make it challenging to use directly as food. However, it can be extracted, dried, and powdered, or simply cut into small slices and dehydrated for teas and medicinal use. Be sure to dehydrate completely for proper storage.

NUTRITIONAL VALUES: Reishi contain up to 40 percent protein, 8 percent fat, 28 percent carbohydrates, and 32 percent fiber. However, these qualities are only bioavailable when consuming the mushroom (powdered) as opposed to extracting its properties, as in making tea.

MEDICINAL PROPERTIES: Reishi has been shown in clinical research to have positive health benefits. These include anticancer effects, regulation of blood glucose, and protection of the liver and gastrointestinal system. Reishi also has antioxidant, antibacterial, and antiviral qualities.

Reishi helps to stimulate the body's natural immune response in many cases to help ward off disease—yet in cases of autoimmune diseases, such as arthritis and allergies, the fungus can mitigate the body's overacting immune system. This modulation activity of medicinal mushrooms is unique and not a quality found in pharmaceutical drugs. Reishi also contains compounds that are used for chronic hepatitis, asthma, bronchitis, nephritis, hypertension, arthritis, diabetes, gastric ulcers, insomnia, and cancer.

Long used due its reputation as an herb of longevity, reishi has been studied for its potential anti-aging properties. It contains antioxidants, which combat oxidative stress and the accumulation of free radicals—two key factors in aging. Longevity associated with reishi is thought to be due to the presence of a specific polysaccharide unique to this mushroom, promoting antioxidation, immunomodulation, and anti-neurodegeneration.

While most research has been done on *G. lucidum*, the North American species *G. oregonense* and *G. tsugae* can also be used for their similar medicinal properties.

Ganoderma resinaceum has been shown to reduce viral infection in bees, a potential aid in reversing the population decline of honey bees.

LOOK-ALIKE SPECIES: Reishi might be confused with other shelf polypores such as *Fomitopsis pinicola* (red-belted conk) and *Ganoderma* species such as *G. polychromum*. That said, the varnished red-brown top is often distinctive.

⚠ CAUTIONS: None. There are no poisonous reishi look-alikes.

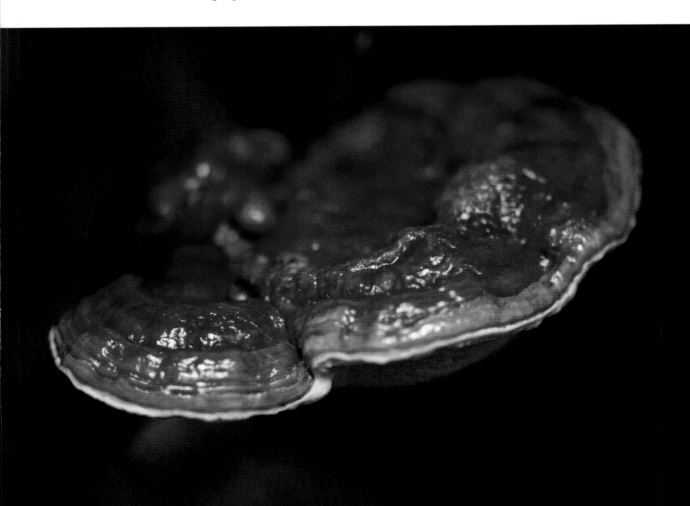

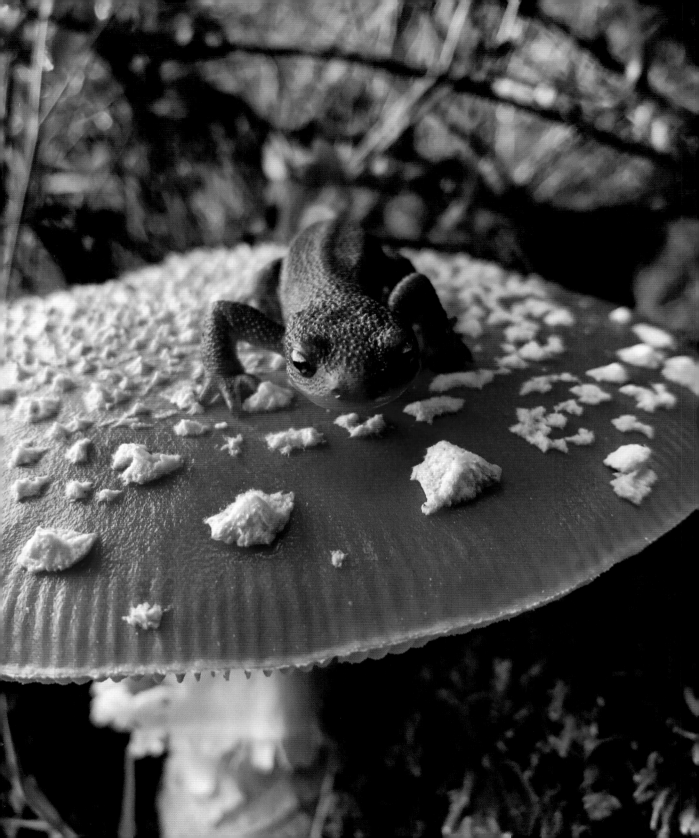

Fly Agaric

Amanita muscaria

No other mushroom has captured the curiosity of humankind more than the *Amanita muscaria*, representing nearly everything that a mushroom can be—toxic, medicinal, hallucinogenic, and edible all in one. With its bright red and contrasting white speckled cap, this strikingly iconic mushroom has long been a part of human history and culture.

This is the enchanting mushroom of fairytales, folklore, and shamanism. With its vibrant red-and-white speckled cap, it is the one that is most associated with the mushroom kingdom and deadly toadstools, despite not being as toxic as its inconspicuously deadly relatives, the destroying angel and the death cap. It is rich with folklore worldwide, as it has been revered or feared throughout its long history.

The Latin *muscaria* references the word "musca," meaning "fly." This name came from its use in Europe as a fly poison. To keep insects controlled, pieces of this mushroom were placed into a dish of milk, creating a trap that would intoxicate and drown the flies.

The fly agaric contains one of the oldest used intoxicants, likely imbibed in ancient times by shamans for religious purposes. Some claim that it was the basis of soma, a drink of the gods, referenced in ancient Hindu texts. Intoxication from this mushroom can produce hallucinations, dizziness, sleepiness, and an altered sense of size of self or objects—likely an inspiration for Alice's descent into Wonderland. Consuming large quantities can cause complications—not necessarily lethal, but special care would be required. It is not recommended for experimentation. Because of its deliriant nature, it does not always offer a good experience.

Most guide books list it as being toxic and poisonous, and many assume that, because of this designation, it is also deadly. While it is not necessarily deadly, it is a mushroom that, much like its deadly cousins, demands respect. If properly detoxed, it can yield an edible mushroom, a risky practice among adventurous mycophagists.

IDENTIFYING FEATURES: The cap of this mushroom varies in shades of red to reddish orange. In age or when exposed to sunlight, it can fade to orangish yellow, or dull pink colors. It will almost always retain a white to yellowish warted texture across the cap, unless the texture has been rubbed off or disturbed by rain or debris. This texture is created from the expanding cap under the universal veil,

breaking apart into warts as the mushroom matures.

The gills are white with white spores. The stipe is thick, white, and ends in a bulbous base encircled with textured rings, usually hidden under the duff. In the Rocky Mountains and on the West Coast, *A. muscaria* var. *flavivolvata* is the regional species and *A. muscaria* var. *guessowii* will tend toward the yellow spectrum. An all-white variety also exists.

HOSTS & ENVIRONMENT: *Amanita muscaria* is associated with a variety of conifer trees, including birch, fir, and pine, and sometimes with hardwoods, such as oak and poplar. It is widespread across North America, with different varieties appearing in specific regions.

SEASON: In most of North America, it can be found from July to November. On the West Coast, it persists through winter and even into early spring months.

CULINARY NOTES: Often categorized as a toxic mushroom, it is not commonly regarded as having any culinary use. Eating this mushroom raw causes nausea and hallucinations. However, according to anecdotal and even controversial evidence, with proper preparations, it can be detoxified and cooked for a meal. It has a mild and nutty taste, similar to other edible Amanitas.

The mushroom needs to be boiled in a large amount of water for at least 15 minutes, and some recommend adding a little salt and vinegar to help extract the toxins. Discard the cooking water and add fresh water, bringing it back to a boil and cooking for another 5 to 10 minutes. After this process, the mushrooms can be prepared like most other mushrooms. Eating *Amanita* mushrooms is not recommended for beginners and should not be experimented with.

NUTRITIONAL VALUES: The fly agaric has not been evaluated extensively for its nutritional content, as it is generally not recommended for consumption. However, it is likely that this mushroom contains many similar nutrients to other mushrooms, including protein, carbohydrates, and fiber, while being low in fat. It is likely also a source of vitamins and minerals, such as ergosterol, the precursor to vitamin D.

MEDICINAL PROPERTIES: Most accounts of consuming fly agaric are connected to medicinal and spiritual uses. Long used by shamans in many cultures around the world, it has been celebrated yet feared for its role in mysticism and its cultural significance as an intoxicant and entheogen. Tribes in eastern Siberia are known to eat fly agaric as a medicine rather than as a food. American Indians used the mushroom to treat infections, induce prophecies, and enhance spiritual journeys.

Used topically, *Amanita muscaria* extracts have been used by herbalists to reduce pain and are said to be anti-inflammatory. This

topical formula is prepared by chopping the fruiting bodies into pieces, covering them in high-proof alcohol, and allowing to steep for several weeks before straining and reserving the liquid. The liquid extract is then applied directly to relieve pain for conditions such as sciatica and joint pain.

Some of the bioactive compounds in this mushroom, such as muscimol, have been shown to possess significant protective neurological effects. Muscimol has been shown to suppress tremors in patients with Parkinson's disease without any impairment of speech or coordination. It has also been shown to be an effective antioxidant, reducing free radicals. The fly agaric has also been studied for having potential anti-tumor activity.

LOOK-ALIKE SPECIES: There are several variations of *Amanita muscaria*, ranging from the classic bright red to orange, yellow and even white, such as the *Amanita muscaria* var. *guessowii* found on the East Coast. *Russula*s that are bright red with their contrasting white stalk can seem similar to an untrained eye. Be sure to look for all identifying features. *Amanita gemmata* and *A. pantherina* are other *Amanita* species that have similar whitish speckles on a colored cap.

⚠️ **CAUTIONS:** Muscarine was the first identified mushroom toxin, but now *A. muscaria* is known to have ibotenic acid and muscimol, which are thought to be responsible for its toxic qualities. Fatalities from *Amanita muscaria* are extremely rare. However, consuming *Amanita muscaria* without harm is anecdotal and not without risk of improper preparation. These mushrooms can cause central nervous depression, coma, hysteria, and seizures in large doses.

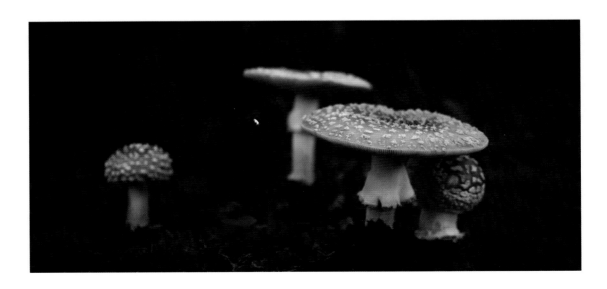

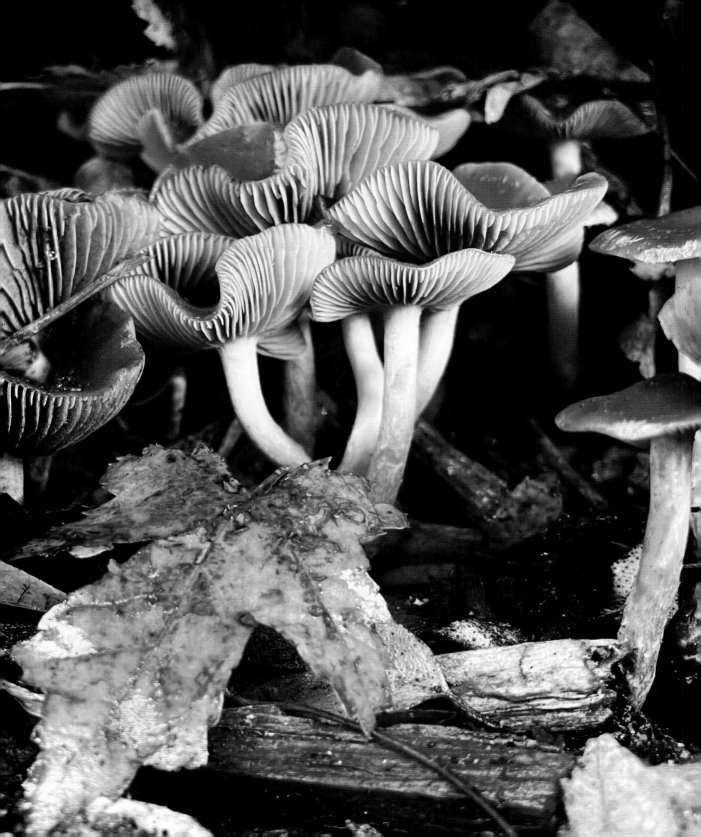

Magic Mushrooms

Psilocybe cyanescens, P. alleni, P. azurescens, P. semilanceata, etc.

In the human quest for enlightenment, prophecy, and healing, hallucinogenic mushrooms are thought to have been used by cultures around the world for millennia, appearing in ritualistic ceremonies, ancient art, and legends. The ability of these mushrooms to help us see our world from a childlike perspective, to rekindle the awe and wonder of life itself, is very unique.

Magic mushrooms, but perhaps more importantly, the compound psilocybin that they contain, are currently experiencing a renaissance in contemporary science and media after they were first brought to light in the modern world in the 1960s, prompting an entire art and cultural movement. Curious folk sought out this mysterious mushroom in Mexico. Some hoped for visions and otherworldly experiences that would lead them to enlightenment, but for some, the hunt was just for a good time.

People have also sought out this mushroom as a combatant to depression and anxiety. Researchers have explored psilocybin's ability to stimulate serotonin receptors in the brain and subsequently produce serotonin—the happiness chemical. Research has also explored psilocybin as an effective treatment for patients suffering from terminal diseases. It helps to ease their psychological and existential distress and pain. In 2018, the FDA declared that psilocybin is a "breakthrough therapy for treatment-resistant depression," despite its categorization still as a Schedule I drug. Other psychological conditions that have been addressed with the use of psilocybin are obsessive compulsive disorder, post-traumatic stress disorder, and addiction to alcohol and nicotine.

When consuming this mushroom, the user can experience a combination of somatic and psychotherapeutic effects for around four hours, with feelings of ineffability, compassion, empathy, and altered perceptions. However, not every experience is a good one, and some people have frightening or disturbing visions. While some say there is always something to be learned or gained from a trip, good or bad, making a few conscious preparations beforehand can be helpful. Attention to what is known as "set and setting" is crucial to a positive trip. This means having a trusted, safe and comfortable space along with a positive mindset and outlook.

IDENTIFYING FEATURES: *Psilocybe* mushrooms are small, nondescript mushrooms that are often overlooked. *Psilocybe cyanescens* has a smooth, orange-brown, wavy-margined

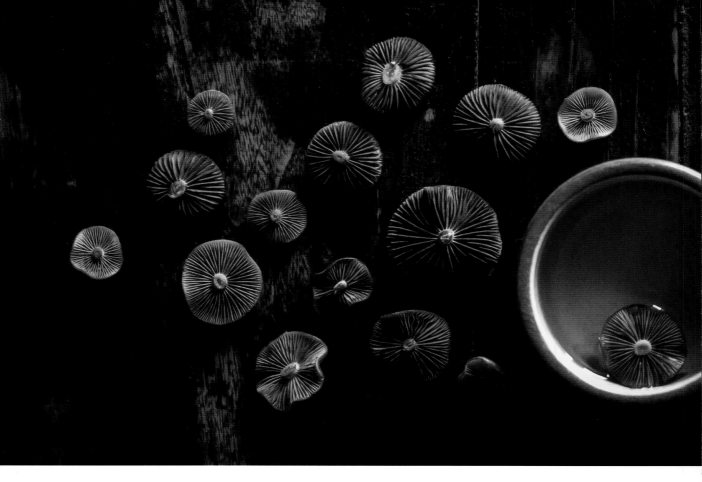

cap, brown gills that darken over time with a bright contrasting whitish stipe, and a fibrous partial veil that disappears as it matures. Their unique characteristic is that, when bruised, their flesh turns blue or blue-green and will have a dark purple brown spore print. *Psilocybe cubensis* is the most commonly cultivated species.

HOSTS & ENVIRONMENT: Many of these species are widespread, some specific to region, but they're concentrated in eastern and western regions of North America, particularly Mexico, Central America, and the Pacific Northwest. They are often found in disturbed urban areas such as landscaping, particularly in wood chips and grassy areas.

SEASON: Fall throughout winter on the West Coast.

CULINARY NOTES: While most culinary mushrooms are revered for their flavor, magic mushrooms are used in a culinary sense to mask their deeply earthy, bitter, and sometimes unpleasant flavors. It is commonly

extracted in hot water as a tea with lemon and other aromatics, such as cinnamon or ginger, then sweetened with honey. The addition of lemon or other citrus expedites the absorption as the acid breaks down the compounds before they enter the stomach, increasing the intensity but also shortening the experience. It also helps to ease any nausea. Magic mushrooms are also often powdered and blended into chocolate bars, truffles, or cacao beverages.

NUTRITIONAL VALUES: *Psilocybe* mushrooms have not been evaluated extensively for their nutritional content. However, it is likely that these mushrooms contain many similar nutrients to other mushrooms, including a moderate percentage of protein, high carbohydrates, and fiber, while being low in fat as well as a source of vitamins and minerals.

MEDICINAL PROPERTIES: Despite their history of recreational use, contemporary research is exploring the many medicinal properties of *psilocybin*, the bioactive compound in these mushrooms, for use in mental health conditions. With groundbreaking research and clinical trials, studies are confirming that participants can find relief from treatment-resistant depression, PTSD, anxiety, and nicotine and alcohol addiction, while also stimulating neurogenesis and enhancing creativity. Studies showed an increase in feelings of overall empathy, interconnectedness, and well-being in participants.

Psilocybin-containing mushrooms have been used by those who suffer from cluster migraine headaches with lasting efficacy.

"Microdosing" on psychedelics is an increasingly popular practice—that is, using a subperceptual dose that does not produce hallucinations but helps to increase divergent thinking, connecting ideas, and problem solving.

LOOK-ALIKE SPECIES: *Psilocybe* species can look very similar to many other little brown mushrooms. Most are nontoxic, or may cause mild poisoning, but it is imperative that you not confuse them for the deadly *Galerina marginata*.

⚠ **CAUTIONS:** Hallucinations and out-of-body sensations can result from consuming these mushrooms. Some people experience nausea and gastrointestinal distress from consuming *Psilocybe*. In a medicinal and therapeutic sense, psilocybin-containing mushrooms should be used responsibly in a safe and controlled environment. It should also be noted that despite findings in current research, they are still classified as a Schedule I drug in the United States and are illegal to possess and sell.

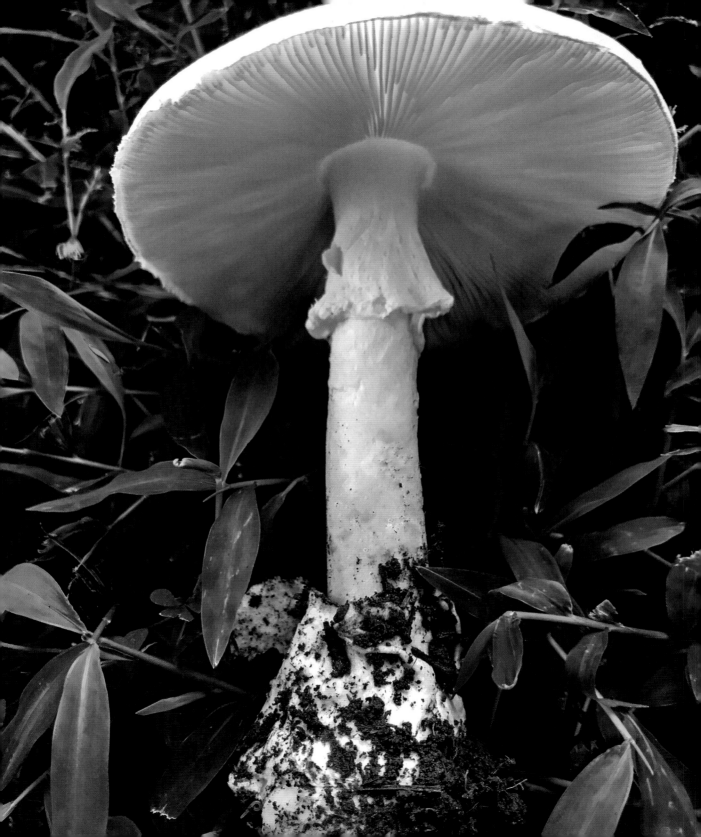

Toxic Mushrooms

When it comes to studying mushroom identification, many mycophiles would recommend that you learn the poisonous ones first. By familiarizing yourself with toxic mushrooms, you'll learn what to avoid and how to spot them in case one accidentally finds its way into your basket. Very few fungi end up being deadly, but many more will make you so sick that you'll feel like death may actually be lurking around the corner. These are just a few easily mistaken mushrooms that you may encounter.

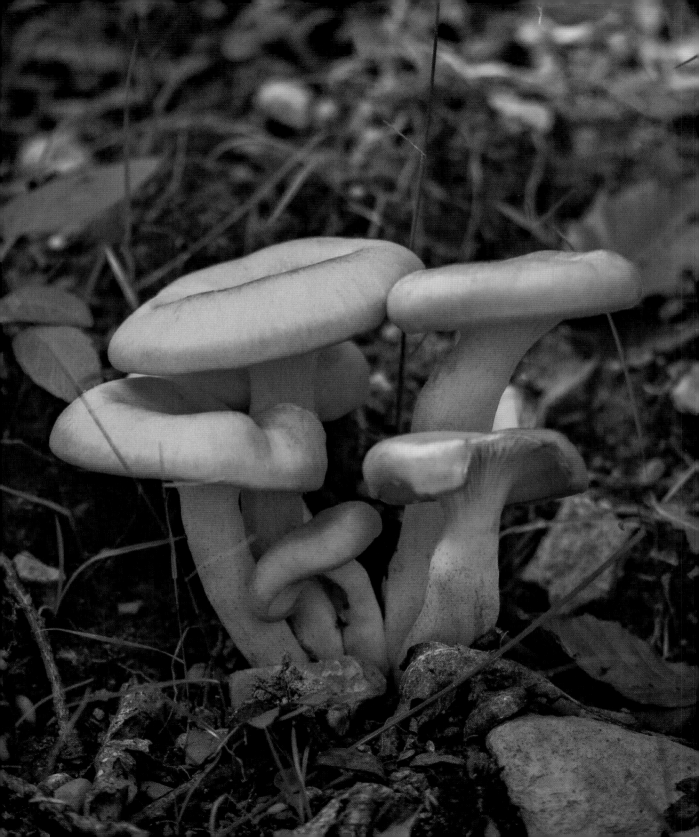

Jack o' Lantern

Omphalotus illudens & O. olivascens

Named after its purported bioluminescent quality, the jack o' lantern is a toxic mushroom that glows faintly in the dark. Unfortunately, it is too faint to light your way in the forest after sunset—you'll need a prime specimen, a very dark room, and adjusted eyes in order to see them. Some enthusiasts even claim this fact to be a tall tale, never able to produce the effect to prove its accuracy, while others claim to have photos to back up their stories. True or not, the jack o' lantern is not the only bioluminescent mushroom in the kingdom; other species, mostly found in the tropics, produce a much more significant glowing effect. This biological feature is similar to the glow of fireflies and has likely evolved to attract insects in order to spread their spores.

Because of its bright color, this orange-hued

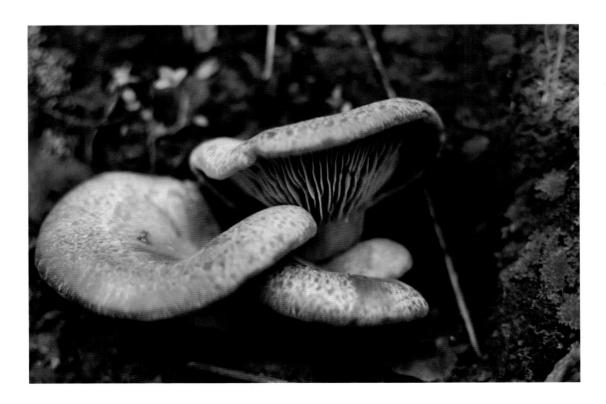

fungus is often mistaken for the edible chanterelle. Although not deadly poisonous like some other toxic mushrooms, it can cause severe weakness, dizziness, nausea, vomiting, and diarrhea, but recovery is expected with sufficient fluids.

While it has no place at the table, it can be used as an excellent dye for fabric and yarn. Despite its natural orange color, it results in either a dark violet or dark green dye (depending on the addition of a mordant) that is coveted by many natural dyers worldwide.

IDENTIFYING FEATURES: Usually found in large, dense clusters or bouquets, the *Omphalotus* species ranges from yellowish-orange to dark ochre or brown in age, with gills. *Omphalotus olivascens*, as the name implies, has an olive hue.

HOSTS & ENVIRONMENT: *Omphalotus* is a saprophytic white-rot fungus, decomposing dying and dead hardwoods, particularly oaks.

SEASON: The East Coast species, *Omphalotus illudens*, can be found July through November, while *O. olivascens* on the West Coast commonly appears in late fall to midwinter.

LOOK-ALIKE SPECIES: Easily confused for chanterelles, the *Omphalotus* species will have true gills rather than the false gills or ridges of the chanterelle.

TOXICITY: No species of *Omphalotus* is lethal; however, it can cause severe gastrointestinal distress due to the presence of sesquiterpenes known as illudins.

'Webcaps

Cortinarius species

With their delicate, cobwebby veil covering the immature gills, the vast genus of *Cortinarius* (also known as webcaps) is a beautiful and diverse group of mushrooms with a spectrum of colors, textures, scents, and sizes. The characteristic "cortina," which means "curtain," covers their developing gills, protecting them until they reach maturity. As the largest genus of gilled mushrooms, many species are still undescribed. A majority of them are considered toxic, with a few being potentially lethal.

Many species in this genus are poisonous and can be difficult to accurately identify; they are not worth experimenting with for edibility. The symptoms of poisoning also may not appear until three to fourteen days after ingestion, delaying necessary treatment.

Only a few species of *Cortinarius* are eaten, although they are not very desirable. The *Cortinarius casperatus*, also known as the gypsy mushroom, is the most commonly consumed species and was only recently moved to the *Cortinarius* genus after DNA analysis.

Despite toxicity in a few species, several *Cortinarius* species have been studied for medicinal uses. *Cortinarius sanguineus*, *C. collinitus*, *C. elatior*, *C. turmalis*, and *C. latus*, among others, show inhibition against sarcoma-180, suggesting anti-tumor properties. Other research suggests antimalarial and antimicrobial activity.

Several species of webcaps are also used as a fabric or yarn dye, especially the red-hued *Cortinarius sanguineus*, which results in vibrant orange, red, and purple colors.

IDENTIFYING FEATURES: The one feature that brings all of these species together is their unique "cortina"-like veil. It is a cobweb or thread-like membrane that covers the gills when they are young and still developing. This important identification feature is likely to disappear over time, but as the mushroom ages, the rust-colored spores generally stain the gills or surfaces underneath. This makes spore print an important part of identification for the *Cortinarius*; the spores are within a range of rust, ochre, or bright-orange colors.

HOSTS & ENVIRONMENT: *Cortinarius* are mycorrhizal, forming important relationships with many different trees in forests worldwide.

SEASON: Various species of *Cortinarius* can be found year-round across North America.

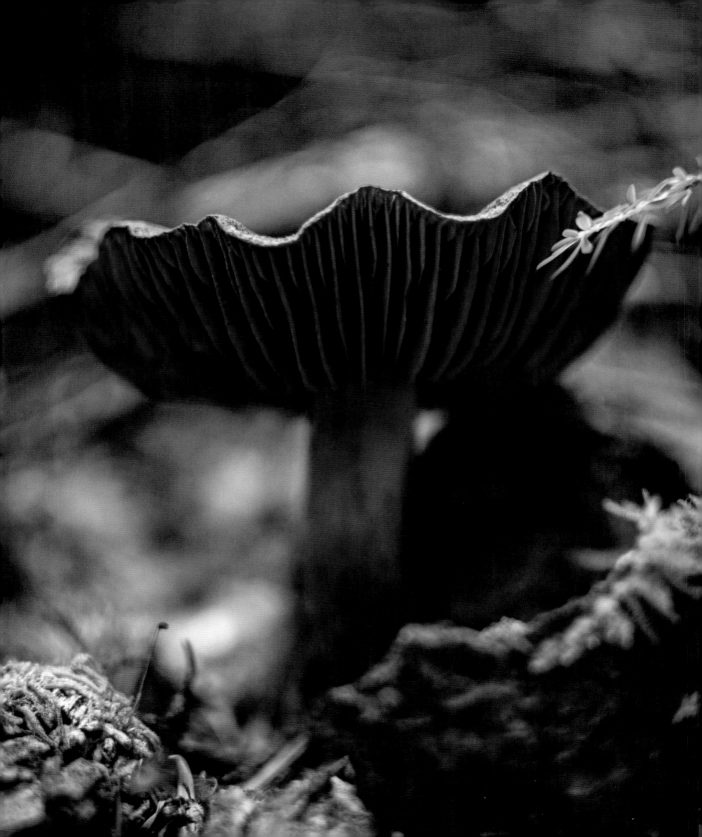

LOOK-ALIKE SPECIES: Edible species of other genera can be mistaken for *Cortinarius*. For example, a purple species of *Cortinarius* is sometimes mistaken for edible wood blewit *Clitocybe nuda*. Likewise, the honey mushroom *Armillaria* species also bears resemblance to some *Cortinarius* mushrooms. Check for spore color and other identifying features.

TOXICITY: Many species are toxic and can cause gastrointestinal upset, while *Cortinarius rubellus*, the deadly webcap, causes irreversible kidney damage that can lead to death due to the presence of a compound known as orellanine.

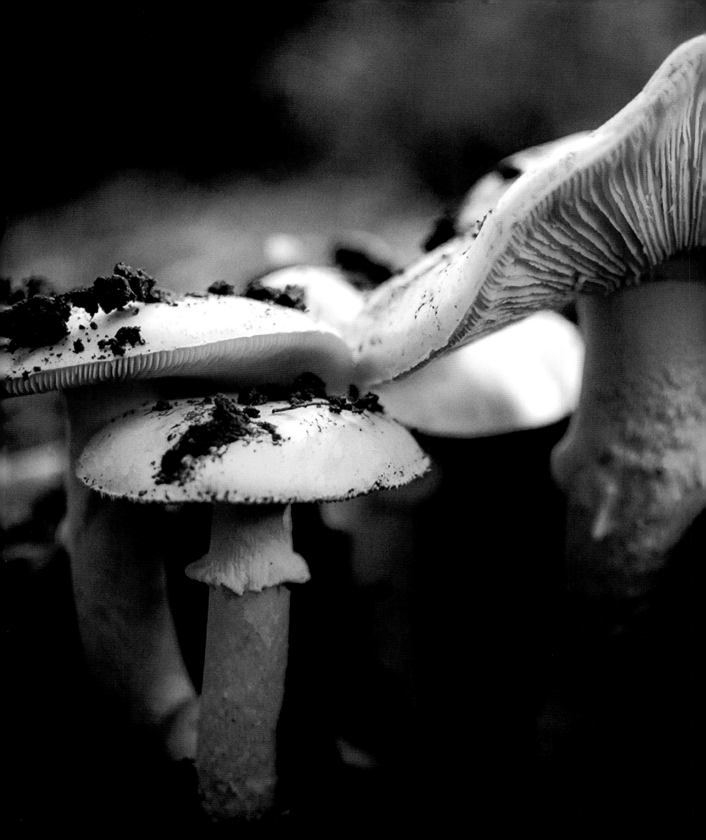

Destroying Angel

Amanita bisporigera & A. ocreata

Tall, elegant, and strikingly pure white, this alluring well-dressed beauty is known as the Destroying Angel or the Angel of Death, a haunting specter of the forest that reminds us humans of the unforgiving power of nature and our mortality. It reminds us to slow down, pay attention to details, and be present in our forest wandering. One careless and hasty addition to the forager's basket can mean life or death for the amateur hunter (or even the careless expert). It can easily be mistaken for some of the riskier edible mushrooms in the same *Amanita* genus, such as *A. velosa*. However, the Destroying Angel mushrooms are not toxic to touch or handle briefly; it can only harm you if it is consumed, but awareness is still warranted.

Two similar species can be found across the country, with *Amanita bisporigera* on the East Coast and *Amanita ocreata* on the West Coast, keeping mushroom hunters on either end of the continent wary of this ghastly fungus. Consuming even half of a fruiting body is enough for a lethal dose of amatoxins, the toxic compounds responsible for liver failure.

To a newcomer, these all-white mushrooms can appear to look just like the ones found at the supermarket, but after careful observations and taking the time to understand the discrepancies, correct identification can be learned. While some mushrooms in the *Amanita* genus can be cooked or boiled with a change of water and rendered edible (such as the *Amanita muscaria*), amatoxins are NOT destroyed or rendered edible by heat. Do not experiment.

IDENTFYING FEATURES: Ranging from medium to large, these mushrooms are nearly pure white, sometimes turning light tan as they age (aiding to challenges in misidentification). A membranous annulus or "skirt" under the cap is a typical *Amanita* feature that is distinct in these species.

HOSTS & ENVIRONMENT: The *Amanita* genus is mycorrhizal. *Amanita bisporigera* is widely found and is common in mixed coniferous and deciduous forests on the East Coast. *Amanita ocreata*, however, on the West Coast, is associated with oaks, especially the coast live oak.

SEASON: *Amanita bisporigera* is common in July through October. *A. ocreata* fruits at the same time in the spring as other edible Amanitas such as *A. velosa* and *A. vernicoccora*.

LOOK-ALIKE SPECIES: The destroying angel can look nearly identical to edible *Amanita* species such as *Amanita virosa* (the European Destroying Angel), *Amanita velosa*, and *Amanita vernicoccora*, all of which are risky edibles with many variations in identifying features. Use a proper field guide or confirmation from an expert.

TOXICITY: The destroying angel contains the same toxins as the death cap—amatoxins, phallotoxins, and virotoxins, which are not destroyed by heat and are deadly poisonous. The mushroom is fatal when consumed in sufficient quantities, although it is not toxic to touch or handle briefly.

Death Cap

Amanita phalloides

As its name would suggest, this fungus is one of the deadliest mushrooms and is responsible for the majority of deaths caused by mushroom poisoning. It has made its way around the globe, earning its status as possibly the only invasive ectomycorrhizal fungus. Originating from Europe and Scandinavia, the death cap, *Amanita phalloides*, came to California through the introduction of the Cork Oak used to make corks for the wine industry. It has since naturalized to the native and exotic species in North America as well as every other continent besides Antarctica.

The *Amanita* genus of mushrooms should not be approached casually (see note on page 137). It contains both deadly varieties, like the destroying angel and the death cap, as well as some of the tastiest, such as the coccora (*A. calyptroderma*) and velosa (*A. velosa*). This spectrum of toxicity within the genus means that it can be easy to misidentify the mushrooms; just one wrong identification while foraging could result in the end of the road.

The taste of death cap mushrooms is reported to be misleadingly pleasant. Signs of poisoning, such as gastrointestinal distress, may not even appear until after 6 to 24 hours of ingestion. Deceptively, these symptoms will seem to disappear during a brief phase of remission, in which the person may believe they only suffered from typical food poisoning, ultimately leading to progressive liver failure and death within 3 to 5 days.

IDENTIFYING FEATURES: *Amanita phalloides* is an inconspicuous and drably colored mushroom, often with fine streaks on the cap. It has a variable greenish, gray to yellowish cap and white to creamy colored gills. Some have reported collecting nearly all-white specimens. The spores and stalk are white with a membranous partial veil, protruding from a white or yellowish volva.

HOSTS & ENVIRONMENT: The *Amanita* genus is mycorrhizal. *Amanita phalloides* is found with hardwoods, including oaks, birch, and non-native species when it has been introduced to a new location.

SEASON: *Amanita phalloides* is common during summer through fall in most areas across North America, but it can be found sporadically throughout the year in various areas.

LOOK-ALIKE SPECIES: Other *Amanita* species, such as *Amanita vernicoccora*,

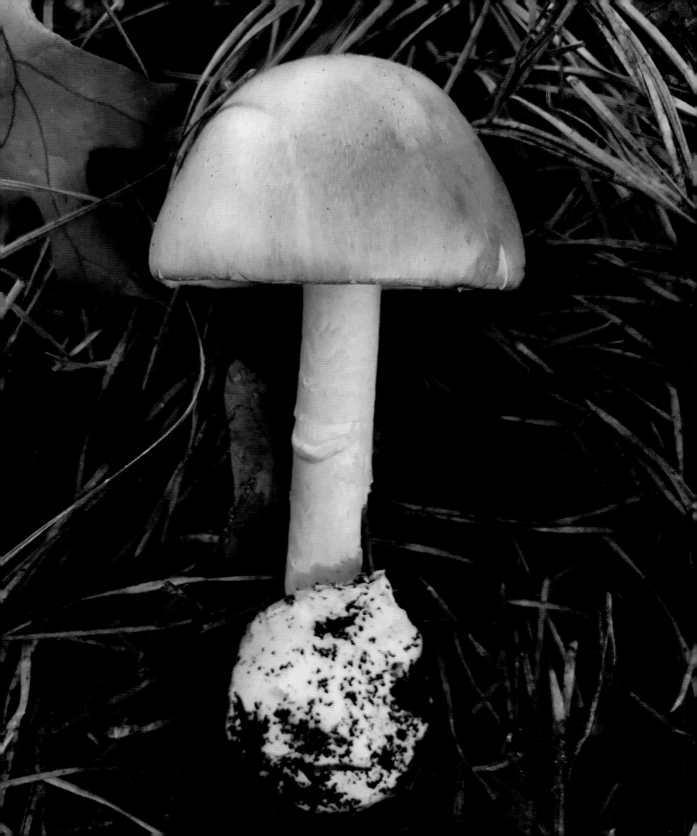

A. cochiseana, and *A. velosa*, are commonly sought-after culinary mushrooms. These are risky mushrooms for beginning mushroom foragers and should be confirmed by an expert.

TOXICITY: *Amanita phalloides* contains amatoxins, phallotoxins, and virotoxins, the most deadly mushroom toxins. These toxins are not destroyed by heat (i.e. cooking). The mushroom is fatal when consumed in sufficient quantities, although it is not toxic to touch or handle briefly. The amount of toxins have a high range of variability between specimens, even when collected in the same area.

Deadly Galerina

Galerina marginata

One of the challenges of mushroom identification is the plethora of unremarkable, indistinct, and seemingly featureless little brown mushrooms. Notoriously difficult to pinpoint as part of a specific species, most are harmless. The exception is the nondescript little brown mushroom known as *Galerina marginata*.

While most of the choice edibles are quite distinct and fairly easy to identify, *Galerina marginata* is known to be easily confused with honey mushrooms (*Armillaria* species, which can be distinguished by their white spore print) or magic mushrooms (*Psilocybe* species)—increasing the risk in the hunt for enlightenment.

The deadly galerina fungus contains the same toxins present in the deadly *Amanita phalloides*. This type of poisoning can lead to liver and kidney failure if not treated promptly. The first symptoms of poisoning occur within 6 to 12 hours of ingestion, followed by a brief sense of recovery while toxins accumulate in the liver, resulting in gastrointestinal bleeding and coma, with the likelihood of death within 7 days.

IDENTIFYING FEATURES: This small, brown mushroom has a bell-shaped cap that can have a slight orange hue but is generally brown in color. It typically has a very thin ring around the stipe that can disappear with age, as well as a rusty brown spore print.

HOSTS & ENVIRONMENT: These saprophytic mushrooms grow on the decaying wood of conifers and hardwood trees, generally in clusters throughout North America.

SEASON: Spring and fall, but sometimes throughout the year in temperate regions.

LOOK-ALIKE SPECIES: Because they are easily mistaken for similarly colored honey mushrooms (*Armillaria* species), which are edible, honey mushrooms are not recommended for beginners. Other possible look-alikes that are often collected are velvet foot *Flammulina velutipes* and the many species of magic mushrooms *Psilocybe* species, etc.

TOXICITY: Deadly poisonous due to the presence of amatoxins, α-amanitin, and γ-amanitin.

Other Curiosities

Just because they don't have a specific use for us humans, everything in nature has a purpose, whether as food and habitat for other creatures or serving as a critical role in an ecosystem.

I like to think other living beings meant for us to share in the diverse beauty to help us appreciate nature, and, in turn, see the beauty in ourselves.

In addition to these selected mushrooms, hundreds of thousands more all take part in our world, each one serving a purpose. With many yet to still be discovered, anyone willing to take a wander through the woods can access this fungal frontier.

Coral and Club Fungi

Appearing much like their namesake, coral mushrooms can range in their vibrant hues of yellow to orange to purple and neon pink. Others are a more muted tan and white, but they still have distinct and striking forms. These saprophytic fungi decompose dead and dying organic matter in the forest. Some are edible and relatively tasty, but they can be difficult to identify. Research should be done before consuming them, as some can cause gastrointestinal issues. Club fungi, such as the *Clavariadelphus* species, are known as candy coral and have a sweet and sugary taste.

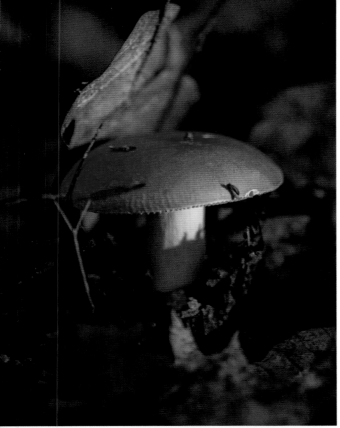

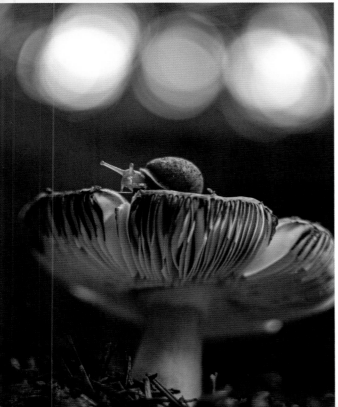

Russula

Russula species

The *Russula* genus of mushrooms is a common find throughout the forest worldwide. Their brightly colored caps come in nearly every hue of the rainbow, from deep reds to magenta, yellow, green, violet, and blue contrasted with their stark white flesh underneath. Depending on who you ask, some are edible and worth collecting, but some cause digestive upset or are unpalatable, though none are deadly. This genus is probably one of the most discarded types of mushrooms, as the species is notoriously difficult to identify.

They show up at the same time as many sought-after edibles, pushing up through the forest floor much like the desirable mushrooms, giving the hunter a moment of hope for something tasty. With great disappointment after identifying it as a *Russula*, novice mushroom hunters are known to toss these fungi over the shoulders before moving on to another area. While ever-so-tempting to do so, best practices would be to respectfully place it back under the duff without leaving a trace. One of the notable and tasty *Russulas* is known as shrimp russula, *Russula xerampelina*, which has a stipe with pink or purple shades and a distinct shrimp-like odor.

Earthstars

Geastrum species, *Astraeus hygrometricus*

Full of superstition, these mushrooms were known as "fallen stars" by the Blackfoot tribes and used as tinder and incense to ward off ghosts. Starting out as a round sphere, it splits open from a center point, forming rays much like a star or flower, which reveals the center spore sac. This center structure performs much like a puffball, releasing its spores when dried and cracked open. The barometer earthstar has a very similar appearance to mushrooms in the earthstar group, although it is technically a member of a different family (Asteraceae). The barometer earthstar changes due to the presence of humidity in the surrounding air. Its protective rays will unfold, eventually reaching downward to lift the spore-producing sac high into the air, awaiting raindrops to expel the spores into the air current for dispersal. This process can be very quick, almost happening right before your eyes. As the air dries out, the extended rays will curl back around to protect the spore sac once again from the elements, awaiting ideal conditions that may be years away.

Jelly Fungi

Appearing as blob-like growths on trees and branches, jelly fungi have a gelatinous texture. Some are edible and medicinal while others are just interesting to touch and admire. There is the bright orange "witch's butter," *Tremella aurantia*, which is a parasite on other fungi such as *Stereum hirsutum*, the false turkey tail. This species of jelly fungi is reported to be edible but lacks an appealing taste and texture. The similar white snow fungus, *Tremella fuciformis*, found in the tropics, is used medicinally. Meanwhile, *Pseudohydnum gelatinosum*, a white jelly fungus found in North America, is occasionally eaten by candying; it is known as jelly tooth or cat's tongue because its underside resembles a cat's rough tongue. *Auricularia auricula-judae*, or wood ear fungus, is a popular food in Japan and is used as a folk remedy for throat and respiratory tract inflammation, among many other ailments.

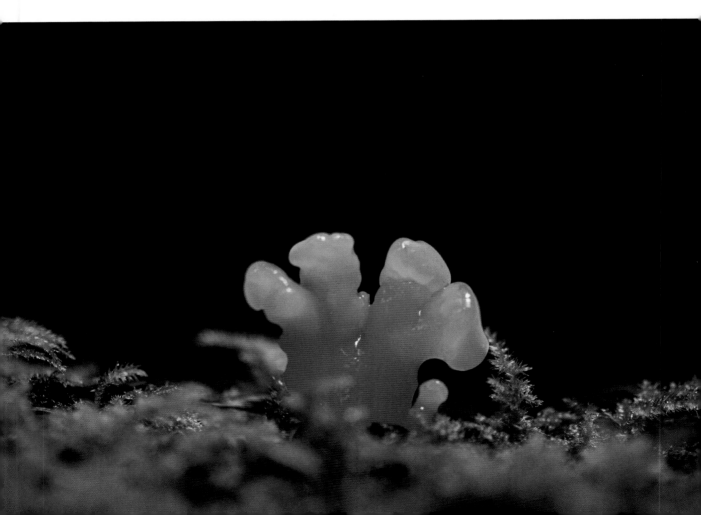

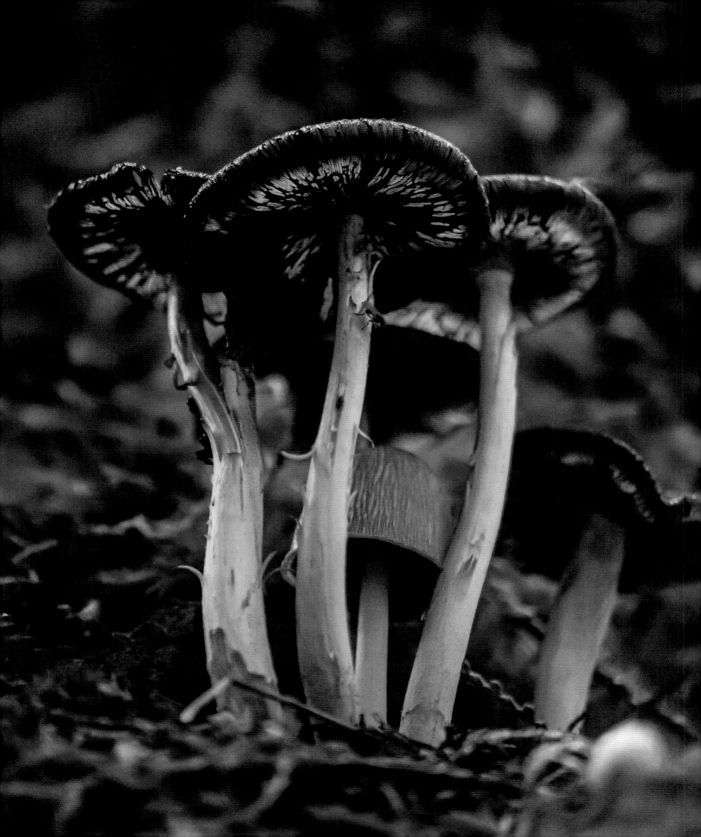

Inky Caps

The ephemerality of mushrooms is dramatically displayed best in none other than those known as inky caps. These transient fungi, members of the *Coprinoid* group, exhibit a unique trait of deliquescence. As they age, which is rather quickly, their flesh deteriorates into a black, liquid-like substance, which resembles the Wicked Witch of the West, melting until there is nothing left but a black smear. Despite this dark and grotesque process, some of these mushrooms are quite a delicacy, such as the shaggy mane *Coprinus comatus,* which some claim to be a favorite edible mushroom. When hunting this fungus, heat and damage in the basket can speed up its decay. While this is a fairly safe group to explore, *Coprinopsis atramentaria*, known as the alcohol inky, can become poisonous when consumed while alcohol is present in the consumer's system. All of the mushrooms in this group can be made into ink and used for calligraphy, paintings, or other art.

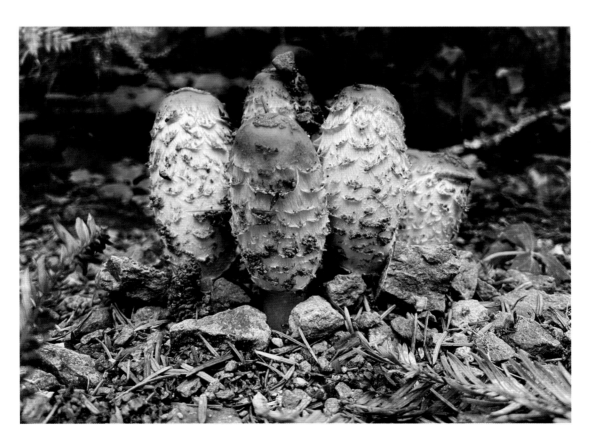

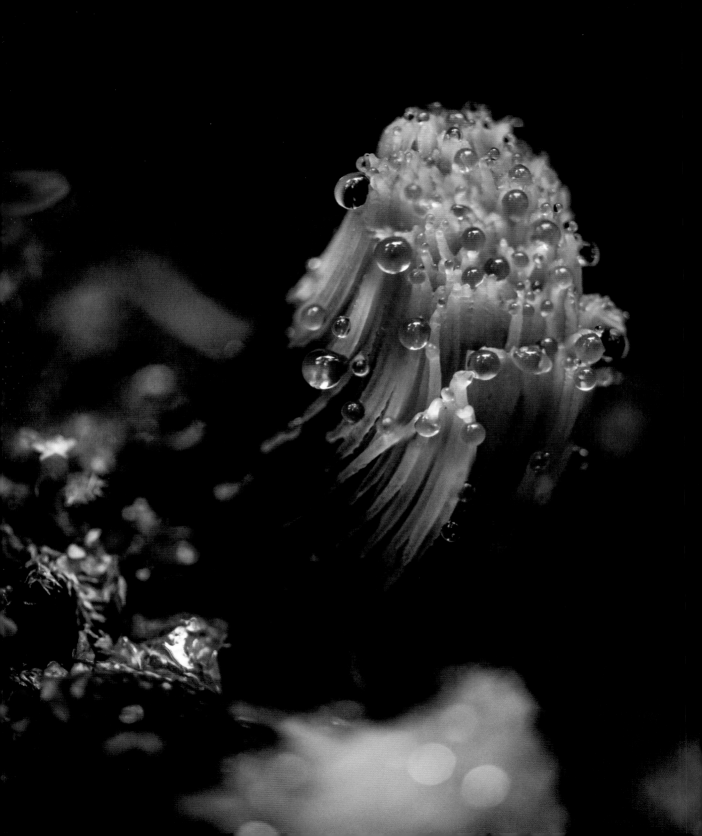

Slime Mold

Venturing down into the fungal rabbit hole of slime mold reveals an entirely new and breathtaking universe at a tiny scale. These tiny growths are not actually mold nor fungi at all, but rather a single-celled eukaryote. They live freely yet aggregate to change their form depending on the environment they are feeding from and the function they need to perform, such as reproduction by producing spores. One of the common slime molds often encountered by mushroom hunters and forest wanderers alike is the "dog vomit" slime mold, *Fuligo septica*, which is a bright yellow globular mass and looks very similar to what it sounds like. That being said, around 900 different species are known and have been gaining the attention of scientists and even casual mycophiles who take the time to slow down and look closer into this mysterious world.

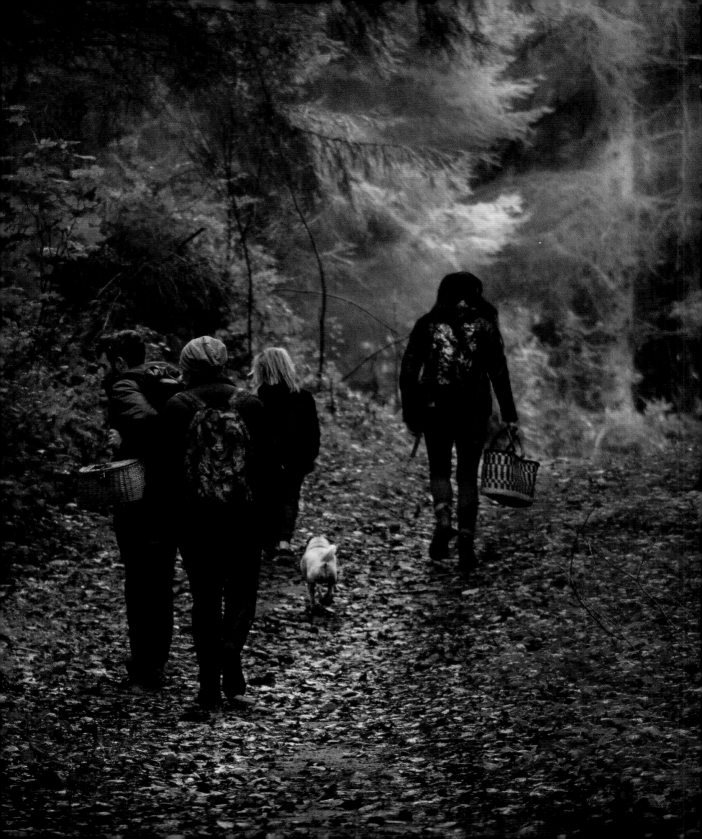

Acknowledgments

Writing a book has been a lifetime goal of mine and it could not have happened without the collective support of family, friends, and the community. It takes a collaborative contribution from the entire forest just to produce a single mushroom . . . or in this case, a book about mushrooms. I couldn't have done this without you all.

Mom and Dad, thank you for inspiring a passion for the outdoors at an early age and your unconditional, never-ending support and love. Thank you, Mom, for always being there and listening to my wacky ideas. Dad, you continue to inspire me to work hard and follow my dreams, no matter what anyone else says. And of course, thank you both for watching the kids when deadlines were pressing and making what seemed impossible possible.

I couldn't have finished this project on time without the patience of my daughters, Isabella and Sage. Thank you for humoring me time after time for sudden stops on our road trips just to photograph a mushroom and joining me on long and tiring quests into the forest in search of mushrooms and just the right lighting. But also, thank you for reminding me to continually seek balance in our lives. I love you both forever.

So much gratitude to my agent, Leslie Stoker, whom I met by way of Sally Ekus and Ben Watson, and who didn't let this path end at the first "no." Thank you to Ann Treistman of The Countryman Press, who saw enough potential in my original proposal to say yes and then pushed it into a different direction. I am forever grateful to the assistant editor, Isabel McCarthy, who has worked with me tirelessly on this project, making it the best it can be. Thank you also to the entire team at The Countryman Press, who worked on making this book a reality.

So much gratitude to my friend, Kyle Lapp, not only for contributing some of your photos, but mostly your friendship, honest feedback, and our unforgettable hunting adventures into wonderland that have been an integral part of this book.

To my good friend, Pascal Baudar, I am so grateful for your support and friendship, for asking me a few years ago why I hadn't written a book yet, but also for helping me believe in myself and pushing my creative edges for all these years.

I am incredibly grateful to all my new friends on the East Coast who helped make this book possible and relevant across North America: Bill Neill, Stephanie Emery, Christine Gagnon, Kathy Wilson, Tommy Stoughton, and David Spahr. I couldn't have done this without your generous help guiding me into new territory.

Thank you to the friends who've wandered

the forest with me to look at the ground, the wonderful adventures, but also for listening to my rambling stories and supporting me through this amazing but challenging journey—Tina Loyo, Stu Pickell, and Rochelle Kuan Hoffman.

Immense gratitude to my teachers who have supported me along this path over the years—Lanny Kaufer, James Adams, Enrique Villaseñor, and Christopher Nyerges. Many thanks to my art and photography teachers, Luke Matjas and Larry Lytle, who taught me, many years ago, how to see and think critically about the natural world around me.

The mushroom community, despite the rampant secrecy about prime locations and competitiveness, is an incredible group of people that I am honored to be a part of and so many have helped me indirectly on this path.

I'd like to thank particularly Elle Mathews and Mike Dechter for inviting me out into the forests with you. I appreciate all of my friends and contacts at the Los Angeles Mycological Society, Arizona Mushroom Society, and Mycological Society of San Francisco and for their continued efforts at education.

Thank you also to Tadashi Gietzen and Megumi Osakabe as a resource for Japanese mushroom lore.

Thank you to Mary Smiley for your photo contributions, which were a great help in completing the task of finding these mushrooms in such a short time frame.

Gratitude to my students of all ages over the years: you continually remind me to look at the world from new perspectives, inspire wonder, and always ask questions.

Resources

MUSHROOM IDENTIFICATION

Arora, David. *All That the Rain Promises and More: A Hip Pocket Guide to Western Mushrooms*. Berkeley, CA: Ten Speed Press, 1991.

Baroni, Timothy. *Mushrooms of the Northeastern United States and Eastern Canada*. Portland, OR: Timber Press, 2017.

Bessette, Alan, Arleen Bessette, and David Fischer. *Mushrooms of Northeastern North America*. Syracuse, NY: Syracuse University Press, 1997.

Bessette, Alan, William C. Roody, and Arleen Bessette. *Boletes of Eastern North America*. Syracuse, NY: Syracuse University Press, 2017.

Desjardin, Dennis E., Michael Wood, and Frederick Stevens. *California Mushrooms: The Comprehensive Identification Guide*. Portland, OR: Timber Press, 2015.

Evenson, Vera Stucky. *Mushrooms of the Rocky Mountain Fegion: Colorado, New Mexico, Utah, Wyoming*. Portland, OR: Timber Press, 2015.

Marrone, Teresa, and Kathy Yerich. *Mushrooms of the Upper Midwest*. Cambridge, MN: Adventure Publications, 2020.

Siegel, Noah, and Christian Schwarz. *Mushrooms of the Redwood Coast: A Comprehensive Guide to the Fungi of Coastal Northern California*. Berkeley, CA: Ten Speed Press, 2016.

MEDICINAL MUSHROOMS

Rogers, Robert. *The Fungal Pharmacy: The Complete Guide to Medicinal Mushrooms & Lichens of North America*. Berkeley, CA: North Atlantic Books, 2011.

Rogers, Robert. *Medicinal Mushrooms: The Human Clinical Trials*. Independently published, 2020.

COOKING MUSHROOMS

Gardner, Alison, and Merry Winslow. *The Wild Mushroom Cookbook: Recipes from Mendocino*. Mendocino, CA: Barefoot Naturalist Press, 2015.

Hyatt, Chad. *The Mushroom Hunter's Kitchen: Reimagining Comfort Food with a Chef Forager*. San Jose, CA: Chestnut Fed Books, 2018.

GROWING MUSHROOMS & MYCOREMEDIATION

Cotter, Tradd. *Organic Mushroom Farming and Mycoremediation: Simple to Advanced and Experimental Techniques for Indoor and Outdoor Cultivation*. White River Junction, VT: Chelsea Green Publishing, 2014.

GENERAL FORAGING

Nyerges, Christopher. *Foraging Wild Edible Plants of North America: More than 150 Delicious Recipes Using Nature's Edibles*. Guilford, CT: Falcon Guides, 2016.

Thayer, Samuel. *The Forager's Harvest: A Guide to Identifying, Harvesting, and Preparing Edible Wild Plants*. Birchwood, WI: Forager's Harvest Press, 2006.

OTHER MUSHROOM BOOKS OF INTEREST

Bone, Eugenia. *Mycophilia: Revelations from the Weird World of Mushrooms*. New York: Rodale Books, 2013.

Hallock, Robert M. *A Mushroom Word Guide: Etymology, Pronunciation, and Meaning of Over 1,500 Words*. Independently published, 2019.

McCoy, Peter. *Radical Mycology: A Treatise on Seeing & Working with Fungi*. Portland, OR: Chthaeus Press, 2016.

Pouliot, Alison. *The Allure of Fungi*. Clayton South, VIC: CSIRO Publishing, 2018.

Sheldrake, Merlin. *Entangled Life: How Fungi Make Our Worlds, Change Our Minds & Shape Our Futures*. New York: Random House, 2020.

Woon, Long Litt. *The Way Through the Woods: On Mushrooms and Mourning*. New York: Random House, 2019.

Bibliography

Asim, S., S. Bacha, S. Ali, Y. Li, H. ur Rehman, S. Farooq, A. Mushtaq, S. A. Wahocho, S. M. Aslam. "Lion's mane mushroom; new addition to food and natural bounty for human wellness: A review." *Journal of Biodiversity and Environmental Sciences*, 13(4): 396–402; 2018.

Balaji, P., R. Madhanraj, K. Rameshkumar, V. Veeramanikandan, M. Eyini, A. Arun, B. Thulasinathan, D. A. Al Farraj, M. S. Elshikh, A. M. Alokda, A. H. Mahmoud, J.-C. Tack, H.-J. Kim. "Evaluation of antidiabetic activity of Pleurotus pulmonarius against streptozotocin-nicotinamide induced diabetic wistar albino rats." *Saudi Journal of Biological Sciences*, 27(3): 913–924; 2020.

Batra, P., A. K. Sharma, and R. Khajuria. "Probing Lingzhi or Reishi medicinal mushroom Ganoderma lucidum (higher Basidiomycetes): a bitter mushroom with amazing health benefits." *International Journal of Medicinal Mushrooms*, 15(2): 127–143; 2013. https://doi.org/10.1615/intjmedmushr.v15.i2.20

Bromley, E., S. Gabrielian, B. Brekke, R. Pahwa, K. A. Daly, J. S. Brekke, and J. T. Braslow. "Experiencing community: perspectives of individuals diagnosed as having serious mental illness." *Psychiatric Services* (Washington, DC), 64(7): 672–679; 2013. https://doi.org/10.1176/appi.ps.201200235

Cardwell, G., J. F. Bornman, A. P. James, and L. J. Black. "A Review of Mushrooms as a Potential Source of Dietary Vitamin D. *Nutrients*, 10(10): 1498; 2018. https://doi.org/10.3390/nu10101498

Chong, P. S., M. L. Fung, K. H. Wong, and L. W. Lim. "Therapeutic Potential of *Hericium erinaceus* for Depressive Disorder." *International Journal of Molecular Sciences*, 21(1): 163; 2019. https://doi.org/10.3390/ijms21010163

Cieniecka-Rosłonkiewicz, A., A. Sas, E. Przybysz, B. Morytz, A. Syguda, and J. Pernak. "Ionic liquids for the production of insecticidal and microbicidal extracts of the fungus *Cantharellus cibarius*." *Chemistry & Biodiversity*. 2007; 4(9): 2218–2224; 2007. doi:10.1002/cbdv.200790179

Cohen, N., J. Cohen, M. D. Asatiani, et al. "Chemical composition and nutritional and medicinal value of fruit bodies and submerged cultured mycelia of culinary-medicinal higher Basidiomycetes mushrooms." *International Journal of Medicinal Mushrooms*, 16(3): 273–291; 2014. doi:10.1615/intjmedmushr.v16.i3.80

Cornaccia, P. "Amanita muscaria in Italy." 1980. http://www.autistici.org/mirrors/www.psicoattivo.it/media/libri/amanita/am_06.html

De Mattos-Shipley, K. M., K. L. Ford, F. Alberti, A. M. Banks, A. M. Bailey, and G. D. Foster. "The good, the bad and the tasty: The many roles of mushrooms." *Studies in Mycology*, 85: 125–157; 2016. https://doi.org/10.1016/j.simyco.2016.11.002

Eroğlu, C., M. Seçme, P. Atmaca, O. Kaygusuz, K. Gezer, G. Bağcı, and Y. Dodurga. "Extract of Calvatia gigantea inhibits proliferation of A549 human lung cancer cells." *Cytotechnology*, 68(5): 2075–2081; 2016. https://doi.org/10.1007/s10616-016-9947-4

Friedman M. "Chemistry, Nutrition, and Health-Promoting Properties of *Hericium erinaceus* (Lion's Mane) Mushroom Fruiting Bodies and Mycelia and Their Bioactive Compounds." *Journal of Agricultural and Food Chemistry*, 63(32): 7108–7123; 2015. https://doi.org/10.1021/acs.jafc.5b02914

Grienke U., M. Zöll, U. Peintner, and J. M. Rollinger. "European medicinal polypores—a modern view on traditional uses." *Journal of Ethnopharmacology*, 154(3): 564-583; 2014. doi:10.1016/j.jep.2014.04.030

Habtemariam S. "*Trametes versicolor* (Synn. *Coriolus versicolor*) Polysaccharides in Cancer Therapy: Targets and Efficacy." *Biomedicines*, 8(5): 135; 2020. https://doi.org/10.3390/biomedicines8050135

Hallen, H. E., H. Luo, J. S. Scott-Craig, J. D. Walton. "Gene family encoding the major toxins of

lethal Amanita mushrooms." *Proceedings of the National Academy of Sciences of the United States of America*, 104(48): 19097–19101; 2007.

Hammen, C. "Risk Factors for Depression: An Autobiographical Review." *Annual Review of Clinical Psychology*, 14: 1–28; 2018. https://doi.org/10.1146/annurev-clinpsy-050817-084811

Hansen, M. M., R. Jones, and K. Tocchini. "Shinrin-Yoku (Forest Bathing) and Nature Therapy: A State-of-the-Art Review." *International Journal of Environmental Research and Public Health*, 14(8): 851; 2017. https://doi.org/10.3390/ijerph14080851

Hedman, H., J. Holmdahl, J. Mölne, K. Ebefors, B. Haraldsson, and J. Nyström. "Long-term clinical outcome for patients poisoned by the fungal nephrotoxin orellanine." *BMC Nephrology*, 18(1): 121; 2017. https://doi.org/10.1186/s12882-017-0533-6

Helbling A, N. Bonadies, K. A. Brander, and W. J. Pichler. "*Boletus edulis*: a digestion-resistant allergen may be relevant for food allergy." *Clinical & Experimental Allergy*, 32(5): 771–775; 2002. doi:10.1046/j.1365-2222.2002.01400.x

Heuschkel, K., and K. Kuypers. "Depression, Mindfulness, and Psilocybin: Possible Complementary Effects of Mindfulness Meditation and Psilocybin in the Treatment of Depression. a Review." *Frontiers in Psychiatry*, 11: 224; 2020. https://doi.org/10.3389/fpsyt.2020.00224

Hirsch, K. R., A. E. Smith-Ryan, E. J. Roelofs, E. T. Trexler, and M. G. Mock. "*Cordyceps militaris* Improves Tolerance to High-Intensity Exercise After Acute and Chronic." Supplementation. *Journal of Dietary Supplements*, 14(1): 42–53; 2017. https://doi.org/10.1080/19390211.2016.1203386

Hoek, T., T. Erickson, D. Hryhorczuk, and K. Narasimhan. "Jack o' lantern mushroom poisoning." *Annals of Emergency Medicine*, 20: 559–61; 1991. doi:10.1016/S0196-0644(05)81617-8.

Irshad, A., S. Sharif, M. Riaz, and F. Anjum. "An insight into nutritional profile of selected *Pleurotus* species." *Journal of Biological Regulators and Homeostatic Agents*, 32(1): 107–113; 2018.

Jesenak, M., M. Hrubisko, J. Majtan, Z. Rennerova, and P. Banovcin. "Anti-allergic Effect of Pleuran (β-glucan from *Pleurotus ostreatus*) in Children with Recurrent Respiratory Tract Infections."

Phytotherapy Research, 28: 471–474; 2014. doi:10.1002/ptr.5020

Kıvrak, İ., Ş. Kıvrak, and M. Harmandar. "Free amino acid profiling in the giant puffball mushroom (*Calvatia gigantea*) using UPLC-MS/MS." *Food Chemistry*, 158: 88–92; 2014. https://doi.org/10.1016/j.foodchem.2014.02.108

Klaus, A., M. Kozarski, M. Niksic, et al. "The edible mushroom *Laetiporus sulphureus* as potential source of natural antioxidants." *International Journal of Food Sciences and Nutrition*, 64(5): 599–610; 2013. doi:10.3109/09637486.2012.759190

Kondeva-Burdina, M., M. Voynova, A. Shkondrov, D. Aluani, V. Tzankova, and I. Krasteva. "Effects of *Amanita muscaria* extract on different in vitro neurotoxicity models at sub-cellular and cellular levels." *Food and Chemical Toxicology*, 132: 110687; 2019. https://doi.org/10.1016/j.fct.2019.110687

Koyyalamudi, S. R., S. C. Jeong, C. H. Song, K. Y. Cho, and G. Pang. "Vitamin D2 formation and bioavailability from *Agaricus bisporus* button mushrooms treated with ultraviolet irradiation." *Journal of Agricultural and Food Chemistry*, 57(8): 3351–3355; 2009. https://doi.org/10.1021/jf803908q

Kulshreshtha, S., N. Mathur, and P. Bhatnagar. "Mushroom as a product and their role in mycoremediation." *AMB Express*, 4: 29; 2014. doi:10.1186/s13568-014-0029-8

Laperriere, G., I. Desgagné-Penix, and H. Germain. "DNA distribution pattern and metabolite profile of wild edible lobster mushroom (*Hypomyces lactifluorum/Russula brevipes*)." *Genome*, 61(5): 329–336; 2018. https://doi.org/10.1139/gen-2017-0168

Lemieszek, M. K., F. M. Nunes, C. Cardoso, G. Marques, W. Rzeski. "Neuroprotective properties of *Cantharellus cibarius* polysaccharide fractions in different in vitro models of neurodegeneration." *Carbohydrate Polymers*, 197: 598–607; 2018. doi:10.1016/j.carbpol.2018.06.038

Lemieszek, M. K., M. Ribeiro, H. Guichard Alves, G. Marques, F. M. Nunes, and W. Rzeski. "*Boletus edulis* ribonucleic acid—a potent apoptosis inducer in human colon adenocarcinoma cells." *Food & Function*, 7(7): 3163–3175; 2016. doi:10.1039/c6fo00132g

Liu, Gang, Hui Wang, Benhong Zhou, Xianxi Guo, and Xianming Hu. "Compositional analysis and nutritional studies of *Tricholoma matsutake* collected from Southwest China." *Journal of Medicinal Plants Research*, 4: 1222–1227; 2010.

Liu, G., H. Wang, B. Zhou, X. Guo, and X. Hu., "The mitochondrial genome of *Morchella importuna* (272.2 kb) is the largest among fungi and contains numerous introns, mitochondrial non-conserved open reading frames and repetitive sequences." *International jJournal of Biological Macromolecules*,143: 373–381; 2020. https://doi.org/10.1016/j.ijbiomac.2019.12.056

Madsen, M. K., P. M. Fisher, D. Burmester, et al. "Psychedelic effects of psilocybin correlate with serotonin 2A receptor occupancy and plasma psilocin levels." *Neuropsychopharmacology,* 44**:** 1328–1334; 2019. https://doi.org/10.1038/s41386-019-0324-9

Meng, B., Y. Zhang, Z. Wang, Q. Ding, J. Song, and D. Wang. "Hepatoprotective Effects of *Morchella esculenta* against Alcohol-Induced Acute Liver Injury in the C57BL/6 Mouse Related to Nrf-2 and NF-κB Signaling." *Oxidative Medicine and Cellular Longevity*, 6029876; 2019. doi:10.1155/2019/6029876

Muszyńska B., K. Kała, A. Firlej, and K. Sułkowska-Ziaja. "*Cantharellus cibarus*—culinary—medicinal mushroom content and biological activity." *Acta Poloniae Pharmaceutica*, 73(3): 589–598; 2016.

Nitha, B., S. De, S. K. Adhikari, T. P. Devasagayam, and K. K. Janardhanan. "Evaluation of free radical scavenging activity of morel mushroom, *Morchella esculenta* mycelia: a potential source of therapeutically useful antioxidants." *Pharmaceutical Biology*, 48(4): 453–460; 2010. https://doi.org/10.3109/13880200903170789

Novakovic, A., M. Karaman, S. Kaisarevic, T. Radusin, N. Llic. "Antioxidant and Antiproliferative Potential of Fruiting Bodies of the Wild-Growing King Bolete Mushroom, *Boletus edulis* (*Agaricomycetes*), from Western Serbia."*International Journal of Medicinal Mushrooms*, 19(1): 27–34; 2017. doi:10.1615/IntJMedMushrooms.v19.i1.30

Pavlik, M. and S. Pavlik. "Wood decomposition activity of oyster mushroom (*Pleurotus ostreatus*) isolate in situ. *Journal of Forest Science*, 59: 28–33; 2013. 10.17221/60/2012-JFS, 2013.

Petrović, J., D. Stojković, F. S. Reis, L. Barros, J. Glamočlija, A. Ćirić, I. C. Ferreira, and M. Soković. "Study on chemical, bioactive and food preserving properties of *Laetiporus sulphureus* (Bull.: Fr.) Murr." *Food & Function*, 5(7): 1441–1451; 2013. https://doi.org/10.1039/c4fo00113c

Phillips, K. M., D. M. Ruggio, R. L. Horst, B. Minor, R. R. Simon, M. J. Feeney, W. C. Byrdwell, and D. B. Haytowitz. "Vitamin D and sterol composition of 10 types of mushrooms from retail suppliers in the United States." *Journal of Agricultural and Food Chemistry*, 59(14): 7841–7853; 2011. https://doi.org/10.1021/jf104246z

Pringle, A., R. I. Adams, H. B. Cross, and T. D. Bruns. "The ectomycorrhizal fungus *Amanita phalloides* was introduced and is expanding its range on the West Coast of North America." *Molecular Ecology*, 18(5): 817–833; 2009.

Qizheng, L., M. Husheng, Y. Zhang, and C.-H. Dong. "Artificial cultivation of true morels: current state, issues and perspectives." *Critical Reviews in Biotechnology*, 38:2: 259–271; 2018. doi:10.1080/07388551.2017.1333082

Ratto, D., F. Corana, B. Mannucci, E. C. Priori, F. Cobelli, E. Roda, B. Ferrari, A. Occhinegro, C. Di Iorio, F. De Luca, V. Cesaroni, C. Girometta, M. G. Bottone, E. Savino, H. Kawagishi, and P. Rossi. "*Hericium erinaceus* Improves Recognition Memory and Induces Hippocampal and Cerebellar Neurogenesis in Frail Mice during Aging." *Nutrients*, 11(4): 715; 2019. https://doi.org/10.3390/nu11040715

Research and Markets Ltd. "Mushroom Cultivation Market by Type (Button mushroom, Oyster mushroom, Shiitake mushroom, Other types), By Phase, By Region (North America, Europe, Asia Pacific, South America, Rest of the World)—Global Forecast to 2025." April 2020. Retrieved July 12, 2020, from https://www.researchandmarkets.com/reports/5018601/mushroom-cultivation-market-by-type-button?utm_source=dynamic.

Ribeiro, B., P. B. Andrade, B. M. Silva, P. Baptista, R. M. Seabra, and P. Valentão. "Comparative

study on free amino acid composition of wild edible mushroom species." *Journal of Agricultural and Food Chemistry*, 56(22): 10973–10979; 2008. https://doi.org/10.1021/jf802076p

Rosenbaum, D., A. B. Boyle, A. M. Rosenblum, S. Ziai, M. R. Chasen, and M. P. Med. "Psychedelics for psychological and existential distress in palliative and cancer care." *Current Oncology* 26(4): 225–226; 2019. https://doi.org/10.3747/co.26.5009

Shashidhar, M. G., P. Giridhar, K. Udaya Sankar, and B. Manohar. "Bioactive principles from *Cordyceps sinensis*: A potent food supplement—A review." *Journal of Functional Foods*, 5(3): 1013–1030; 2013. https://doi.org/10.1016/j.jff.2013.04.018

Tuli, H. S., S. S. Sandhu, and A. K. Sharma. "Pharmacological and therapeutic potential of Cordyceps with special reference to Cordycepin." *3 Biotech*, 4(1): 1–12; 2014. https://doi.org/10.1007/s13205-013-0121-9

Vetter, J. "Toxins of *Amanita phalloides*." *Toxicon*, 36(1): 13–24; 1998. doi:10.1016/s0041-0101(97)00074-3

Villares A., L. Mateo-Vivaracho, A. García-Lafuente, and E. Guillamón. "Storage temperature and UV-irradiation influence on the ergosterol content in edible mushrooms." *Food Chemistry*, 147: 252–256; 2014. doi:10.1016/j.foodchem.2013.09.144

Wachtel-Galor, S., J. Yuen, J. A. Buswell, et al. "*Ganoderma lucidum* (Lingzhi or Reishi): A Medicinal Mushroom," in Benzie, I. F. F., Wachtel-Galor, S., editors, *Herbal Medicine: Biomolecular and Clinical Aspects*. 2nd edition. Boca Raton (FL): CRC Press/Taylor & Francis; 2011. Chapter 9. Available from: https://www.ncbi.nlm.nih.gov/books/NBK92757/.

Wang, H., W. Chen, D. Li, X. Yin, X.Zhang, N. Olsen, and S. G. Zheng. "Vitamin D and Chronic Diseases." *Aging and Disease*, 8(3): 346–353; 2017. https://doi.org/10.14336/AD.2016.1021

Wang, J., B. Cao, H. Zhao, and J. Feng. "Emerging Roles of *Ganoderma Lucidum* in Anti-Aging." *Aging and Disease*, 8(6): 691–707; 2017. https://doi.org/10.14336/AD.2017.0410

Wang, Y., and L. H. Kasper. "The role of microbiome in central nervous system disorders." *Brain, Behavior, and Immunity*, 38: 1–12; 2014. https://doi.org/10.1016/j.bbi.2013.12.015

Watanabe, F., J. Schwarz, S. Takenaka, et al. "Characterization of vitamin B12 compounds in the wild edible mushrooms black trumpet (*Craterellus cornucopioides*) and golden chanterelle (*Cantharellus cibarius*)." *Journal of Nutritional Science and Vitaminology*, 58(6): 438–441; 2012. doi:10.3177/jnsv.58.438

Watanabe, F., Y. Yabuta, T. Bito, and F. Teng. "Vitamin B12-containing plant food sources for vegetarians." *Nutrients*, 6(5): 1861–1873; 2014. https://doi.org/10.3390/nu6051861

Whelan, C. "*Amanita muscaria*: The Gorgeous Mushroom." *Asian Folklore Studies*, 53(1): 163–167; 1994. doi:10.2307/1178564

Wood, W. F., J. A. Brandes, B. D. Foy, C. G. Morgan, T. D. Mann, and D. A. DeShazer. "The maple syrup odor of the 'candy cap' mushroom, *Lactarius fragilis* var. rebids." *Biochemical Systematics and Ecology*, 43: 51–53, 2012. https://doi.org/10.1016/j.bse.2012.02.027

Yang, W. W., L. M. Wang, L. L. Gong, et al. "Structural characterization and antioxidant activities of a novel polysaccharide fraction from the fruiting bodies of *Craterellus cornucopioides*." *International Journal of Biological Macromolecules*, 117: 473–482; 2018. doi:10.1016/j.ijbiomac.2018.05.212

Zhang, J., J. Zhang, L. Zhao, X. Shui, L. A. Wang, and Y. Wu. "Antioxidant and Anti-Aging Activities of Ethyl Acetate Extract of the Coral Tooth Mushroom, *Hericium coralloides* (Agaricomycetes)." *International Journal of Medicinal Mushrooms*, 21(6): 561–570; 2019. https://doi.org/10.1615/IntJMedMushrooms.2019030840

Zipora, T., and S. Masaphy. "True morels (Morchella)—nutritional and phytochemical composition, health benefits and flavor: A review." *Critical Reviews in Food Science and Nutrition*, 58(11): 1888–1901; 2018. doi:10.1080/10408398.2017.1285269 SeRes

Index

A

adaptogens, 155
adenosine, 152
Agaricus species (meadow and prince mushrooms), 35–36, 89–93
alcohol inky *(Coprinopsis atramentaria)*, 189
alpha-glucans, 136
Amanita bisporigera/ocreata (Destroying Angel mushrooms), 175–76
Amanita muscaria (fly agaric mushrooms), 14, 137, 159–61
Amanita phalloides (death cap mushrooms), 176, 177–79, 181
amatoxins, 175–76, 179, 181
American Indians, 99–100, 160
amino acids, 90, 96–97, 101, 104, 111, 120, 128, 133, 136, 152
Angel of Death mushrooms. *See* Destroying Angel mushrooms
angel wing mushrooms *(Pleurocybella porrigens)*, 97
antibacterial properties, 117
antibiotic properties, 32, 108
anti-cancer properties, 36, 93, 101, 104, 141, 143, 145
anti-carcinogenic compounds, 104
antifungal therapy, 32, 145
anti-inflammatory properties, 121, 129, 152, 160–61
antioxidants, 108, 125, 129, 147–49, 156–57, 161
antitumor properties, 129, 133, 136, 152
aphrodisiacs, 151–52
Armillaria (honey mushroom), 173, 181
aromas. *See* smells
attire, 54
Auricularia auricula-judae (wood ear fungus), 187
autoimmune diseases, 36, 38, 156

B

barometer earthstar, 186
baskets, 53–54
beta-glucans, 36, 37, 96, 97, 133
bioactive compounds, 131, 148–49, 161, 165
bitter bolete *(Tylopilus felleus)*, 121
Blackfoot tribes, 186
black-staining polypore *(Meripilus sumstinei)*, 133
black trumpet mushrooms *(Craterellus cornucopidoides)*, 35, 123–25
blue-staining boletes, 119
Boletus species (porcini), 119–21
bugs, 62
butter bolete *(Butyriboletus appendiculatus)*, 119
B vitamins, 35, 38, 120

C

calvacin, 101
Calvatia or *Lycoperdon* species (puffballs), 99–101
Candida albicans, 50
candy cap mushrooms *(Lactarius species)*, 103–5
candy cap syrup, 80
Cantharellus species (chanterelle mushrooms), 34–35, 115–17
cap, 46
Catathelasma ventricosum, 137
categories of mushrooms, 85
chanterelle mushrooms *(Cantharellus* species), 34–35, 115–17
chicken of the woods mushrooms *(Laetiporus* species), 107–8
Chinese medicine and herbalism, 93, 101, 129, 144–45, 148
chitin, 37, 62–63, 90
Chlorophyllum molybdites, 93
classification of mushrooms, 44
Clavariadelphus species, 184

cleaning mushrooms, 53, 60–62
Climacodon septentrionalis (northern tooth
 fungus), 108
Clitocybe nuda (edible wood blewit), 50, 173
club coral mushrooms, 153
club fungi, 184
cooking and preserving mushrooms, 59–81. *See
 also* recipes using mushrooms
 beverages, 76
 bugs, 62
 cleaning, 60–62
 dehydration, 68–71
 dry sauté, 63
 fermentation, 75
 more than one way to cook, 62–67
 pickling, 72, 133
 preservation, 68–71, 72, 75, 133
 storing, 62
 wet sauté, 63–64
 whole-roasting, 64–67
Coprinoid group. *See* inky caps
Coprinopsis atramentaria (alcohol inky), 189
Coprinus comatus (shaggy mane), 189
coral fungi, 184
cordycepin, 152
cordyceps (*Cordyceps militaris*), 50, 151–53
cortina, 47, 171
Cortinarius casperatus (gypsy mushroom),
 171
Cortinarius species (webcaps), 171–73
cosmetics, 155–56
Craterellus cornucopidoides (black trumpet
 mushrooms), 35, 123–25
cream of wild mushroom soup, 78
cremini mushrooms, 34, 35, 72, 89
Crepidotus genus, 97
culinary mushrooms, 87–137
 black trumpet, 123–25
 candy caps, 103–5
 chanterelle, 115–17
 chicken of the woods, 107–8
 hen of the woods, 131–33
 lobster, 111–13
 matsutake, 135–37
 meadow, 89–93
 milk caps, 103–5

morel, 127–29
oyster, 95–97
porcini, 119–21
prince, 89–93
puffballs, 99–101
curiosities, 184–91
 club fungi, 184
 coral fungi, 184
 earthstars, 186
 inky caps, 189
 jelly fungi, 187
 Russula, 185
 slime mold, 191
cutting *vs.* pulling, 54

D

deadly galerina mushrooms (*Galerina
 marginata*), 165, 181
deadly webcap (*Cortinarius rubellus*), 173
death cap mushrooms (*Amanita phalloides*), 176,
 177–79, 181
dehydrating mushrooms, 68–71
Destroying Angel mushrooms (*Amanita
 bisporigera/ocreata*), 175–76
dietary benefits, 34–36
dietary fiber, 90
digestive bacteria, 36–38
DNA analysis, 13, 44, 48, 85, 171
dog vomit slime mold (*Fuligo septica*), 191
double-extraction, 37
dried candy caps, 81
dry sauté, 63

E

earthstars (*Geastrum* species), 186
eating mushrooms, 33–36
 Agaricus species, 90
 Amanitas species, 137
 black trumpets, 125
 bolete mushrooms, 120
 chanterelles, 116–17
 cordyceps, 152
 fly agarics, 160
 hen of the woods, 133

Laetiporus species, 108
lion's mane mushrooms, 148
lobster mushrooms, 112
magic mushrooms, 164–65
matsutake, 136
morels, 128–29
oyster mushrooms, 96
puffballs, 100
reishi mushrooms, 156
turkey tail, 145
ectomycorrhizal fungi, 135–37, 177–79
edible wood blewit *(Clitocybe nuda)*, 50, 173
enoki mushrooms, 35
entomophagy, 62
environmental classifications of mushrooms, 49
ergosterol, 34, 125, 160
erinacine, 148
essential fatty acids, 90
evolution of mushrooms, 32

F

fabric or yarn dye uses of mushrooms, 170, 171
fairy club fungi, 153
fallen stars. *See* earthstars
false chanterelle *(Hygrophoropsis aurantiaca)*, 117
false gills, 115, 170
false morels *(Gyromitra esculenta)*, 128–29
false turkey tail *(Stereum hirsutum)*, 145, 187
fermentation of mushrooms, 75
field guides, 53
flavors, 24–26
fly agaric mushrooms *(Amanita muscaria)*, 14,
 137, 159–61
folate, 35
Fomitopsis pinicola (red-belted conk), 157
foraging. *See* mushroom hunting
forest bathing *(shinrin-yoku)*, 27
fruiting bodies, 46, 50, 54, 96, 99, 101, 107, 129,
 151–52, 161, 175
Fuligo septica (dog vomit slime mold), 191

G

Galerina marginata (deadly galerina
 mushrooms), 165, 181

Ganoderma lucidum (reishi mushrooms), 155–57
gasteroid fungi, 99–101
Geastrum species (earthstars), 186
giant puffballs *(Calvatia gigantea)*, 100–101
gills, 44, 46, 53, 90, 96, 103, 111, 115, 117, 135, 136,
 160, 164, 170, 171, 177
glutamic acid, 97, 136
Grifola frondosa (hen of the woods mushrooms),
 108, 131–33
gypsy mushroom *(Cortinarius casperatus)*,
 171
Gyromitra esculenta (false morels), 128–29

H

habitats, 48–50
hallucinations, 159, 160, 165
heavy metals, 50, 97, 120
hedgehog mushrooms *(Hydnum repandum)*, 147
hemolysins, 129
hen of the woods mushrooms *(Grifola frondosa)*,
 108, 131–33
herbalists, 145, 155, 160–61
hericenone, 148
Hericium species (lion's mane mushrooms),
 147–49
honey mushroom *(Armillaria)*, 173, 181
horse mushroom *(Agaricus arvensis)*, 90
Hydnum repandum (hedgehog mushrooms), 147
hydrazines, 129
Hygrophoropsis aurantiaca (false chanterelle),
 117
hyphae, 46
Hypomyces lactifluorum (lobster mushrooms),
 111–13

I

ibotenic acid, 161
identification of mushrooms, 42, 44–48
illudins, 170
immune system, 34, 36–39, 117, 131, 155, 156
inky caps, 62, 189
insecticidal properties, 117
intoxicants, 159–60
iodine, 113

J

jack o' lantern mushrooms (*Omphalotus illudens* and *olivascens*), 117, 169–70
Japanese culture, 27, 131, 135–36
Japanese mysticism, 147
jelly fungi, 187

K

king oyster (*Pleurotus eryngii*), 96–97
knives, 53

L

Lactarius species (candy cap/milk cap mushrooms), 103–5
Lactifluus piperatus, 111–12
Laetiporus species (chicken of the woods mushrooms), 107–8
lion's mane mushrooms (*Hericium* species), 147–49
lobster mushrooms (*Hypomyces lactifluorum*), 111–13
longevity, 157
lovastatin, 36, 97, 149
Lycoperdon perlatum (puffballs), 99–101

M

magic mushrooms (*Psilocybe* species), 14, 163–65, 181
maitake mushrooms, 34. *See also* hen of the woods mushrooms
mammalian diet, 32
matsutake mushrooms (*Tricholoma magnivelare*), 26, 135–37
meadow mushrooms (*Agaricus campestris*), 89–93
medicinal mushroom cocoa latte, 76
medicinal mushrooms, 139–65
 cordyceps, 151–53
 fly agaric mushrooms, 159–61
 lion's mane mushrooms, 147–49
 magic mushrooms, 163–65
 reishi mushrooms, 155–57
 turkey tail mushrooms, 143–45
medicinal properties, 36–39
 Agaricus species, 93
 black trumpets, 125
 Boletus species, 120–21
 Cantharellus species, 117
 cordyceps, 152
 fly agaric mushrooms, 160–61
 hen of the woods mushrooms, 131, 133
 Lactarius species, 104
 Laetiporus species, 108
 and lion's mane mushrooms, 148
 and matsutake, 136
 Morchella species, 129
 Pleurotus species, 97
 psilocybin-containing mushrooms, 165
 puffballs, 101
 reishi, 156–57
 turkey tail, 144–45
 webcaps, 171
Meripilus sumstinei (black-staining polypore), 133
microbiome, 36–38
microdosing, 165
micronutrients, 34–35
milk cap mushrooms (*Lactarius* species), 103–5
morel mushrooms (*Morchella* species), 13–14, 20, 34, 127–29
mudpuppies. *See* chanterelle mushrooms
muscarine, 161
muscimol, 161
mushroom broth, 77
mushroom extracts, 37
mushroom hunting
 and attire, 54
 and baskets, 53–54
 and classification, 44
 and cutting *vs.* pulling, 54
 and field guides, 53
 and habitats, 48–50
 and identification, 42, 44–48
 and immersion, 26–29
 and impact on the land, 42
 and information gathering, 23–26
 introduction to, 9–11, 19–23
 and knives, 53
 and navigation, 54–57
 and poisonings, 51
 practices and safety, 41–57
 and seasons, 42–44
 smells and tastes, 24–26
 as a therapeutic process, 39

and tools for gathering, 51–57
 where to go, 50–51
mushroom jerky, 71
mycelial networks, 13, 24, 32
mycelium, 11–13, 32, 42, 46, 48–49, 54, 95, 129, 136,
 151
mycology, 44
mycophagy, 137
mycoremediation, 95, 97, 120
mycorrhizal fungi, 49, 103–5, 116, 128, 171, 175, 177
mysticism, 147, 160

N

navigation, 54–57
neurogenesis properties, 147, 148, 165
neuro-psychiatric disorders, 38
niacin, 34, 90, 117
nonsymbiotic mushrooms, 50
northern tooth fungus (Climacodon
 septentrionalis), 108

O

Omphalotus illudens and olivascens (jack o'
 lantern mushrooms), 117, 169–70
Ophiocordyceps sinensis, 151
orellanine, 173
oxidative stress, 125, 157
oyster mushrooms (Pleurotus ostreatus), 20–23,
 35, 50, 90, 95–97

P

parasitic or pathogenic fungi, 49, 50, 131, 151–53
partial veil, 47, 90, 164, 177
phallotoxins, 176, 179
pharmaceuticals, 36, 139
photosynthesis, 32, 49
pickling mushrooms, 72, 133
pine mushrooms. See matsutake mushrooms
Pleurocybella porrigens (angel wing mushrooms),
 97
Pleurotus eryngii (king oyster), 96–97
Pleurotus ostreatus (oyster mushrooms), 20–23,
 35, 50, 90, 95–97

Pliny the Elder, 121
poisonings, 51
polymorphic fungi. See morel mushrooms
 (Morchella species)
Polyozellus multiplex, 125
polyphenols, 104
polypore fungi. See hen of the woods mushrooms;
 reishi mushrooms; turkey tail mushrooms
Polyporus umbellatus (umbrella polypore),
 133
polysaccharide compounds, 36, 37, 121, 125, 129,
 143, 145, 148, 152, 155, 157
porcini mushrooms (Boletus edulis), 119–21
pores, 44, 46, 120
portobello mushrooms, 34–35, 89, 90
prebiotics, 36
preservation, 68–71, 72, 75, 133
prince mushrooms (Agaricus augustus), 89–93
protein, 90, 96, 100, 104, 108, 113, 117, 120, 125, 128,
 133, 136, 148, 156, 165
Pseudohydnum gelatinosum (white jelly fungus),
 187
Psilocybe species (magic mushrooms), 14, 163–65,
 181
psilocybin-containing mushrooms, 38–39, 163–65
psychedelics in medicine, 38–39
psychological disorders, 38–39, 163
puffballs (Calvatia or Lycoperdon species),
 99–101

Q

quabalactone III, 104

R

recipes using mushrooms, 68–81
red-belted conk (Fomitopsis pinicola), 157
red snow plant (Sarcodes sanguinea), 127
reishi mushrooms (Ganoderma lucidum),
 155–57
ring/annulus, 47, 175
Rubroboletus eastwoodiae (Satan's bolete), 119
rufuslactone, 104
Russula species, 26, 161, 185
Russula brevipes, 111–12
Russula xerampelina (shrimp russula), 185

S

saprophytic fungi, 49–50, 90, 99–101, 128, 148, 170, 181, 184
Sarcodes sanguinea (red snow plant), 127
Satan's bolete (*Rubroboletus eastwoodiae*), 119
Schizophyllum commune (splitgill polypore mushrooms), 97
seasonality of mushrooms, 42–44
serotonin, 163
sesquiterpenes, 104, 170
shaggy mane *(Coprinus comatus)*, 189
shinrin-yoku (forest bathing), 27
shopping for mushrooms, 51
shrimp russula *(Russula xerampelina)*, 185
slime mold, 191
smells, 24–26
 Agaricus species, 90
 black trumpet mushrooms, 123
 Boletus species, 120
 Cantherellus species, 115, 117
 Lactarius species, 103–4
 matsutake, 135–37
 Russula species, 185
 turkey tail mushrooms, 144
soma, 159
sotolon, 104
splitgill polypore mushrooms (*Schizophyllum commune*), 97
spores, 47
 and cordyceps, 151
 and earthstars, 186
 medicinal properties of, 101
 spore dispersal, 11, 42, 99, 119
 spore prints, 90, 97, 99, 107, 131, 144, 148, 164, 171
 and webcaps, 171
spring kings *(Boletus rex-veris)*, 120
Stereum hirsutum (false turkey tail), 145, 187
stinkhorn mushrooms, 24
stipe, 46
storing mushrooms, 62
Sulfur Shelf. *See* chicken of the woods mushrooms

T

tastes, 24–26
taxonomy, 44

Tibet, 151
tooth/teeth, 46–47
toxicity
 and deadly galerina mushrooms, 181
 and death cap mushrooms, 179
 and destroying angel mushrooms, 176
 and jack o' lantern mushrooms, 170
 and morels, 129
 and webcaps, 173
toxic mushrooms, 167–81
 deadly galerina, 181
 death cap, 177–79
 Destroying Angel, 175–76
 jack o'lantern, 169–70
 webcaps, 171–73
toxins, bioaccumlation of, 50, 117
Trametes versicolor (turkey tail mushrooms), 143–45
Tremella aurantia (witch's butter), 187
Tremella fuciformis (white snow fungus), 187
Tricholoma magnivelare (matsutake mushrooms), 26, 135–37
turkey tail mushrooms *(Trametes versicolor)*, 143–45
Tylopilus felleus (bitter bolete), 121
tyramine, 108, 133

U

umbrella polypore *(Polyporus umbellatus)*, 133
universal veils, 47–48
urban expansion, 42
urban mushrooms, 50–51, 90, 107, 164

V

Verpa bohemica and *conica*, 129
virotoxins, 176, 179
vitamin B12, 35, 125, 152
vitamin D, 34
 in black trumpet mushrooms, 125
 in chanterelle mushrooms, 117
 in hen of the woods mushrooms, 133
 in morel mushrooms, 128

in oyster mushrooms, 96
in wild mushrooms, 90
volva, 48

W

webcaps (*Cortinarius* species), 171–73
wet sauté, 63–64
white button mushrooms, 34–36, 89–90, 93
white jelly fungus (*Pseudohydnum gelatinosum*),
187
white snow fungus (*Tremella fuciformis*), 187
whole-roasting mushrooms, 64–67
witch's butter (*Tremella aurantia*), 187
wood ear fungus (*Auricularia auricula-judae*), 187

Y

yamabushitake. See lion's mane mushrooms
yun zhi. See turkey tail mushrooms

About the Author

JESS STARWOOD is a forager, plant-based chef, and herbalist with a master of science degree in herbal medicine. She teaches about wild food, fungi, and herbalism, and has worked with some of the top Michelin-starred chefs in Los Angeles. She has two daughters (Isabella and Sage), too many houseplants, and three cats.